Engaging English Art

ENGAGING

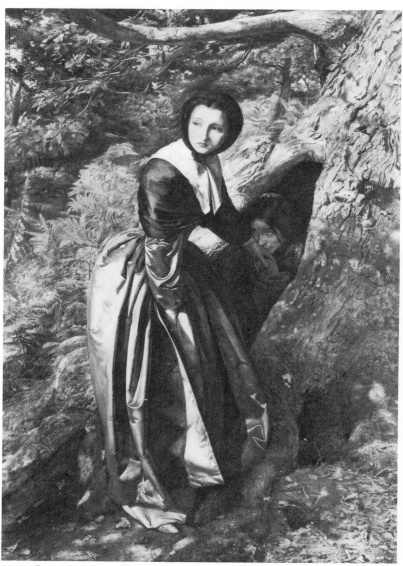

Private collection. Photo courtesy of Christie's, London.

ENGLISH ART

Entering the Work in

Two Centuries of English

Painting and Poetry

Michael Cohen

The University of Alabama Press
Tuscaloosa and London

Copyright © 1987 by
The University of Alabama Press
Tuscaloosa, Alabama 35487
All rights reserved
Manufactured in the United States of America

Library of Congress Cataloging-in-Publication Data

Cohen, Michael, 1943–
 Engaging English art.

 Bibliography: p.
 Includes index.
 1. Arts, English. 2. Ut pictura poesis (Aesthetics)
3. Arts, Modern—17th–18th centuries—England.
4. Arts, Modern—19th century—England. I. Title.
NX543.C64 1987 759.2 86-7075
ISBN 0-8173-0306-5

To Matthew and Daniel

Contents

List of Illustrations ix
Acknowledgments xiii

Introduction **1**
Definition and Scope 1
Engagement and Empiricism 6
The Critical Problems 8
Warnings 13

1 Time and Space for the Observer to Enter 15

Time 16
Space 43

**2 Engaging Metaphors: Comparative Figures
in Hogarth and Blake 49**

Hogarth and Verse Satire 49
Visual Metaphor and Literal Misreading in Blake 65

3 Nature and Engagement 77

Figures in Nature 77
Signs in Nature 112

4 Engagement and the Problems of Realism: The Pre-Raphaelite Experiment 143

Raphaelitism and Reaction 144
Realism and the Mid-century Debate 149
Reversion to Whose Nature? 153
Problems of Realism and the End of the Experiment 173

5 The Earnestness of English Art 177

The Englishness of English Art 178
The Alliance of Taste and Virtue 182
Earnestness and Engagement 185

Notes 189
Bibliography 211
Index 223

Illustrations

Gimcrack with a Groom on Newmarket Heath (c. 1765),
 by George Stubbs 18
The Seven Ages (1838), by William Mulready 18
The Stonebreaker (1858), by John Brett 20
The Cornfield (1826), by John Constable 21
Past and Present, Number 1 (1858), by Augustus Egg 22
Past and Present, Number 2 (1858), by Augustus Egg 23
Past and Present, Number 3 (1858), by Augustus Egg 24
Ecce Ancilla Domini! (1850), by Dante Gabriel Rossetti 26
The Girlhood of Mary Virgin (1849), by Dante Gabriel Rossetti 27
The Awakening Conscience (1853), by William Holman Hunt 28
"The Heir," from *The Rake's Progress* (1733–35),
 by William Hogarth 29
"The Contract," from *Marriage à la Mode* (1743–45),
 by William Hogarth 30
Two Shepherd Boys with Dogs Fighting (1783),
 by Thomas Gainsborough 32
Gypsy Sisters of Seville (1854), by John Phillip 33
Mrs. Siddons as the Tragic Muse (1784), by Sir Joshua Reynolds 36
Mrs. Siddons (c. 1784), by Thomas Gainsborough 37
May Sartoris (1860), by Frederic, Lord Leighton 39
Miss Willoughby (c. 1782), by George Romney 41
"The Levee," from *The Rake's Progress* (1733–35),
 by William Hogarth 54
"The Orgy," from *The Rake's Progress* (1733–35),
 by William Hogarth 56
"The Arrest," from *The Rake's Progress* (1733–35),
 by William Hogarth 58

"The Marriage," from *The Rake's Progress* (1733–35),
 by William Hogarth 59
"The Gaming House," from *The Rake's Progress* (1733–35),
 by William Hogarth 60
"The Fleet Prison," from *The Rake's Progress* (1733–35),
 by William Hogarth 62
"The Madhouse," from *The Rake's Progress* (1733–35),
 by William Hogarth 63
"The Fly," from *Songs of Innocence and of Experience* (1794),
 by William Blake 67
Mr. and Mrs. Andrews (1748–50), by Thomas Gainsborough 79
Wivenhoe Park, Essex (1816), by John Constable 82
Lady Elizabeth Delmé and Her Children (1780),
 by Sir Joshua Reynolds 83
The Proscribed Royalist 1651 (1853), by Sir John Everett Millais 88
A Wounded Cavalier (1856), by William Shakespeare Burton 89
The Long Engagement (1859), by Arthur Hughes 90
Master John Heathcote (c. 1771), by Thomas Gainsborough 96
Miss Murray (1826), by Sir Thomas Lawrence 97
Lady Caroline Howard (1778), by Sir Joshua Reynolds 98
The Blind Girl (1856), by Sir John Everett Millais 108
Paradise (c. 1620), by Peter Paul Rubens and Jan Brueghel 109
Mortlake Terrace (1827), by Joseph Mallord William Turner 118
Regulus (1828, reworked 1837),
 by Joseph Mallord William Turner 119
Elizabeth I, the "Rainbow Portrait" (c. 1600),
 by an unknown painter 126
Beatrice Addressing Dante from the Car (1824–27),
 by William Blake 129
Landscape with a Rainbow (c. 1635), by Peter Paul Rubens 130
Eildon Hills with the Tweed (1807), by James Ward 131
*Titianus Redivivus;—or—The Seven Wise Men Consulting the New
 Venetian Oracle* (1797), by James Gillray 132
Salisbury Cathedral from the Meadows (1831), by John Constable 135
The Wreck Buoy (1849) by Joseph Mallord William Turner 138
*Light and Colour (Goethe's Theory)—the Morning after the Deluge—
 Moses Writing the Book of Genesis* (1843),
 by Joseph Mallord William Turner 139

The Annunciation (1657), by Nicolas Poussin 147
Proserpine (1877), by Dante Gabriel Rossetti 168
The Hireling Shepherd (1851), by William Holman Hunt 169

Acknowledgments

Portions of this book have been published in *Studies in Iconography*, *The Victorian Newsletter*, and *The Journal of Pre-Raphaelite Studies*, whose editors have been kind enough to grant permission to reprint my work. Alfred A. Knopf gave permission to quote from Wallace Stevens's "Sunday Morning," from *The Collected Poems of Wallace Stevens*.

I want to thank Murray State University for a sabbatical leave to finish the manuscript preparation, and the university's Committee for Institutional Studies and Research for financial support in obtaining photographs. Many scholars have given me help, criticism, and encouragement with part or all of the book. Among them I wish to thank Wayne Bates, Robert E. Bourdette, Jr., Christopher Buckley, Ron Cella, Nathan Cervo, David DeLaura, David Earnest, Francis Golffing, John E. Grant, Mark Jarman, Karl Kroeber, Malcolm Magaw, John T. Shawcross, Oliver Sigworth, and William Walling. I owe special gratitude and love to Katharine Cohen, Edith Wylder, and Deb Wylder. Thanks also to Joanne S. Ainsworth of the Guilford Group and to Malcolm MacDonald and Judith Knight of The University of Alabama Press. This book is dedicated to my sons, Matthew and Daniel, in the hope that the love they have already shown for the arts of painting and poetry will engage them all their lives.

Engaging English Art

Introduction

> Comparison of the arts is, in fact, far the best means by which an understanding of the methods and resources of any one of them can be attained.
>
> —I. A. Richards, *Principles of Literary Criticism*

In this book I describe strategies common to poetry and painting for engaging readers and observers. The examples come from eighteenth- and nineteenth-century England, and my intent is not only to establish connections between the sister arts but also to find comparisons which will illuminate individual poems and paintings. The general question I address is, What helps bring about engagement of the audience in art? and the limiting question is, What that is common to both poetry and painting helps bring about engagement?

Definition and Scope

Engagement is a word I wish to use to identify an experience known to readers of poetry and to observers of paintings. The experience begins with a sense of being in the work and includes a conviction that the subject of the work matters; the engaged observer also accedes to a demand for some response—intellectual, moral, or emotional. Engagement includes both entry and effect. Here is how a modern critic describes the observer's entry; John Berger is commenting on two Turner paintings:

> In *The Burning of the Houses of Parliament* the scene begins to extend beyond its formal edges. It begins to work its way round the spectator in an effort to outflank and surround him. In *The Snowstorm* the tendency has become fact. If one really allows one's eye to be absorbed into the forms and colours on the canvas . . . one is in the center of a maelstrom: there is no longer a near and a far. For example, the lurch into distance is not, as one would expect, into the picture, but out of it toward the right-hand edge. It is a picture which precludes the outsider spectator.[1]

The sense of our presence within a work is the beginning of engagement but not its entirety. Additionally, engagement includes our reactions to the events portrayed and a change in us as a result of our being engaged: we have been affected through persuasion, understanding, sympathy, revulsion, or some other response that the work has required of us while we were drawn in and held fast. Another modern critic, John Reichert, describes the variety of such effects in *Making Sense of Literature*. Reichert has been quoting Francis Fergusson on Dante, Richard Poirer on Henry James, and Eric Auerbach on Homeric and biblical narrative:

> The key ideas here, in a foreshortened form, are that Dante, through his presentation of Francesca, *constrains* us to love her; that James *makes us share* Isabel's romantic responses, but also *makes us* skeptical. And the Homeric poems *bewitch, flatter, court our favor*, while the biblical stories *seek* to subject us, *seek* to overcome our reality, *demand* interpretation. All three critics speak of the author or the text as doing something to the reader and of forcing the reader to do something in return (love a character, become more skeptical, take delight in, interpret and investigate, and so on). With very little effort the list of actions that authors perform through their writings could be greatly extended to include leading, guiding, persuading, rebuking, teasing, showing, teaching, humiliating, luring, inviting, misleading.[2]

The effects that Reichert describes follow upon entry and are the second phase of engagement as I have used the term.

I have not invented this sense of the word *engagement* but have modified it from its use in the eighteenth century by Lord Kames. The first English critical work to treat the notion of engagement in

both literature and the visual arts is *The Elements of Criticism*, published by Henry Home, Lord Kames, in 1762.[3] Kames is exploring the question of how the fictions of art work and why they make such an impression on the mind at all, since man is "so remarkably addicted to truth and reality" (1:104). He begins by comparing the effect of fiction to that of memory—not any memory but one of a particularly affecting event which is remembered circumstantially (1:106). Memory in this case puts us in the position of spectators at the event, where we observe it happening in the present and are again affected by it. Kames complains of the inadequacy of language to describe his subject here, since "it is inaccurate to talk of incidents long past as passing in our sight, nor of hearing at present what we really heard yesterday or perhaps a year ago" (1:107). To distinguish it from *real* presence, Kames uses the phrase *ideal presence* to name the sense of actuality we have when we review a strong memory. He also distinguishes the ideal presence created by a strong memory from the fainter reflections of ordinary memory: "when I recall the event so distinctly as to form a complete image of it, I perceive it ideally as passing in my presence," he says, whereas in ordinary memory thinking of a past event "without forming any image . . . is barely reflecting or remembering that I was an eye-witness" (1:109).

The ideal presence of such an affecting memory Kames compares to the same feeling of presence we experience with a work of art:

> I proceed to consider the idea of a thing I never saw, raised in me by speech, by writing, or by painting. . . . An important event, by a lively and accurate description, rouses my attention and insensibly transforms me into a spectator: I perceive ideally every incident as passing in my presence; and in idea we perceive persons acting and suffering, precisely as in an original survey. If our sympathy be engaged by the latter, it must also in some measure be engaged by the former. [1:110]

In the last sentence, Kames is writing about a later stage of what I have called *engagement*, an effect that begins with the illusion of entering the work's own time and space. The entry itself he usually calls *ideal presence*, but occasionally he uses some form of the verb *to engage* for it as well: "The reader, once thoroughly engaged, is in that

situation susceptible of the strongest impression. . . . A masterly painting has the same effect" (1:122–23). The observer's sense of being in the work and having its events pass in his presence is succeeded, according to Kames, by effects on the emotions, the understanding, and the convictions of the observer (1:118, 122). Ideal presence is the beginning of the whole process of engagement. Entry is followed by effect.

Eric Rothstein has shown that Kames's critical position was a widely held one in the eighteenth century. In " 'Ideal Presence' and the 'Non Finito' in Eighteenth-Century Aesthetics," Rothstein quotes from Joseph Warton, Sir Richard Blackmore, Joseph Spence, and others to demonstrate that Kames's views about ideal presence were anticipated earlier in the century, although Kames was the first to apply them to poetry and painting together.[4]

The sense of what a work of art can do to an engaged observer has varied through the centuries and generally weakened since the Renaissance. Renaissance works routinely contain assertions about the great coercive power of art; if we are to take these claims at face value we must suppose that Shakespeare's contemporaries believed a well-written poem could constrain a woman to love its author (Edward III) or that a well-represented dramatic account of a murder could force a confession of guilt from a murderer (Hamlet). In our century we have lost confidence in the power of art to effect meaningful change: "today the idea has been largely dismissed," says Robert Hughes of visual art's power as moral force. George Steiner and others have made the same point about literature; Ortega y Gasset and others, about art in general.[5]

This book draws its examples from English arts of about 1680 to 1880. These centuries still retain much of the Renaissance exuberant confidence in the power of art. Readers and spectators of this time regularly expected their art to confirm or challenge political values, to chasten and ridicule (sometimes even to the extent of provoking an armed attack on a satirist by his victim), to elevate the mind and stretch it to try to encompass ideas of infinity and omnipotence, as Milton's poetry and some landscapes were able to do in the opinion of Addison and other commentators on the "natural sublime." As in other times, art during this period had the undeniable power to

shock and to appeal to prurient interest. It was also seen as able to praise by creating memorials and panegyrics, to instruct and define, and to accuse as well as ridicule and expose to shame the vicious and the foolish.[6]

The period's confidence in art to affect its audience through engagement makes these two centuries rich with examples for my topic. These are the two great centuries of English painting, the centuries in which poets, painters, and critics recognize the greatest affinity between the two arts, and the period that produces the artists whose work is the best English testimony to the relation of the sister arts: William Hogarth, William Blake, and Dante Gabriel Rossetti. Before the end of the seventeenth century, English painting is still an infant sister who cannot usefully be compared with her elder sibling; in the 1700s and 1800s the two arts, now of equal competence and scope, also come to share close to equivalent prestige and much the same audiences, which expect the same effects from both. But toward the end of the nineteenth century, a new trend in the arts, away from engagement, becomes apparent. It begins with aestheticism and eventually results in self-referential and non-referential forms which express alienation by alienating rather than engaging their audiences. Engagement ceases to have the aesthetic premium that it has carried for two centuries.

Engagement is certainly not a peculiarly English reaction to art,[7] but in eighteenth- and nineteenth-century England, engagement as an aesthetic goal has preferred critical status, and this development can be linked to an earnestness in English arts and to the background of English empirical philosophy. It is not exaggerating to say that English pictures and poems of these centuries represent the transmutation of a heroic ideal. Aspirations toward writing in the most exalted of genres, epic poetry, were after Milton turned into writing of effective satire, evocative meditative/landscape poems, poems of spiritual autobiography, poetic equivalents of the genre picture, and dramatic monologues such as Browning's "My Last Duchess" and Rossetti's "Jenny." Aspirations toward painting in the most exalted of genres, history painting, were before and after Reynolds turned into the painting of portraits, landscapes, and genre scenes. Ronald Paulson has commented that "the 'modern moral subjects' of Hogarth, the horses of Stubbs, the more informal portraits of Reynolds,

and the candle-lit interiors of Wright of Derby were the actual triumphs of 'history painting' in England."[8] We can add the portraits, landscapes, and "modern moral subjects" of nineteenth-century painters such as Augustus Egg, William Holman Hunt, David Wilkie, John Millais, and John Brett. All of these works are set apart from those of Continental contemporaries by a distinctly English moral earnestness—sometimes, but by no means always, stemming from Puritanism.

Engagement and Empiricism

The ease with which English works of these centuries engaged their audiences depended partly on a view of perception shared by those who grew up in an intellectual climate where empirical philosophy and empirical theories of perception prevailed. The key elements of such theories, from the point of view of artistic perception, are notions about the interdependence and relative nature of space and time and the idea of percipients as active agents, forming and testing hypotheses as they read a text or view a scene.

A coherent empirical theory of perception was not recorded until Hermann von Helmholtz (1821–94) published his "unconscious induction," or hypothesis view of perception, in the last quarter of the nineteenth century, but the elements of this theory are anticipated much earlier in John Locke's and George Berkeley's discussions of the way other senses and memory are consulted when the meaning of visual information is assessed. Helmholtz used the example of language recognition to illustrate the general process of perception, a synecdoche employed by both Locke and Berkeley. One view of perception—that held by Gotthold Lessing—had considered it passive: one sits reading and information streams into the eyes and brain, perhaps finding niches in the memory or perhaps being momentarily acknowledged by the mind and then disappearing forever from consciousness. One looks at a picture and its entirety is simultaneously absorbed by the consciousness. Helmholtz argued that perception is a very active process in which the perceiving eye and mind work together to absorb impulses, attempting to fit them together to form larger ideas, constructing

hypotheses, testing them against each new percept, rejecting them and substituting new ones as each word or phrase of a text or each passage of a painting is scanned.[9] Artists found in this view of perception a chance to make their readers and spectators part of the works themselves.

Helmholtz gave specific credit to Locke for having first discussed the nature of perception empirically, in terms of inference.[10] In *The Essay Concerning Human Understanding* (1690), Locke had made a distinction between several kinds of perception (2.21.5). Although he said the simplest kind of perception was mostly passive (2.ix.1), his use of the word *perception* throughout most of the *Essay* denoted a process that included the recognition of ideas, the identification "of the significance of signs," and the discrimination between "the agreement or disagreement" of ideas (2.21.5). Locke asserted that the influence of the judgment may alter a perception unconsciously, identifying it as a wrong hypothesis and correcting it (2.9.8). Hypothesis forming and testing is common to visual perception and to language recognition (2.9.9).

Berkeley argued that the visual data of perception are mediated by information from the other senses and from memory and that the data of perception consist largely of arbitrary systems of signs.[11] Both Locke and Berkeley posited inferential and hypothesis-forming perception in response to the same question, raised by William Molyneux and generally known as Molyneux's problem: could a man born blind, but suddenly allowed to see, distinguish a sphere from a cube by sight alone? Locke and Berkeley said no—he would need to touch the objects while looking at them to distinguish, because every visual perception of an object is an inference based on memory and comparison with other sense data.[12] All these theories or parts of theories have in common the assumption that vision does not give seen objects directly to the understanding but offers nothing more than signs for what is perceived—hence the recurrent comparison of visual perception with the special case of reading.

Another common feature of these theories concerns temporal and spatial modes of perception. English descriptions of our perception of time, beginning well before Locke with the Cambridge Platonists, all contain the idea that relative time, the only kind di-

rectly accessible to the understanding, is perceived solely through a succession of ideas in the mind.[13] Moreover, space in these descriptions is related to time not only in absolute physical ways but in relative, perceptual ways also, especially in the perception of art.

Not only the poets and the painters but also the readers and spectators of eighteenth- and nineteenth-century English arts were conditioned to expect active involvement with works. Moreover, the empirical philosophical tradition, going back to Francis Bacon's insistence on observation and substance rather than speculation, also influences the realistic mode of the works considered in the following pages. The philosophers provided the intellectual climate, but the poets and painters educated observers in the mechanics of perception, the similarities between the sister arts, and the kinds of illusion of which the arts were capable.

The Critical Problems

Many of the critical problems taken up in this book are raised, at least in elementary form, in Kames's The Elements of Criticism. Kames raises the question of how a work's power to evoke ideal presence—and thus to engage its audience—is related to its ability to represent time and space. He finds painting's power to raise passions limited because "of all the successive incidents that concur to produce a great event, a picture has the choice but of one, because it is confined to a single instant of time." But, according to Kames, "seldom can a passion be raised to any height in an instant, or by a single impression" (1:117). Thus Kames suggests that the work's effectiveness in engaging us depends on its ability to evoke time, but he also suggests (without pursuing it) a way for painting to evoke time, since for these purposes time means "a succession of impressions": "our passions, those especially of the sympathetic kind, require a succession of impressions" (1:117–18). In the first chapter below I will argue that engagement depends on the successful evocation of both time and space in a work, and that artists and poets of this period had developed extremely sophisticated techniques to evoke both. Before Lessing's Laocoön, critics in England, Kames among them, had argued that painting was an art of space, and

poetry an art of time, but no such limitations deterred the artists themselves.

A question of paramount importance in the comparison of the sister arts asks whether the most effective techniques of one art have counterparts in the other, and more specifically, whether the most common techniques of poetry, involving comparison of one sort or another, have corresponding effective techniques in painting. Kames spends much of his three volumes on what might be called comparative figures in poetry and the philosophic and psychological bases of comparison. When he discusses simile, metaphor, allegory, personification, and other comparative figures, Kames speaks little of painting, and he appears to have thought little about how graphic images actually work on us as spectators. But in his more general treatments of resemblance and contrast, uniformity and variety, congruity and propriety (chapters 8–10), Kames makes subtle observations about how certain juxtapositions—physical as well as in states of mind—influence perception. Finally Kames is too conventional to go far in exploring whether those literary figures most conducive to engagement have graphic counterparts. I treat this question in chapter 2 here, where I compare the methods of Hogarth's pictorial satire to the techniques of literary verse satire and I explore the connections between visual and verbal metaphor, using as example a poem and design from Blake's *Songs of Innocence and of Experience*.

Kames's main subjects are emotion and passion as they are represented in art and as they are evoked in a reader or spectator by human action. He looks at the world of nature only briefly, glancing at the effect of landscape on the emotions (1:154–56, 298), including a chapter on "Grandeur and Sublimity" (chapter 4), and drawing examples from landscape gardening as well as considering it and architecture in a penultimate chapter (chapter 24). But eighteenth- and nineteenth-century English poetry and painting are almost exclusively concerned with human beings, with landscape, or with some combination of the two. Landscapes always involve human beings, even if they are only implicit as observers outside the painting or poem; works that concentrate on human figures all have backgrounds, and even neutral backgrounds are choices to exclude architectural or landscape accompaniments to the figures. More

subtle questions need to be asked about these relationships than Kames has asked, and particularly about those that are conducive to engagement. I begin chapter 3 here with a taxonomy of relations between figures and landscape backgrounds, largely ignoring the usual generic categories of poems and pictures, and I ask what functions of these relations promote engagement. As the chapter continues I take a closer look at one class of examples: children depicted within gardens or excluded from gardens. In a concluding section I examine two natural totems, the sun and the rainbow, and their roles as engaging emblems in the two arts.

A passing concern of Kames but a major one of this book is the role of realism in ideal presence and engagement. "It is the perfection of representation to hide itself, to impose upon the spectator, and to produce in him an impression of reality, as if he were spectator of a real event," says Kames, speaking of dramatic representation (3:279). But Kames also points out, anticipating Johnson's famous comment on the unities, that no spectator is literally fooled by the drama onstage. The implicit general critical principle is that the arts' representation involves an illusion and a simultaneous awareness that it is an illusion, and that only the critically simple-minded would suppose that the stronger the illusion and the fainter the awareness of illusion, the better the art. What are the limits of realistic representation in art and how is engagement dependent on realism? These questions are discussed in chapter 4, on the Pre-Raphaelites, who deliberately set out with the goal of complete realism and engagement in their work, and whose failures are as instructive as their successes for our discovery of the limits of effective realism in representation.

Kames could not have anticipated modern criticism's depth of interest in questions about audience response to an art work. The most important of these questions, from the perspective of my topic, asks whom the art work engages. Who is the reader or spectator who enters and is affected by the poem or picture? This question can be adequately confronted only within the individual studies in following chapters, but it will be well to put my attempts to answer it in the context both of recent criticism and that of the periods I am considering.

The brilliance of recent critical work on audience response

should not obscure for us the fact that issues of audience involvement were debated by English and Continental writers from the seventeenth century on. When Wolfgang Iser writes of the reader's creative activity in "filling in gaps left by the text," and when he speaks of the imagination's creation of the "virtual dimension" of the text out of its "indeterminacy," his language resembles very closely eighteenth-century descriptions of what Eric Rothstein has called "the non finito, the art of making the reader or viewer supply what is unstated" in a work. "The evidence strongly suggests, I believe, that an eighteenth-century Englishman or Frenchman dwelt upon and responded to poetic imagery and to paintings by creating in his imagination those significant parts of the scene which were not presented in the text."[14] Iser is careful to point out that texts such as *Tristram Shandy* and the novels of Jane Austen show how the reader's engagement with the text is active and creative, acknowledging that his view of reading is "no new discovery."[15]

A parallel example comes from the work of Stanley Fish. In both *Self-Consuming Artifacts* and *Is There a Text in This Class?* Fish has described "the developing responses of the reader in relation to the words as they succeed one another in time," the guesses, revisions, forecasts, and reassessments of "the temporal flow of the reading experience."[16] This "hypothesis theory" of reading is not new. Locke and Berkeley wrote in very similar ways, in 1690 and 1709, respectively, of perception in general and of the special case of language interpretation in particular. I point out these correspondences not to detract from current theorists, but merely to show a continuity of interest in audience response.

The simplest answer to the question of who the reader/spectator is in the following pages must be that I am, with all my limitations, warts, and prejudices. My own report as a real reader is bolstered by the testimony of real critics such as Theophilus Thoré and Ruskin, from writers and readers such as Johnson and Henry James, from artists such as Hogarth, Hunt, Rossetti, and Whistler. But readers are partly determined by their texts, and this concept of an enriched or enhanced reader will not suffice to describe the complexities of encounters with works of such diversity as those that follow. The term *reader*, in the next few paragraphs, must be understood to include the function of spectator when the work encountered is visual rather than verbal.

The reader described as engaging with certain of these works is a species of ideal reader, to use Iser's distinction in The Act of Reading among real, ideal, and implied readers.[17] This ideal reader complies with certain instructions laid down in the work about how to read and how not to read; such a one might be called a tame reader. The tame reader is most useful in considering the case of pictorial and verse satire, as I do in the first part of chapter 2, dealing primarily with Hogarth. The reader is encouraged in certain reactions to The Rake's Progress by the figure of Sarah Young and warned away from other reactions by the presence of the idle and shocked sightseers in the Bedlam scene. There is a close correspondence here with the cautionary force of caricatures in verse satire (who warn against kinds of reading as well as kinds of living) and with the commendatory force of the satirist's own personality or that of the satirist's friends, ideally presented. In "The Muse of Satire," Maynard Mack described how Pope presents himself as the vir bonus in certain of his satires. The satirist as good man wishes no one evil, hopes for a virtuous and undisturbed life, but fights fools as a public duty.[18] Mack did not point out that the satirist's ideal self-portrait is also a pattern for the reader, where an ideal reader-pattern such as Arbuthnot or Fortescue is not present in the text. The tame reader has been discussed under different names, appearing as Wayne Booth's created reader, the mock reader of Walker Gibson, and the intended reader of Erwin Wolff.[19]

The tame reader proves an inadequate model for some romantic and Victorian texts, however, and even before the end of the eighteenth century there are questions, even in as tame a genre as portraiture, about how response can stay within such carefully delineated bounds as those of any ideal reader. I suggest in chapter 3 that there is in the portraits of children by Joshua Reynolds, Thomas Gainsborough, Thomas Lawrence, and Frederic Leighton a kind of subtext, working simultaneously with the surface of the pictures and sometimes at as extreme odds with it as death is to life and age to youth. The perspective given by time, distance, and lack of ties to the sitters makes the subtext easier to see but also raises questions of intended readership. Do the patrons of these artists and their families constitute the sole audience or even the primary audience for which the artists work? Entry into a work seemingly designed for an audience of nobility or gentry proves surprisingly easy for

those of us who are neither. And this entry is not always solely on the terms set by the picture's apparent intention.

With Blake the tame reader is also at a loss. Blake's integration of text and picture in his designs makes for a new relation of the visual and verbal, which in turn requires an active, intuitive reader capable of making syntheses without explicit instructions or models. The synthesis of compared subjects and states, as well as the synthesis of the two arts, takes place in the observer. In the latter part of chapter 2, I examine how Blake's use of visual/verbal metaphor and his integration of the two arts both point to a transcendent synthesis of ways of seeing as reflections of contrary states of being— Innocence and Experience.

With the Pre-Raphaelites, who are dealt with in chapter 4, a further modification of the reading model becomes necessary. In Rossetti's "Jenny," for example, the reader, far from being given instructions for a comfortable role, is compromised by being in the poem at all. Changes undergone by the reader in moving through this text, and discriminations that must be made between male and female audiences, make a phenomenological approach most useful. This reading model comes closest to Wolfgang Iser's implied reader, whose individual, class, and gender differences combine with unchanging structures in the text to produce "structured acts" in the reader.[20]

Despite these modifications, I take my view of the reader/spectator to be a conservative one. I could never say with Fish that "there is no direct relationship between the meaning of a sentence (paragraph, novel, poem) and what its words mean."[21] The following separate analyses emphasize that texts create their readers rather than vice versa. And though my own readers must decide to what extent concentration on engagement replaces the art work as the center of importance in what follows, I confidently leave that judgment to them.

Warnings

The method I use in this book is to examine questions about engagement by looking at particular examples of poetry and painting. Examples are sometimes grouped from widely different times and

genres. Nothing like a comprehensive history of the period, in either art, is intended. Nor do I attempt here a comprehensive treatment of artists chosen for comment. The main topic is the phenomenon in which readers and spectators find themselves drawn into a work and reacting in ways beyond simple recognition or assent, ways which include an emotional or intellectual identification with the concerns of the work.

More than half of what follows concerns painting—not from an intention to slight poetry, but from the necessities of argument. Often a point about poetry's power to engage appeared more self-evident, less in need of elaboration, than a similar point about painting. The subjects of the first chapter provide good examples. "Common sense" divides poetry and painting into arts of time and space, respectively. This common sense division is challenged in chapter 1. But the counterassertion of poetry's ease in evoking space commands more easy agreement than does the corresponding assertion that painting is not limited to a single moment in what it depicts but can evoke movement and the passage of time. The latter seems argumentative and in defiance of common sense, and it takes a more thorough demonstration with examples, I can only hope that those who pick up the book out of interest in poetry will stay to read what is written, at slightly greater length, about painting.

1

Time and Space for the Observer to Enter

We may take it as axiomatic that English poems and paintings of the eighteenth and nineteenth centuries needed to evoke time and space successfully if they were to engage their audiences. Before there can be emotional, intellectual, or moral conviction, the imagination must be awakened and helped to construct the world of time and space where humans live. Poems and pictures cannot reproduce the actual physical and temporal dimensions our bodies occupy, but they must represent a virtual time and space that convinces our perceptions, or we cannot close with them or enter their worlds.

It is something of a paradox that critics such as Kames recognized these necessities—required of a work, in order that it engage its audience, the successful evocation of both time and space—and yet denied to painting the power of evoking time and to poetry the power of evoking space. It was a critical commonplace long before Lessing that painting was an art of space, and could represent no more of time than the single instant—the *punctum temporis*—that the painter chose to depict. Poetry was declared to be an art of time, unfolding sequentially, excelling in the portrayal of actions, but unable to recreate space.[1] Given these critical convictions about the limits of the arts, if we wish to look at how eighteenth- and nineteenth-century artists managed to provide illusions of time and space, we will have to look at their own practice rather than at what

their contemporaries have to say about it. Some comments by modern critics who speak to the issue of perception of time and space in art will also be helpful.

Time

Poetry is sequential, but reading time rarely corresponds with represented time. The poet no less than the painter relies on the observer's ability to take perception time as a larger or smaller token for represented time, to look at two actions sequentially and see them as simultaneous, and to do other manipulative feats with time. Both arts rely on the observer to fill in gaps, extend one moment of perceived time backward or forward, and to see (to paraphrase Eliot) time past contained in time present and both contained in time future. The poet and the painter relate perceived time to represented time by means of verbal or graphic signals—time cues.

Time Cues

In Pope's *The Rape of the Lock*, an apparently straightforward narrative backs up, slows down, makes jumps in time, and represents simultaneous actions sequentially. The poem's action begins with morning:

> *Sol* thro' white Curtains shot a tim'rous Ray
> And op'd those Eyes that must eclipse the Day.
>
> [1.13–14]

We are then taken back a short while to Belinda's sylph-inspired morning-dream, which leads up to the moment of her awakening (1.114–16). Then, with no intervening time described, Belinda is suddenly at her dressing table:

> First, rob'd in White, the Nymph intent adores
> With Head uncover'd, the *Cosmetic* Pow'rs.
>
> [1.123–24]

The ensuing lines describe a process—the "inferior Priestess . . . begins . . . culls . . . decks;" Belinda "rises" in charms, "repairs" her

smiles, and so on—but this process must be imagined by the reader as taking longer than the reading of its two dozen lines.

Suddenly, with canto 2, Belinda is "Lanch'd on the Bosom of the Silver Thames"; then we discover that in an indefinite past the Baron has coveted Belinda's two locks of hair. Immediately Pope describes the Baron's prayer, a scene which took place before dawn, before the action of the poem began. Finally we return to Belinda's boat for a scene which would have taken *less* time to enact than to read of: the sylph council-in-air.

Within 150 lines, just in the first two cantos of the poem, Pope signals half a dozen time shifts forward and backward, skipping, slowing, and speeding up time as he wishes. The shifts are signaled by means of verbal cues: "Now . . . when . . . then . . . and now . . . ere Phoebus rose . . . But now." These time markers, along with changes from past tense to present indicating return to present action (1.121; 2.47), give us readers all we need to follow the shifts. The sequence of lines has no absolute correspondence with a represented time sequence; represented time is signaled not by any regular line progression (the clock time that it takes to read the lines; some metronomic beat measuring the five stresses of each line) but by arbitrary markers—arbitrary because they are in a language. Represented time is *virtual* time, an illusion in verbal art no less than in visual art.

For painters the representation of movement and time is a great challenge as technical problem to be solved. In one of the simplest and oldest solutions, one frame contains two or more actions or scenes succeeding each other in time. The best known example is Michelangelo's *Fall and Expulsion* panel from the Sistine Chapel ceiling (1512), which shows from left to right the temptation, the fall, and the expulsion of Adam and Eve from the Garden of Eden.[2] In England an eighteenth-century example is George Stubbs's *Gimcrack with a Groom on Newmarket Heath* (c. 1765), where Lord Bolingbroke's horse Gimcrack appears with his groom in the left foreground and again in the background two lengths ahead of his nearest rival as he wins the Newmarket races. The picture shows the horse in action as well as at rest in a more flattering pose. Moving across the painting, our eyes recreate the represented sequence as we see first the horse close up and unencumbered, then the approaching jockey, then

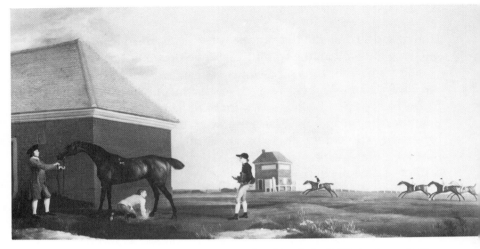

Gimcrack with a Groom on Newmarket Heath (c. 1765), by George Stubbs.
Reproduced by kind permission of the Jockey Club, Newmarket, Suffolk.

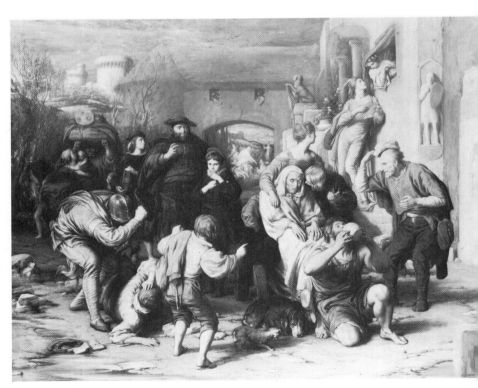

The Seven Ages (1838), by William Mulready.
Courtesy of the Victoria and Albert Museum, London.

horse and jockey together in action. The blank space behind the winner and the trailing horses do not conclude the picture but tend to send our glance back to the large and dominant image at the left, which can now be imagined as the horse *after* the race.

In the next century William Mulready uses the multiple-scene technique in *The Seven Ages* (1838), illustrating the passage from *As You Like It* (2.7.143–66) that describes the infant, the schoolboy, the young lover, the soldier, the justice, the "lean and slippered pantaloon," and finally:

> Last scene of all,
> That ends this strange eventful history,
> Is second childishness and mere oblivion,
> Sans teeth, sans eyes, sans taste, sans everything.

Mulready solves one of the problems of such a complex composition and sequence by arranging his figures in two tiers, but the movement of the eye in each tier is from left to right. Mulready's is one example of a "span of life" picture where the whole life of man or a man is indicated, by various cues, within a single frame. A more subtle example, John Brett's *The Stonebreaker* (1858), is discussed in chapter 3. The best-known example is Constable's *The Cornfield* (1826), in which a young boy drinks from a stream in the left foreground, the middle of the picture opens out into fields where laborers are at work, and in the right distance we can see a church. Karl Kroeber has written of this picture that its "diagonal progression from youth to the hope of life beyond death ... is almost too contrived," but he also recognizes that the confident linking of each time phase with the natural scene and with the striking perspective softens the contrivance.[3]

Another method of handling time sequence is with a series of pictures, which can show causation, gradual change, and all the sequential features of narrative. The best-known examples are Hogarth's painted and engraved series such as *The Rake's Progress* (1735). A series may cover only a few hours or a few days, as do Hogarth's four *Election* pictures (1754), or it may cover a number of years, as does his *Marriage à la Mode* (1743–45). Within these series individual pictures constitute episodes—"the levee," "at the gaming table," "in prison," and so on—such as might be found in a Fielding or

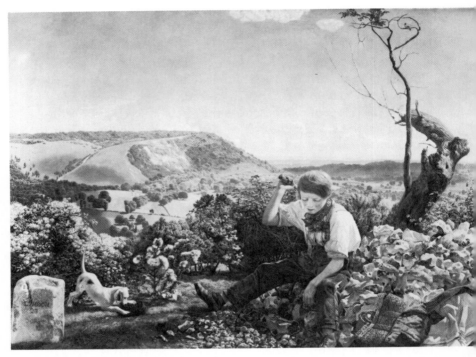

The Stonebreaker (1858), by John Brett.
Courtesy of the Walker Art Gallery, Liverpool.

Smollett novel or a Goldsmith or Sheridan play, and each picture has its own methods of conveying movement and time: one series of Hogarth's, *The Rake's Progress*, has especially interesting connections with the techniques of verse satire, and it will be examined at length in the next chapter.

Nineteenth-century picture series are at least as numerous as those in the previous century.[4] One of the most interesting examples for its time cues is Augustus Egg's *Past and Present* (1858), composed of three pictures. In the first, a husband has found a letter from or to his wife's lover; she lies cowering at his feet while one small child looks on with amazement and fear and another seems too young to grasp any of the scene's significance. Interest in the "fallen" woman, as Linda Nochlin has commented, "exerted a peculiar fascination on the imagination of nineteenth-century artists, not to

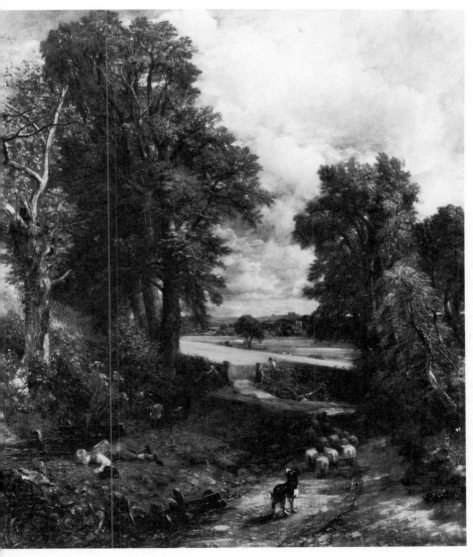

The Cornfield (1826), by John Constable.
Courtesy of the National Gallery, London.

Past and Present, Number 1 (1858), by *Augustus Egg*.
Courtesy of the Tate Gallery, London.

speak of writers, social critics, and uplifters, an interest that reached its peak in England in the middle years of the nineteenth century." There is further special fascination in the discovery scene and in the love letter as the evidence of the fall. T. J. Edelstein, who has traced the sources of Egg's composition and iconographic motifs in *Past and Present*, discovered both a novel and a contemporary play (the latter alluded to by a playbill in the third painting) that used the device of a letter to reveal the wife's infidelity.[5] Egg's triptych may itself be a partial source for George Meredith's *Modern Love* (1862), a sonnet sequence in which the husband finds a letter his wife has written to her lover and confronts her with it, along with an older love letter she had written to her husband:

> Her waking infant-stare
> Grows woman to the burden my hands bear:
> Her own handwriting to me when no curb
> Was left on Passion's tongue. She trembles through:
> A woman's tremble—the whole instrument:—
> I show another letter lately sent.
> The words are very like: the name is new.
>
> [Lines 8–14]

In the Meredith sonnet sequence the wife dies by suicide, and as Edelstein has noted, the third picture of Egg's triptych seems to point to the wife's suicide. But there are no children in the Meredith sequence, while the children are the subject of Egg's second picture.

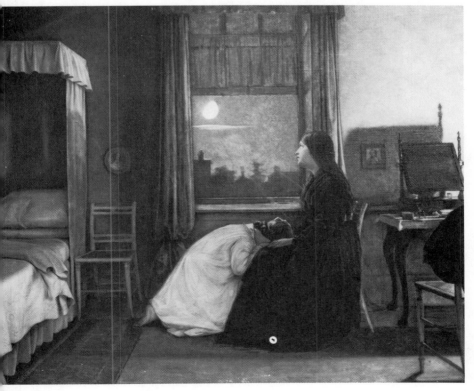

Past and Present, Number 2 (1858), by *Augustus Egg.*
Courtesy of the Tate Gallery, London.

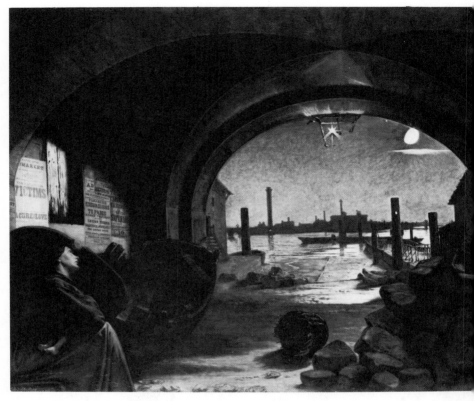

Past and Present, Number 3 (1858), by *Augustus Egg*.
Courtesy of the Tate Gallery, London.

In *Past and Present*, we might reasonably expect the last two pictures to represent scenes later and still later, but in fact they represent two different places at the *same* time, years after the first scene and presumably what we are to take for the present of the title. Egg signals the simultaneity with the identical moon and cloud combination to which attention is drawn by the gaze of the main female subject in each picture. In the second picture, one daughter, now almost grown, comforts her younger sister while staring at the moon, which appears outside their garret window. In the third picture the wife looks hopelessly at the moon as she sits miserably in her only shelter under the Adelphi arches. The moon here is the visual equivalent of the writer's "meanwhile." The pictorial dispo-

sition of space in these pictures corresponds to the way stories are told in narratives. In these pictures, to use Rudolf Arnheim's words, space is "an image of time."[6]

Emblems of Time

Multiple scenes, whether in one frame or several, give the observer an active role in filling gaps between the several times depicted. More of the painter's real virtuoso skill is revealed in finding ways time, movement, causation, and change can be shown within a single scene. One solution is emblematic, using both symbols and signs.

Symbols, whether traditional or of the painter's own derivation, can extend a picture's time to remind us of past events and look forward to the future. In Rossetti's *Ecce Ancilla Domini!* (1850), a red embroidery, on its stand in the right foreground, takes us back to an earlier time which Rossetti had painted the year before as *The Girlhood of Mary Virgin*. There, with her mother, Saint Anne, looking on, Mary embroiders the cloth which will appear in the later picture. Two sonnets are attached to the earlier picture and together they bear the title "Mary's Girlhood: For a Picture"; the second one glosses its various symbols, including those that look forward to the crucifixion and beyond:

> These are the symbols. On that cloth of red
> I' the centre is the Tripoint; perfect each,
> Except the second of its points, to teach
> That Christ is not yet born. The books—whose head
> Is golden Charity, as Paul hath said—
> Those virtues are wherein the soul is rich:
> Therefore on them the lily standeth, which
> Is Innocence, being interpreted.
> The seven-thorn'd briar and the palm seven-leaved
> Are her great sorrow and her great reward.

Although many of these symbols are of Rossetti's own invention, they resemble typological symbols, which can also function as important time cues. Typological symbolism implies a Christian view of history and the fulfillment of former prophecy by finding "types" or prophetic forerunners of Christ's birth, life, death, and second

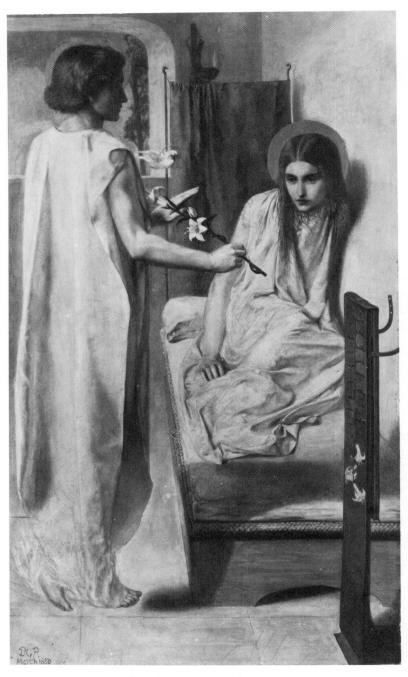

Ecce Ancilla Domini! (1850), by Dante Gabriel Rossetti.
Courtesy of the Tate Gallery, London.

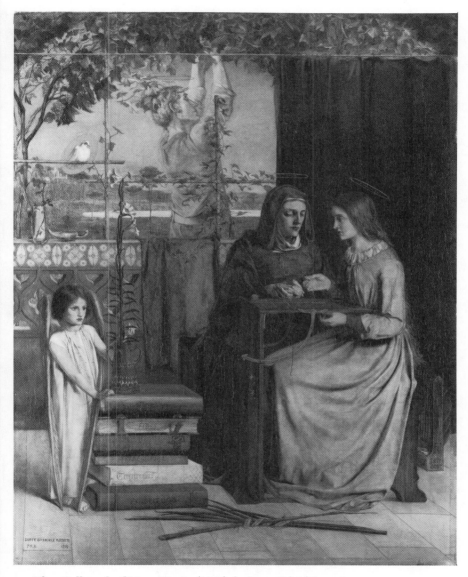

The Girlhood of Mary Virgin (1849), by Dante Gabriel Rossetti.
Courtesy of the Tate Gallery, London.

The Awakening Conscience (1853), by *William Holman Hunt.*
Courtesy of the Tate Gallery, London.

coming in the events of the Old Testament. Typology has been studied by Earl Miner, Paul Korshin, and others, but most extensively by George Landow. In *William Holman Hunt and Typological Symbolism* and *Victorian Types, Victorian Shadows*, Landow has shown how widespread the use of such symbolism is in the works of Victorian artists and poets. Landow writes that "typology offers a means of enriching a picture's effect by locating it simultaneously in several different times," and he proves that thesis not only in pictures with biblical subjects such as Millais's *Christ in the House of His Parents* (1850) and Hunt's *The Finding of the Saviour in the Temple* (1860), but also in pictures with secular subjects such as Hunt's *The Awakening Conscience* (1853)—another "fallen woman" picture.[7]

"The Heir," from The Rake's Progress (1733–35), by *William Hogarth*.
Courtesy of the Trustees of Sir John Soane's Museum, London.

"The Contract," from Marriage à la Mode (1743–45), by William Hogarth.
Courtesy of the National Gallery, London.

Hogarth's individual pictures reveal causes of the present situation and look forward to effects of it through various emblems and signs. In the first painting of The Rake's Progress, for example, signs all around the room reveal that it is the miserly father's recent death which puts the young rake in his present moneyed situation. At the same time his attempt to buy off the young woman to whom he has made written promises, and the ease with which the steward surreptitiously pockets money, both look forward to a wasteful and careless future for the rake. In other pictures Hogarth uses emblematic means of various sorts to suggest the future, often including a painting within the painting whose mythological or biblical subject predicts an outcome. Animals can also reflect the human goings-on, as in the first scene of Marriage à la Mode, where the chained dogs

at the left forecast the stage the two young people behind them will soon be in.

Composition and Time

Composition, especially that of a number of figures, can work to signal the passage of time. E. H. Gombrich points out a strategy used in pictures where a crowd of onlookers watches some important event; it is "that dramatic device of bystanders not looking at the scene itself but at each other, which extends the time span. They have seen what is happening and are now exchanging glances or remarks."[8] The technique of compositional time sequencing may be seen in Gainsborough's *Two Shepherd Boys with Dogs Fighting* (1783). Here there is a sequence of events signaled by the two parts of the picture. In the lower left, two dogs are fighting, and the black dog gains the advantage over the white one. Next the blond boy, who apparently owns the white dog, raises a stick to strike the black dog and stop the fight. Finally the dark-haired shepherd boy, who seems to be enjoying the fight, reaches up to prevent his friend from stopping it. All these events are presented simultaneously though we read them in a sequence.[9]

All paintings, as Michael Fried has commented, "necessarily imply the presence before them of a beholder"[10] But when the picture's composition overtly *includes* the spectator, an especially engaging illusion is created, and time is an important element of the illusion. In John Phillip's *Gypsy Sisters of Seville* (1854), one sister has just spoken; the other looks directly at the observer. We are drawn into the pictured action with a startling illusion of what has just happened and is now happening. The woman on the left has just whispered into the ear of the one on the right, and we know what the whispered remark concerns—us. Our gaze is met evenly and curiously by the woman on the right, as if we had just entered the room and the women's attention. It is a disconcerting turn of the tables between observer and observed, an extension of the strange feeling we experience when we discover the eyes of a portrait seeming to follow us as we move around a room. Portrait painters long ago realized the efficacy of the latter device and the way it fits the memorial function of many such pictures: in the

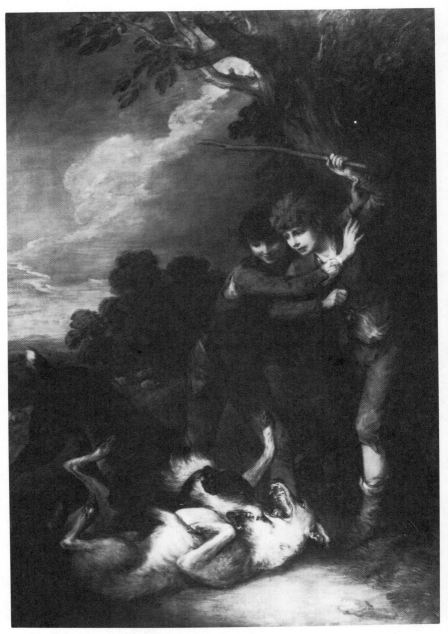

Two Shepherd Boys with Dogs Fighting (1783), by Thomas Gainsborough.
Courtesy of the Greater London Council as Trustees of the Iveagh Bequest, Kenwood.

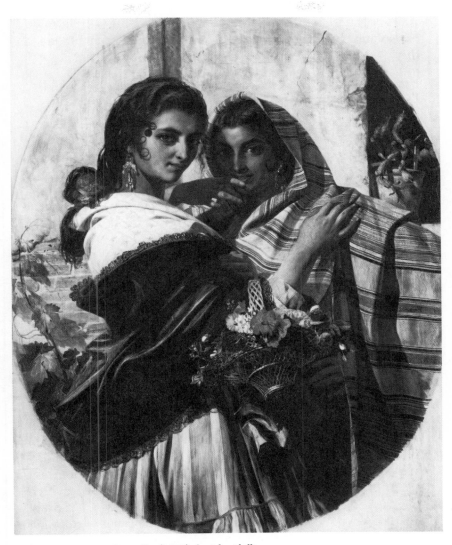

Gypsy Sisters of Seville (1854), by John Phillip.
Courtesy of the Walker Art Gallery, Liverpool.

relation between observer and ancestral portrait, we see the past scrutinizing the present, while the present looks to the past for a way to connect and apply tested experience. But the portrait painter's solutions to the problem of depicting time are often unique to that art and deserve separate consideration.

Portraits through Time

The portrait painter has a special task in regard to time. He must capture a likeness of his subject, but he must avoid what is only momentary in the face of his sitter. What he strives for could not be farther from the *punctum temporis* of the reductive critics. Most of us have had the experience of seeing a snapshot of a friend or family member who is nearly or completely unrecognizable in the instant he has been caught. The camera did its job honestly: he really looked like that in that instant. But the angle is so odd or the expression so strained or otherwise uncharacteristic that we say, "He does not look like that at all." And what we mean is that during most moments he does not look like that. A good portrait is a record of a face during most moments—through time. The uncharacteristic snapshot image is the portrait painter's nightmare, and he dreads capturing the unusual arch of the eyebrow or expression of the mouth, the momentary puffiness or tic or direction of the glance.

To make a record of what a face looks like through time, a painter needs to study the face through time. But few sitters or artists have leisure or patience enough for the eighty or ninety sittings Gertrude Stein is said to have had with Picasso for her portrait. The painter must train himself to discern quickly what his sitter's real features are and what is only momentary. Many portrait painters train by study of their own faces through many years. It is no accident that good portrait painters tend to leave numbers of self-portraits, such as those of Rembrandt and Reynolds and Gainsborough. It is probably also not accidental that painters whose best suit is not portraiture often leave single and rather silly self-portraits, such as Benjamin West's.

Although nothing can substitute for this study of the face, the portrait painter can draw on other resources to convey what his subject is habitually, constitutionally, or temperamentally like. For

many people the most revealing key to personality is through work: they are what they do. A profession for such people is not merely what half or more of their waking hours is spent doing; it is an expression of their personality and nature. Eighteenth-century portraits such as Reynolds's of Commodore, later Admiral Viscount, Keppel (1753–54 and 1780) reflect this equation of man and position. Joseph Wright of Derby gets the essence of his middle-class, Midlands industrialists when he paints them with their cotton-spinning machines or lumps of iron ore. Reynolds's portrait *Mrs. Siddons as the Tragic Muse* (1784) both captures and defeats time: Sarah Siddons is seen, not in a transitory, daily moment but in the symbolic trappings which framed her for her audiences during a whole career. At the same time, Reynolds does freeze the moment in the sense that it is this picture which *is* Sarah Siddons for us and all those who never knew the woman directly. But this is not to suggest that a completely different kind of portrait, Gainsborough's painting of Mrs. Siddons (c. 1784), showing her just as she came in from the street for her sitting, is a transitory image or snapshot record. It is clear that Gainsborough accentuates her extravagant costume and the absurdly large hat which tends to exaggerate her already large nose—"Damn the nose," Gainsborough is supposed to have said, "there's no end to it." In some ways the portrait is almost a caricature of Mrs. Siddons, like that done of her by Thomas Rowlandson, but Gainsborough is showing us the flamboyance, the pushing forward of not-so-pretty features which the woman does herself as a kind of self-caricature with calculated effect. She might not look like this at every moment, but she *is* like this.

Suppose the sitter has a dual nature and alternates between liveliness and seriousness, happiness and sadness? For a duality that is professional and a matter of stage roles, Reynolds, in *David Garrick between Tragedy and Comedy* (1762), provides an emblematic solution derived from the classical motif of the choice of Hercules. But if the sitter presents a serious face, as apparently May Sartoris did to Frederic Leighton (1860), and yet she is mischievous, with contrasting moods, some way must be devised to show this. Leighton does it by strong contrasts, especially with the flaming red scarf against the darker colors, and he also does not take the child's expression too seriously. Something in the combination of costume and expression

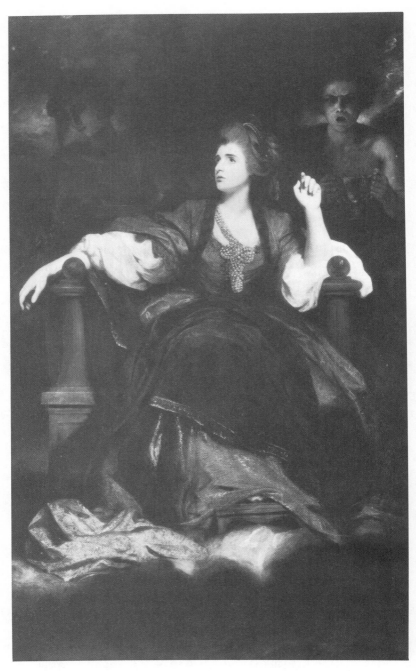

Mrs. Siddons as the Tragic Muse (1784), by Sir Joshua Reynolds.
Courtesy of the Huntington Art Gallery, San Marino, Calif.

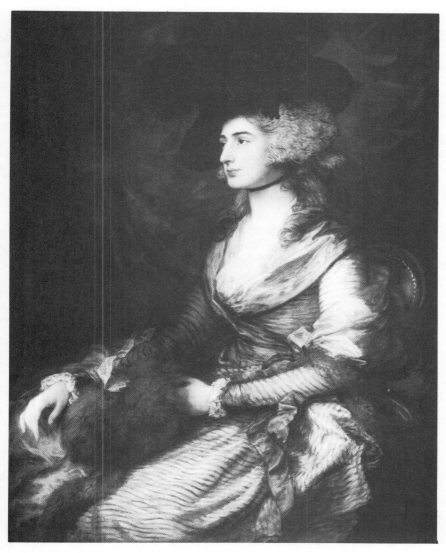

Mrs. Siddons (c. 1784), by Thomas Gainsborough.
Courtesy of the National Gallery, London.

suggests she is sometimes the young woman and sometimes very much the child dressed up in clothes too large for her.

The painter's word in these matters is not always so eloquent or so convincing as his practice. Reynolds says in his *Discourses on Art* that a "mixed passion . . . particularly appears to me out of the reach of our art" (Discourse 5). Yet he and Leighton prove themselves capable of painting mixed passions, mixed natures, and ambivalence.

Perception Takes Time

A great ally in the painter's depiction of time is the psychological fact that it takes the viewer time to apprehend a painting.[11] Sometimes the argument is made that painting does its work instantaneously, but very little reflection shows that this cannot be so. Thus Dryden, in "A Parallel Betwixt Painting and Poetry" (1695), first asserts the instantaneous action of a painting, and then begins to qualify his assertion:

> I must say this to the advantage of painting, even above tragedy, that what this last represents in the space of many hours, the former shows us in one moment. The action, the passion, and the manners of so many persons as are contained in a picture are to be discerned at once, in the twinkling of an eye; at least they would be so, if the sight could travel over so many different objects all at once, or the mind could digest them all at the same instant, or point of time. Thus, in the famous picture of Poussin which represents the Institution of the Blessed Sacrament, you see our Saviour and his twelve disciples all concurring in the same action, after different manners, and in different postures, only the manners of Judas are distinguished from the rest. Here is one indivisible point of time observed; but one action performed by so many persons, in one room and at the same table; yet the eye cannot comprehend at once the whole object, nor the mind follow it so fast; 'tis considered at leisure, and seen by intervals.[12]

It is easier to see the necessity for successive and prolonged contemplation of some pictures than of others. The first painting from Hogarth's *Marriage à la Mode* series (1743–45), for example, demands a great deal of "reading," while we may think no prolonged atten-

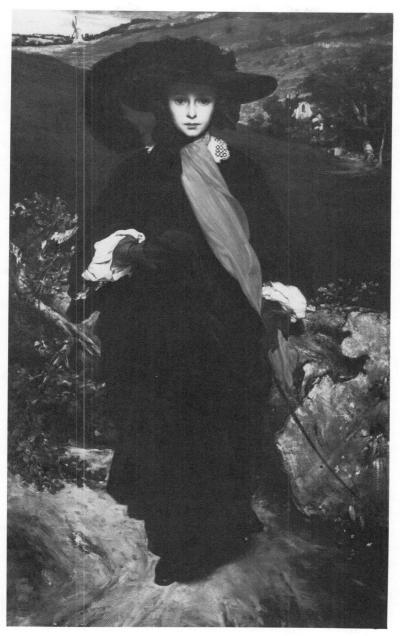

May Sartoris (1860), by Frederic, Lord Leighton. Dimensions: 152.1 × 90.2 cm.
Courtesy of the Kimbell Art Museum, Fort Worth, Texas.

tion is necessary for a simple portrait such as George Romney's *Miss Willoughby* (c. 1782). As Robert Wark says of the Hogarth picture, it "gives the initial impression of a very busy, crowded, almost cluttered, scene" which requires great attention because "the eye hardly knows where to begin. Anyone looking at the painting for the first time . . . is likely to explore it for several minutes before reaching definite conclusions about what is going on." Gradually the details emerge and we realize we are watching a marriage agreement between an earl and a rich merchant, and that the two young people seated on the left are the unfortunate subjects of the negotiations. "Remember," writes Wark, "the process by which we discovered what is going on. There was no dramatic, sudden revelation. The meaning of the picture developed gradually as our eyes roamed about it, picking up details, reading labels, interpreting various signs" until we had read the picture's meaning.[13]

By contrast, Romney's *Miss Willoughby* may seem an image that can be absorbed in a moment—a charming young girl in a natural setting. But a longer look reveals that Romney has taken great pains formally to fit the girl into her background, to give an impression of harmonious ease within natural surroundings, though Romney is not at all interested in actual fields, trees, rocks, or hills. He echoes the angle of the girl's head and her left forearm in the slope behind her. The muted blue of the sky and the muted yellow of the hillside are exactly mediated by the muted red, pink, of her sash. These details are deliberate, subtle, and not apparent at the first instant of observing the picture

In fact all images work on us more slowly than we imagine. If this were not so we would not need specialists in design to create, with some difficulty, highway signs to work on us quickly. How much can a person absorb from a picture in a short exposure? Overall form and some information about color seem to be perceived first, but even identification of the subject takes longer. Any narrative content of a picture is not evident in a short glance. We derive our perception of meaning in a picture from relationships within it; we have to see how a figure fits into a background or stands away from it, how two or three or more figures are related or juxtaposed. We have to move our eyes from one principal part of the picture to another and then back again to perceive these relationships. Re-

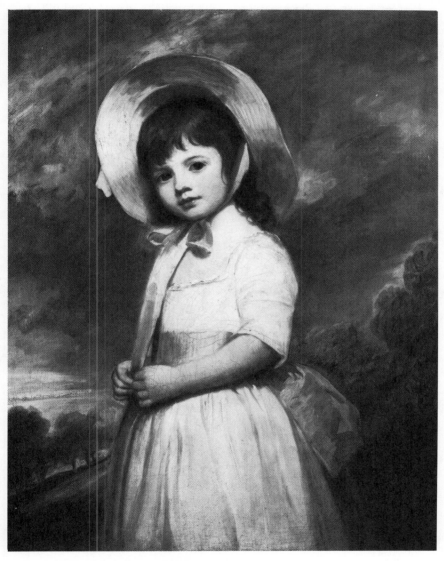

Miss Willoughby (c. 1782), by George Romney.
Courtesy of the National Gallery of Art, Washington, Andrew W. Mellon Collection.

search on the psychology of looking at pictures has demonstrated that we move our eyes dozens of times, usually in very short, jerky motions, in every minute that we examine a painting.[14] We would not absorb much more from a few seconds' glance at a painting than we would from the same length's glance at a printed page, from which we could identify the language and see whether it was prose or poetry, but without a title we would probably fail to even identify the subject. To say that all elements of a picture are present to the viewer simultaneously is not to say that he or she can perceive them so, any more than he or she can read all four hundred words on a printed page simultaneously.

The process of reading a poem or painting involves interpreting visual or verbal metaphors, checking the interpretation of individual passages against total context, recognizing tone, reading allusions and fitting them into the current context, and the whole complicated testing and retesting of interpretation. All of these activities of perception take time and help foster the illusion of time *within the work*. During the period from 1680 to 1880, the people who made up painting's English audience, though they knew little of the actual mechanisms of the eye or brain in looking at pictures, had no trouble in assenting to the illusion of time that perception creates. It was a commonplace of British philosophy that our knowledge of time derives from the succession of our ideas; as I pointed out in the Introduction, this is one strain of British empirical philosophy which remained the same from the early seventeenth century to the nineteenth. In Locke's words:

> To understand *time* and *eternity* aright, we ought with attention to consider what idea it is we have of *duration*, and how we came by it. It is evident to any one who will but observe what passes in his own mind, that there is a train of ideas which constantly succeed one another in his understanding, as long as he is awake. Reflection on these appearances of several ideas one after another in our minds, is that which furnishes us with the idea of *succession*: and the distance between any parts of that succession, or between the appearance of any two ideas in our minds, is that we call *duration*.

Locke goes on to identify duration with time: "This consideration of duration, as set out by certain periods, and marked by certain

measures or epochs, is that, I think, which most properly we call time." In pictures, the observer's experience includes a succession of ideas but no actual movement, resulting in the illusion of time's being helped by the duration of the perception of the scene, which "the eye cannot comprehend at once . . . nor the mind follow it so fast; 'tis considered at leisure, and seen by intervals."[15]

Space

Engagement requires a place into which an observer may be drawn. What place does the flat canvas of a painting afford? Those critics who asserted that painting was an art of space could not have meant it was a real or human space, that humans or any of the painter's subjects could live in two dimensions. The space in paintings can be entered by observers but only as an illusory space actively created by perception—virtual space. Suzanne Langer defines the concept of virtual space in *Feeling and Form*:

> the space in which we live and act is not what is treated in art at all. The harmoniously organized space in a picture is not experiential space, known by sight and touch, by free motion and restraint, far and near sounds, voices lost or re-echoed. It is an entirely visual affair; for touch and hearing and muscular action it does not exist. For them there is a flat canvas, relatively small, or a cool blank wall, where for the eye there is deep space full of shapes. This purely visual space is an illusion, for our sensory experiences do not agree on it in their report. Pictorial space is not only organized by means of color (including black and white and the gamut of grays between them), it is created; without the organizing shapes it is simply not there. Like the space "behind" the surface of a mirror, it is what the physicists call "virtual space"—an intangible image.[16]

The virtual space created by painting is a visual matter, evoked by organized areas of paint and the active participation of the audience. As with time in the arts, represented space is an illusion in which the audience collaborates, helping to create it out of what is given. In painting what is given is flat surface and what may be close to a flat projection of a three-dimensional scene, though actual paintings

rarely approach any uniform and accurate projection. The psychology of the eye and brain transforms a flat visual image into an imagined three dimensions. This transformation is also precisely what the brain does with the flat image on the back of the retina. In fact the image of a painting on the retina and the image of a real three-dimensional scene on the retina would both be flat; only movement of the head and binocular vision would afford differing visual information between a real scene and a flat painted one. In the psychological process of perception, the mind tries very hard to create real space out of two-dimensional cues and thus gives painting an edge in the creation of virtual space.

What is given in poetry with which the mind may work to create space? The answer includes a great deal more than merely *description* of objects in spaces and may be illustrated by starting with a Wordsworth poem:

> Strange fits of passion have I known:
> And I will dare to tell,
> But in the lover's ear alone,
> What once to me befell.
>
> When she I loved look'd every day
> Fresh as a rose in June,
> I to her cottage bent my way,
> Beneath an evening moon.
>
> Upon the moon I fix'd my eye,
> All over the wide lea;
> With quickening pace my horse drew nigh
> Those paths so dear to me.
>
> And now we reach'd the orchard-plot;
> And, as we climb'd the hill,
> The sinking moon to Lucy's cot
> Came near, and nearer still.
>
> In one of those sweet dreams I slept,
> Kind Nature's gentlest boon!
> And all the while my eyes I kept
> On the descending moon.

> My horse moved on; hoof after hoof
> He raised, and never stopp'd:
> When down behind the cottage roof,
> At once, the bright moon dropp'd.
>
> What fond and wayward thoughts will slide
> Into a lover's head!
> "O mercy!" to myself I cried,
> "If Lucy should be dead!"

Wordsworth uses many strategies to engage the reader in this short poem, not the least of which is the illusion created in line 3 that the poem is directed to the reader alone, an illusion analogous to the painter's device of portrait eyes which fix on and seem to follow the observer. But one of the most remarkable characteristics of the poem is its spatial character, which gives the impression of movement from wide lea to path to orchard plot to hill as the reader moves from line to line and stanza to stanza. Partly by bringing us "along" in this way and creating this spatial sense, he brings us to the point where we are gripped with the same irrational fear at the "fond and wayward" thought that his beloved might be dead.

The critics from Shaftesbury to Lessing who classified poetry as an art of time did not exclude space as subject matter but excluded it from the medium and the perception of poetry: the lines of a poem, recited or read sequentially, clearly take time, but not space. But if we look more closely at the mechanisms of perception we discover that this neat separation of time and space does not hold in the mind's workings. As simple an act as listening to a spoken sentence involves the persistence of sounds for short intervals in a way not adequately described as an operation of memory. Such experiences, as Gombrich says, "corrode the sharp *a priori* distinction between the perception of time and of space. Successive impressions do in fact persist *together* and are not wholly experienced as successive. Without this holding operation we could not grasp a melody or understand the spoken word."[17] A musical or verbal composition has to be converted into simultaneous—and therefore *spatial*—terms in order for the mind to comprehend its wholeness. As Rudolf Arnheim puts it, sequence must be translated into "the synoptic condition of space":

in order to do justice to events extended in time and space, the nervous system needs . . . to integrate successive apprehension in order to reconstruct the wholeness of those events. . . . It follows that memory serves not only to preserve, like a tape recorder, the inputs of the fleeting moments as a sequence but must also convert that sequence into simultaneity, time into space.

We are led to the startling conclusion that any organized entity, in order to be grasped as a whole by the mind, must be translated into the synoptic condition of space. This means presumably a translation into visual imagery, since the sense of sight is the only one that offers spatial simultaneity of reasonably complex patterns. Accordingly a musical composition, a choreography, a novel, a play, or a film, in order to be conceived as a whole, must be available in the form of a synoptic image, although the medium may be aural and the structure to be scrutinized not an immobile picture but a succession of happenings in time. This becomes obvious if we consider that one cannot even establish the center point of a line without knowing its total length.[18]

Arnheim believes "spatial simultaneity of reasonably complex patterns" in one "synoptic image" to be necessary for our perception of arts such as poetry; the memory must actively mediate sequential stimuli. Our perception of the simplest aspects of structure—even so much as identifying where the middle of a poem is—depends on this spatial translation. All of our perceptions of relations depend on it as well.

The most extensive exploration of how space is perceived in literature is W. J. T. Mitchell's "Spatial Form in Literature: Toward a General Theory," which begins by pointing out the dependence of spatial on temporal perception and vice-versa.[19] Like Arnheim, Mitchell points to ideas such as continuity and sequentiality itself, which are "spatial images based on the schema of the unbroken line or surface"; simultaneity too is based on a spatial image (542). Mitchell distinguishes four varieties of spatial form in literature, the first of which is the physical existence of the written or printed text in space (550). For poetry to become an art of time, as the critics would have it, it must first be transformed by the reading process from this spatial form into a temporal form (550).

A second variety of spatial form includes whatever the poem *describes*, and Mitchell includes here not only characters and objects existing in space, but also "images, sensations, or emotions" (551).

A third level or variety of spatial form is that of structure: "Any time we feel that we have discovered the principle which governs the order or sequence of presentation in a text, whether it is based in blocks of imagery, plot and story, the development of character or consciousness, historical or thematic concerns—any time we sense a 'map' or outline of our temporal movement through the text, we are encountering this third level of spatiality" (552). Mitchell's levels are progressively inclusive. The third level, for example, includes the way in which the physical spaces in a text—stanza divisions, rhyme groups and so on—(level 1) reflect and relate the descriptive spaces in the text (level 2). In the Wordsworth poem the rhymes of stanza 3 divide those lines from stanza 4 and provide a physical separation between the descriptive content of the stanzas and their separate spatial concerns with the "wide lea" in the former to the "orchard-plot" and hill in the latter. Mitchell's level 3 can be exemplified by our realization that there is a structural principle at work in the previous two levels.

The fourth variety of spatiality is the most inclusive of all; it is the level at which we go beyond grasping structural principles and grasp the meaning of the whole literary work. According to Mitchell our apprehension of the whole is spatial in the sense that its subject is an arrangement or a total order that we see with the mind's eye. Our apprehension or understanding of this order we commonly call "seeing" as in "I see what you mean" (553). The concept was earlier discussed in Northrop Frye's *Anatomy of Criticism*, where Frye borrows Aristotle's term *dianoia* to label this kind of vision of a whole work's significance: "We listen to the poem as it moves from beginning to end, but as soon as the whole of it is in our minds at once we 'see' what it means"[20]

Most relevant to a discussion of engagement is Mitchell's conviction that at each of these levels "*readers* participate in the creation of literary space" in their involvement with the text, so that "the formation and dissolution of spatial forms is a crucial aspect of the reading process" (553).

Our examples, contemporary reactions, and modern psychological criticism—all reveal the conventional nature of time and space in the sister arts. Time and space are not easily separable in most realms of human experience. Their interrelations enliven physics and mathematics as well as painting and poetry. Most important, they are the modes in which human beings live, and they must be successfully evoked by art which aspires to engage human beings in its concerns. English poets and artists of the seventeenth, eighteenth, and nineteenth centuries knew this necessity and were often able to triumph over what critics saw as insuperable temporal and spatial limitations.

2

Engaging Metaphors: Comparative Figures in Hogarth and Blake

Comparison is the poet's most useful tool for engaging an audience. Simile, metonymy, and all the figures of metaphor bring the readers in by connecting their experience directly with the poem's subject. Comparison, contrast, analogy, juxtaposition, and all the operations of metaphor capture the reader because they tap into the mind's very workings, into the processes of learning, classifying, and ordering experience, by finding resemblances and differences.

How does comparison rank in the graphic artist's equipment? Is there a direct visual equivalent to the battery of comparative techniques the poet has at his or her disposal? The answer to the latter question, as given by the work of William Hogarth and William Blake, is yes, and in this chapter we will look at engagement strategies of these two great English artists and examine how the poets' devices of comparison and metaphor function in their work. At the same time we will see how the reader/spectator's role changes in moving from Hogarth's work to Blake's.

Hogarth and Verse Satire

William Hogarth (1697–1764) has always been recognized for the closeness of his work to literature.[1] He shared subject matter with

many of the writers of the period: he joined forces with Fielding in attacking the uncontrolled sale of gin (one of those rare but refreshing instances when satire actually helped to bring about reform); he castigated election abuses in his *Election* series of 1754; and he took up, in *Marriage à la Mode* and *The Rake's Progress*, themes which interested many dramatists and novelists of his time. Even some of the physical details of Hogarth's art can bear comparison with literary endeavors. He aimed at broad popular appeal, and to that end he first painted his series in oil and then engraved plates so that relatively inexpensive prints could be made from them. The distribution paralleled that of many new literary works: Hogarth first solicited for subscribers, and after they received a careful, personally supervised impression, a larger run was made and distributed through print and book sellers.

The affinity of Hogarth's work with literature extends to technique. He himself drew the analogy between his pictures and dramatic satire: "I . . . wished to compose pictures on canvas, similar to representations on the stage; and farther hope, that they will be tried by the same test, and criticised by the same criterion. . . . I have endeavored to treat my subject as a dramatic writer; my picture is my stage, and men and women my players."[2] The comparison can be extended, since each of Hogarth's series has a cast of characters with the principals appearing in picture after picture. Peter Quennell calls the appearance of Sarah Young in *The Rake's Progress* a subplot,[3] and even though each painting in the series is only one static tableau, several techniques give a sense of dramatic action, besides the fact that we look at a number of tableaux serially. For one thing, Hogarth chooses the most dramatic moment within the scene he is depicting, and then he often renders it in a composition involving violent movement and crisp color definition; here the trend of rococo painting and Hogarth's narrative techniques come together, for he eschews the stately, static architectural groupings of figures and the subdued colors which became popular with painters from the Royal Academy. Moreover, he adds a temporal dimension through pictorial devices which show the causes of the present moment while either subtly or blatantly foretelling its likely consequences. There is more than chronological serialization here; there is causation as well, and thus plot.

These narrative and dramatic elements create a world of space

and time into which the viewer may enter. But other of Hogarth's techniques of engagement are identical in aim, workings, and effect to the comparative techniques of verse satire, and most specifically, to the couplet art of Dryden and Pope. Hogarth's satiric techniques, like Dryden's and Pope's, include caricature, emblematic parallels, similes, antithesis and ironic juxtaposition, parody and parodic allusion, and the introduction of an explicit satiric touchstone, or normative influence, into his pictures. He often depicts satiric targets with the selection and exaggeration of detail which results in caricature rather than portraiture, much as Dryden, for example, lights on Shaftesbury's dwarfishness or Shadwell's fatness as the basis for his descriptions of them. He includes portraits of real men, to be sure, but when he takes us along the progress of a type, the features reflect the inner man. He also uses emblematic parallels of all sorts, but most frequently dogs, so that the human activity is diminished in the comparison, much as in Pope's lines from *The Rape of the Lock*: "Not louder Shrieks to pitying Heav'n are cast, When Husbands or when lap-dogs breathe their last" (3.157–58). He uses parallelism, balance, and antithesis; for example, in the first and last pictures of *Marriage à la Mode*, which set the tasteless, oversumptuous house of the earl against the tasteless, over-stingy house of the merchant, or in the successive pictures of that series which show us the parallel degradation of the viscount and the countess separately. Such comparisons, usually between two equally unpleasant choices, are frequent in Pope:

> 'Tis strange, the Miser should his Cares employ
> To gain those riches he can ne'er enjoy;
> Is it less strange, the Prodigal should waste
> His Wealth, to purchase what he ne'er can taste?[4]
>
> 'Tis hard to say, if greater Want of Skill
> Appear in Writing or in Judging ill.[5]

Hogarth uses parody and parodic allusion, such as taking the composition for *An Election Entertainment* from Da Vinci's *Last Supper*. He uses all kinds of allusions to other arts (music, poetry, drama, painting, and architecture); to classical mythology; to contemporary places, events, and personalities in order to give perspective and realism to his satire. And finally, by introducing the character of

Sarah Young into The Rake's Progress, he gives us an explicit moral touchstone or satiric norm with which we can contrast the doings of the principal, Tom Rakewell. All of these techniques work to bring us into his satire, to make its world familiar, to render his moral judgments our moral judgments, and finally to make us see ourselves as satiric targets rather than mere innocent spectators.

The eight paintings of The Rake's Progress (1733–35) constitute the longest and most involved of Hogarth's painted series and the most interesting for comparison with verse satire in terms of effect on an observer. Ronald Paulson has argued that the engraved prints have more satiric force and are more easily "read,"[6] but I have chosen to discuss the paintings here for a number of reasons. The paintings are prior in conception and represent the medium of choice; Hogarth engraved and sold prints because that was the only expedient he had for reproduction and inexpensive sale. The oil paint on canvas of The Rake's Progress is plastic and more expressive than the prints can be; its color relationships are an integral part of its rococo composition. Nothing in the line and shading of the prints can correspond to the brightness, variegation, and texture of the surface of the orgy scene, number 3 in the series, where the paint application reflects the sensual indulgence of the subject. Moreover the black-and-white line engravings interpose a convention between the spectator and the scene which vitiates some of the engaging realism of Hogarth's method. More people have seen the prints, of course, but this is an additional justification for displaying the less-often-seen paintings.

The subject of The Rake's Progress was a frequent topic for literary treatment in the century: as Robert Moore points out, "both the history of Mr. Wilson in Joseph Andrews and the more famous story of the Man of the Hill in Tom Jones might well be called The Rake's Progress."[7] Earlier literary analogues include Addison and Steele's Will Honeycomb and various Restoration stage rakes, some of them with real-life prototypes like the earl of Rochester. And the story begins with a contrast between the young prodigal and his miserly father much like the portraits of young and old Cotta in Pope's Moral Essays or the story of Young Tom Wildair and his father in The Tatler, no. 60.[8]

In the first painting of the series, the rake, standing in the left center, has already begun squandering his miserly father's money

before the funeral hangings for the old man have been completely hung (a servant uncovers a secret hoard of coins in the molding while tacking up mourning cloth). Around the room are various direct or indirect indications of what has happened, what father and son are like, and what can probably be foretold from this point on. The hoarded wigs and shoes in the closet on the right, the plate in the chest, the starved cat, the coat of arms or funeral escutcheon (vises, indicating the pinchpenny, with the motto "Beware"), the portraits of the old man at his favorite activity of counting money— all bespeak the father. The son is identified in the engravings as Tom Rakewell, and several commentators have pointed out how the patronymic fits both father and son in different senses. Tom has already started fitting himself out in elegant style (these are not mourning clothes). He allows the clerk or steward to steal from the inheritance he is supposed to be accounting for while he extends his hand, offering a cash settlement to the mother of a pregnant girl, apparently in lieu of other promises he had made, indicated by the ring the girl holds and the letters in the mother's apron. The girl, whom we will see again, is identified in the fourth painting as Sarah Young. (See illustration on p. 29.)

From the first painting we can already see that Hogarth's dominant mode, like that of satiric couplet art, is comparative and antithetical; he continually sets up contrasts and ironic juxtapositions. Here, for example, though the father is not actually in the picture, Hogarth brings the steward in to act as surrogate so that he can enforce the contrast, expressed in the poses of the central pair, between the two excesses: the callow liberality—without generosity—of the rake and the cramped venality of the steward. It is the same kind of contrast between the joyless miser and the tasteless spendthrift with which Pope begins the *Epistle to Burlington*:

> 'Tis strange, the Miser should his Cares employ
> To *gain* those riches he can ne'er *enjoy*:
> Is it less strange, the Prodigal should *waste*
> His Wealth, to purchase what he ne'er can *taste*?

The rake's face in this painting is relatively blank and characterless, a *tabula rasa* on which Hogarth is going to trace the successive stages of dissipation, failure, and finally madness. Many people have no-

ticed that there often seems little resemblance between the faces of main figures in successive pictures of a Hogarth series. Hogarth believed that habituated expression could mold the features and create a distinctive face. With the rake we may see little resemblance between the vapidness of this face and the silliness of the face in number 2 of the series or the worldliness of the face in number 5. But Hogarth is giving us a cumulative portrait as these expressions and their occasions shape the rake's features into those we see in the last two pictures.[9]

In the second painting the rake is surrounded at his levee by flatterers and hangers-on, several of whom are Hogarth's own contemporaries and can be recognized from these portraits. The real

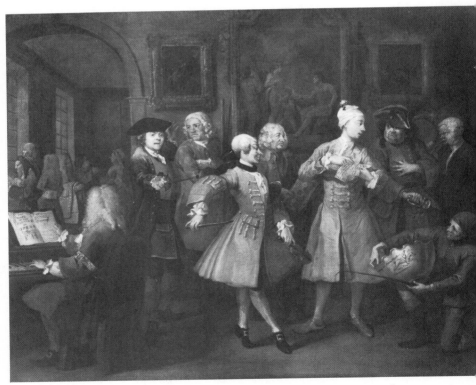

"The Levee," from The Rake's Progress (1733–35), by William Hogarth.
Courtesy of the Trustees of Sir John Soane's Museum, London.

faces make the fiction more realistic, but they have another appeal—that of the celebrity for the common people, and common people are what we observers are. The man presenting the garden land-scape, behind the rake to the left, is Charles Bridgeman, who helped Pope lay out his grounds at Twickenham. The harpsichordist may be intended to represent Handel,[10] and the man with the quarter-staves is James Figg, a famous prizefighter and quarterstaff player. Others around the rake offer their services as bodyguard, dancing and fencing masters. The kneeling jockey holds a cup won at Epsom, apparently by the rake's newly acquired racehorse, who is called, appropriately enough, "Silly Tom." Tailors, milliners, and a poet wait in the anteroom in the left background.

Hogarth's technique here is self-conscious, and he calls attention to the painting as painting. All the people around the rake are literally striking poses, and a painting within the painting reflects and com-ments on the whole. The large central picture is *The Judgment of Paris*, done in the derivative style of Continental artists against whom Hogarth was always inveighing because they were preferred over more talented English painters.[11]

When Hogarth includes paintings of mythological subjects, he ordinarily does so for two reasons. First, he lets the choice of picture and the manner of displaying it (as here, between pictures of two fighting cocks) make a comment on the vicious and undiscerning taste of his characters. Second, he uses the mythological subject to make an allusive contrast with the rake's situation: like Paris, the rake, surrounded by flatterers, makes choices which determine his future course and which have disastrous consequences.[12] The fact that Paris's choice had such momentous consequences gives the comparison a diminishing effect on the satiric subject. It is precisely the mechanism of mock heroic and draws on the same tradition, which is both literary and pictorial. Just as Homeric, Virgilian, and biblical allusions furnish the heroic contrasts for verse satire, so do they furnish Hogarth with his pictorial juxtapositions. Heroic allu-sions engaged Hogarth's audience in visual as well as verbal contexts because the classical or biblical heroic was the standard of worth and admiration. From early schooling, his contemporaries were taught the classics as measures of value in human enterprise. Even now, when the classics are less familiar and less useful as sources of allusion, they still function as possible entry points for us into an

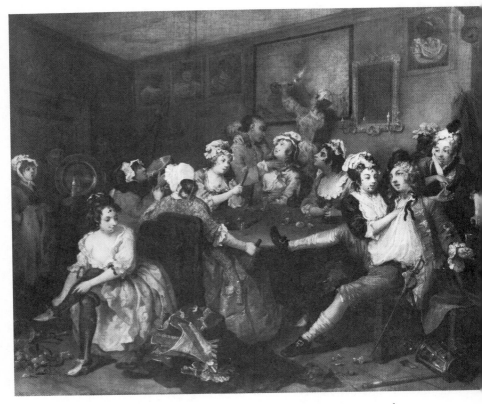

"The Orgy," from The Rake's Progress (1733–35), by William Hogarth.
Courtesy of the Trustees of Sir John Soane's Museum, London.

unfamiliar fiction, and ignorance has even enhanced their power as metaphors of ancient value.

The third painting of the series, the most famous single painting of The Rake's Progress, exists in two versions: one an oil sketch in the Atkins Museum, Kansas City, and the finished picture in the series which hangs in Sir John Soane's Museum, London. From this point on in the series, each painting has a specific, identifiable setting in the London of the 1730s. Moreover, Hogarth gives us settings which are public or semipublic, further drawing us into his satire. Rather than being present at scenes which are so private that only the license of fiction could take us there, we find ourselves looking at

these episodes as if we, the rake's contemporaries, happened into the room or street where they are taking place while we went about the ordinary course of our lives. The rim of the platter here identifies the place as the Rose Tavern in Drury Lane. Another contemporary reference is the "posture woman" in the left foreground, who, after undressing, performed on the platter set on the table a completely uninhibited burlesque turn.

The extent of this allusiveness to real places and people in *The Rake's Progress* reflects the traditions of satire, but Hogarth has an edge the verse satirist lacks. The pictorial satirist is never called upon to give an account of himself, to defend his position in the way that Pope, for example, feels the need to in the *Epistle to Dr. Arbuthnot*, the *Epilogue to the Satires*, and the *First Satire of the Second Book of Horace Imitated*. Pictorial satire creates the illusion that we are looking through a window at the real world, and yet nothing could be more "intrusive" than Hogarth's methods of arrangement, juxtaposition, and exaggeration. The illusion is fostered by these recognizable landmarks from everyday London. Ian Donaldson notes this effect of the London settings of various satires: "A background of recognizable London streets and parks and houses may seem at times to lend a satire persuasive force, helping greatly to convince us that its propositions, like its scenario, must be demonstrably true."[13] If this technique is persuasive in verse, it must be even more effective where the observers are not told what the setting is but are allowed to recognize it for themselves. It is as if Hogarth were to say, "You think I exaggerate? Step down to the Rose any night and you may see such scenes played out."

In this picture, the rake has come in after beating up the watch, whose lantern and staff lie at his feet. He is drunkenly oblivious of the fact that his watch is being stolen, and his sword thrust into his belt, missing the scabbard, may tell us that he is responsible for cutting the faces of the various Roman emperors out of the pictures around the walls; one of the faces lies near his feet. But the portrait of Nero has been allowed to stand unmolested, and he looks down on the scene of debauchery with a proprietary expression.

Saint James's Palace in the distance locates the fourth painting of the series, and Hogarth lets us infer the occasion by putting into the picture two men with leeks in their hats. Welshmen wore leeks in

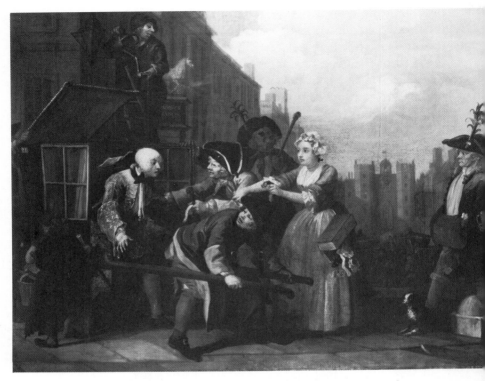

"*The Arrest*," from The Rake's Progress (1733–35), by *William Hogarth*.
Courtesy of the Trustees of Sir John Soane's Museum, London.

this way to celebrate the feast day of their patron, Saint David, which falls on March 1, and since that was also the birthday of Queen Caroline, we can guess that the elegantly dressed rake, along with the others in carriages farther down Saint James's Street, is attending a royal levee. If he had intended to repair his fortunes by seeking royal favor or a court position, he has begun too late, for a bailiff pulls him out of his sedan chair with an order for his arrest. But the girl from the first painting, here identified by the name on her sewing box as Sarah Young, intervenes, offering the bailiff a purse—apparently the arrest is for debt. It is at this point, halfway through the series, when her intervention might have changed the rake's course, that Hogarth reintroduces her. She fails, the rake continues his

progress, but her unwanted presence in three of the remaining four pictures is a continual reminder of his rejected alternatives. She points out the moral in this comic moral essay; her selflessness and constancy, contrasting with the indifference and self-serving of the rake, give us the satiric norm against which his actions can be measured. Sarah provides another entry to the picture for us as observers. She is not our surrogate, bound up in the action as she is, but she is a touchstone for us as well as for the rake. It is not only his behavior that is implicitly measured against hers, but ours as well: our lack of sympathy and even perhaps our condemnatory pleasure in the rake's declining fortunes stand against her praiseworthy attempts to reclaim him without judgment or selfishness.

"The Marriage," from The Rake's Progress (1733–35), by William Hogarth.
Courtesy of the Trustees of Sir John Soane's Museum, London.

In painting number 5, Marylebone Old Church is the setting for the rake's marriage to an old, rich, one-eyed woman whose fortune he needs at this point in his career. The courting dogs, one of which has only one eye like the bride, offer Hogarth's succinct emblematic comment on the human scene.

We may be reminded not only of Pope's lapdogs but of Rochester's lines in *A Satyr against Mankind* (1680):

> I'd be a Dog, a Monkey, or a Bear.
> Or any thing but that vain Animal,
> Who is so proud of being rational.

[Lines 5–7]

"The Gaming House," from The Rake's Progress (1733–35), by *William Hogarth.*
Courtesy of the Trustees of Sir John Soane's Museum, London.

The rake's face has changed since our first look at him, becoming fuller, more worldly, and here, more supercilious as he eyes the bridesmaid with a side glance, even as he places the ring on his ancient bride's finger. In the background the pew-opener, with the huge ring of keys, is engaged in a battle with Sarah Young's mother, who has apparently come with her daughter and grandchild to prevent the marriage. The state of the church (extremely dilapidated though the inscription tells us it was beautified in the year 1725) and the charity boy in the foreground with his tattered clothes, both constitute some random satiric shots at charitable "benefactors" of the time.

The sixth painting is set at White's, the origin of "All Accounts of Gallantry, Pleasure, and Entertainment" in the *Tatler* papers. This is the London gambling house where Hogarth depicts the rake cursing his luck after the loss of his new wife's fortune. His expression seems a definite harbinger of the last scene in the madhouse. White's caught on fire in 1733, and Hogarth has incorporated this event into his painting, though the smoke coming from the molding on the back wall is difficult to make out in reproduction. Only three of the patrons even notice the fire; the rest are too bound up in their own activities of lending, losing, or bemoaning the loss of their money.

The seventh painting shows the rake jailed for debt in the Fleet Prison, while his one-eyed wife nags him and Sarah Young, visiting him with their child, falls into a faint. The boy wants money for the mug of beer he has fetched, and the jailer, like Lockit in John Gay's *The Beggar's Opera*, points to the ledger in which he enters garnish money; we can imagine him saying, like Lockit, "You know the custom, Sir. Garnish, Captain, Garnish" (2.7.3). Like Melopoyn in Smollett's *Roderick Random* and Wilson in *Joseph Andrews*, the rake has written a play to get money, but it has been returned by John Rich, the manager of the Covent Garden theater, with a note (more clearly legible in the engravings): "Sr. I have read your Play & find it will not doe. Yrs. J. R . . h." The wings and the alchemist's forge show other unsuccessful attempts to get out of the Fleet.

Still accompanied by Sarah Young, the rake appears in the last painting at the end of his progress, mad, shackled, and, in neat balance with the sumptuous and expensive clothes that he affected

"The Fleet Prison," from The Rake's Progress (1733–35), by William Hogarth.
Courtesy of the Trustees of Sir John Soane's Museum, London.

from the first painting on, practically naked. The scene would have been immediately recognizable to contemporaries as Bedlam, or the Bethlehem Hospital for the indigent insane, but Hogarth has added one more allusion to make the setting surer: the poses of the rake and the religious lunatic in the nearer cell reproduce the figures of melancholy and raving madness, two bronze statues at the doors of the hospital which were done by Colley Cibber's father, and which Pope refers to in the Dunciad as "Cibber's brazen, brainless brothers" (1.32).[14]

Hogarth has arranged the rake and the figures around him to suggest a pietà composition.[15] Such religious allusions in secular

"*The Madhouse*," from The Rake's Progress (1733–35), by *William Hogarth*.
Courtesy of the Trustees of Sir John Soane's Museum, London.

contexts may surprise us but were frequent in poetry of the period also. Pope parodies Genesis in his couplet on Newton (1730):

> Nature and Nature's Laws lay hid in Night:
> God said, Let NEWTON be: And all was Light!

Dryden uses the Absalom and Achitophel story from 1 and 2 Samuel in his poem on Charles II (1681); he alludes to John the Baptist as a type of Christ and places the allusion in a comic context in *Mac Flecknoe* (1682) when Flecknoe says of his son:

> *Heywood* and *Shirley* were but Types of thee,
> Thou last great Prophet of Tautology:
> Even I, a dunce of more renown than they,

> Was sent before but to prepare thy way;
> And coursly clad in Norwich Drugget came
> To teach the Nations in thy greater name.
>
> [Lines 29–34]

The context of religious art, like that of biblical texts, is one of familiarity and value for Hogarth's audience, and his use of it here is not wholly ironic, since the rake's progress is over and judgment can wholly give way to sympathy now—or should.

The rake is surrounded by unfortunates who suffer from delusions of varied sorts: a would-be astronomer behind him observes the heavens through a paper tube; a mad tailor, musician, and lover are ranged across the painting; and behind the stairs another case plays the pope in a paper tiara and a triple cross made of lath. In the second cell a lunatic who imagines himself king is urinating against the wall while the lady holding the fan pretends not to watch. Visitors to Bedlam, come to be entertained by the madmen, were frequent during this period and later: Boswell records a visit he made there with Dr. Johnson in 1775—it was Johnson's second visit. But the lady and her maid or companion are satiric objects who bring us into the scope of Hogarth's commentary. We too have been entertained by our view of the rake's changing fortunes, so that the implications of the visitors' presence are also aimed at us, as if Hogarth were to say, "If you see only the comic here, like these people, and nothing which touches you more nearly, you are lacking in perception and fellow-feeling." We must choose to react, and even our very presence here involves us more than we could have anticipated in a scene we only meant to observe; as Robert Uphaus says of the effect of equivalent literary scenes, we are forced into the "abandonment of critical objectivity to the more compelling, though less determinate, claims of human feeling."[16]

Here as in previous pictures Hogarth's satiric techniques are overlaid one upon the next in a kind of "stratification," to use a term Geoffrey Tillotson employed to describe multiple, simultaneous effects in Pope's couplets.[17] At one and the same time Hogarth uses the rake's pose to allude to his setting, his nakedness to offer a rueful comment on the splendor of the rake's aspirations throughout the series, and his face to close his typology with a fitting balance and contrast to the first view we had of the main character. The

empty hopelessness of the rake's face calls up the vapid hopefulness of his expression in the first painting, and we feel that some kind of final comment has been made.

Hogarth's contemporary audience could appreciate here the same balance and antithesis they applauded in literary works. As Ronald Paulson has commented, "the eighteenth-century critics who called him [Hogarth] the Shakespeare of painting and a greater poet than painter (meaning these as compliments) were writing from assumptions that Hogarth shared and indeed fostered."[18] In addition to relying on the strength of the literary analogy, Hogarth could also be confident of his audience's recognition of his satiric techniques because they were accustomed to satire's many methods by the best literary practitioners of the art. In Hogarth they found a satiric vision similar to that of the verse satirists. Hogarth, like Pope or Dryden, presents scenes that maintain an illusion of looking into a window on the world but that include judicious exaggeration. He too leads the reader/spectator to praise or blame by contrasting foolish or vicious behavior with heroic or more modestly humane ways of acting. And as in the best written satire, he brings his complacent observer into the work, forcing the response and commitment of human feeling.

Visual Metaphor and Literal Misreading in Blake

A technical continuity of eighteenth-century graphic tradition links Hogarth to William Blake (1757–1827). As a boy, Blake was apprenticed to the same engraver, William Basire, who had worked for Hogarth. Blake's early technical training was in engraving illustrations for the literary works of other men. But when he came to produce his own works, Blake developed a new process of printing from relief etched plates and hand-colored the impressions. He also developed a new relation between the visual and verbal parts of his designs, drawing and etching the text into the pictures which illustrate it. In Blake's work the use of comparative techniques is not a transfer from one art to another, but a complementary effort in which both text and picture work together. The role of the reader-

spectator changes also, since the synthesis of compared subjects and states, as well as the synthesis of the two arts, takes place in the observer. None of the overt models or directions for reading that may be found in Hogarth guides the reader/spectator in Blake. Moreover there is no textual or logical clue revealing the point of this synthetic reading: that the metaphors which span and unite the arts and the synthesis of the visual and verbal point to a transcendent synthesis of the two contrary states which the reader/spectator must achieve.

In Blake criticism a real attempt is made to get at relationships between the sister arts. Studies of Blake take up this problem because they must; he does not reveal his meaning in one medium, and looking at his text alone (in any of the illuminated works) will not give an integrated or complete notion of what he wishes to convey. The result has been a series of fine studies on Blake's use of motifs from medieval illuminated manuscripts, his knowledge of iconographic traditions, and his development of a catalogue of personal images he repeats with enough consistency to make possible a useful book like S. Foster Damon's *A Blake Dictionary*.

But the basis of this excellent Blake scholarship—the insistence that poem and picture are not identical statements of the same thought but complementary parts of a larger whole—is still occasionally ignored in criticism even of Blake's best-known works, the *Songs of Innocence and of Experience*. One extended example, the poem and design titled "The Fly," will illustrate Blake's use of metaphor whose terms are spread across the verbal and visual parts of his plate and the ways in which he relies on the engaged observer to connect his words and design. The example may also show the dangers of "unilateral" criticism which ignores one of these complementary arts.

"The Fly": Design and Poem

"The Fly" may be the Blake poem with the most problematic relationship to its illustration.[19] The nurse or mother helping the child to walk and the girl playing at battledore and shuttlecock hardly seem relevant to the man who has realized that his life or death is

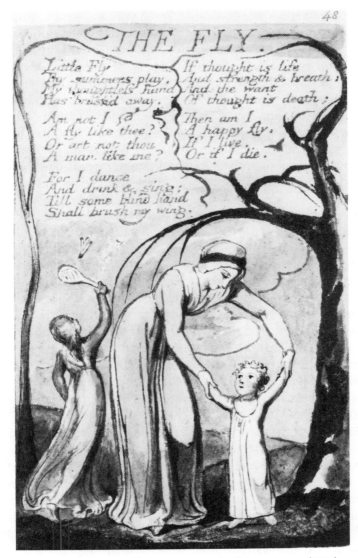

"The Fly," from Songs of Innocence and of Experience (1794), by William Blake.

Reproduced by permission of the Huntington Library, San Marino, Calif.

in the arbitrary control of some "blind hand" and who attempts, in the last two stanzas, to reconcile himself to this realization.

Critics react to the seeming disparity between text and illustration either by misreading the text or by trying to adjust the symbolic import in the actions of the three figures to fit the meaning of the text. The result of the latter procedure is that they see the illustration as negative or threatening. John E. Grant, for example, calls the illustration ominous, troubled, and oppressive, a "scene of frustration" with "sinister overtones" (610–11). No candid first appraisal of the picture would come up with these phrases as descriptive of it, and candor rather than predisposition is part of what is needed to see "The Fly" clearly.

There are actually two activities pictured on the plate, and their positions relative to the text are as important as their content. "The Fly" is the only poem in *Songs of Innocence and of Experience* which Blake has broken into two columns, which, taken together with the separateness of the two pictured activities in size, spatial orientation, and imagistic content, suggests that the designs are intended to illustrate two different sections of the text.[20] The girl with the racquet and shuttlecock on the left side of the plate is in the middle distance and made smaller than the other illustration; the portion of the poem's text immediately above her—the first three stanzas of the poem—is larger than the text on the right. In the right-hand scene beneath the final two stanzas of text, a nurse or mother assists a walking child by holding both of his arms.

Nothing described in the poem is directly illustrated in the design, but rather everything about poem and design reveals a complementary relationship between the two. The poem's speaker is a *man* (line 8), which we can either take literally as adult male or generically as person, human being. The design illustrates every other possibility besides an adult male: a young boy, a girl, and an adult woman. There is no man and no fly in the design, though some commentators have tried to see a fly in the bird above the right-hand tree or have believed that the shuttlecock suggests a fly. The poem speaks of dancing, drinking, and singing; the design illustrates a girl's play (the poem speaks only of the fly's "summer's play") and a boy's learning to walk.

The left-hand scene in the illustration provides another meta-

phor to supplement the text's image for the arbitrary control of fate, while the whole design helps to resolve the otherwise puzzling conditional proposition of the last two stanzas and the apparently careless optimism of the concluding lines.

The Left-hand Design

The left-hand design is placed below the lines of the poem which introduce the dramatic situations: the destruction of the fly by the man's "thoughtless hand" in stanza 1 and his consequent musing upon the identity of their conditions in stanza 2. Directly above the left-hand design, in stanza 3, is a kind of gloss or explanation of lines 5–6: the man sees his condition as identical with the fly's because he dances, drinks, and sings (like the fly's "summer's play") until some arbitrary force ("blind hand") destroys him just as his "thoughtless hand" destroyed the fly in stanza 1.

Precisely what Blake meant by the word "fly" has been debated by numerous commentators, and the consensus is that he did not necessarily mean a housefly but could have meant any winged insect. The force of his lines, however, is to convey the idea of something so small and helpless it can be destroyed by a man without his taking much notice of the act, an act somewhat arbitrary if not downright malicious. Gloucester conveys this same idea in the famous lines from *King Lear* (4.1.36–37) which the first three stanzas of "The Fly" recall to many readers:

> As flies to wanton boys are we to th' gods;
> They kill us for their sport.[21]

The design below the first three stanzas provides another metaphor for the subjection of all creatures to arbitrary control by fate or destiny or chance or whatever referent we may feel compelled to give to Blake's phrase "some blind hand." The girl plays at battledore and shuttlecock (an ancient game which is a forerunner of badminton and which has been popular among children in Europe for almost as many centuries as tennis among adults). The game of tennis has been traditionally used as a metaphor for the arbitrary or malicious control of man by forces outside himself; an example

from the same era as *Lear* and like it in import is Bosola's remark in John Webster's *The Duchess of Malfi*:

> We are merely the stars' tennis balls, struck and bandied
> Which way please them.
>
> [5.4.58–59]

Mario Praz has traced examples of the tennis-game image back from the seventeenth century through European literature and art as far as Plautus's *Captivi*. An emblem book published in Madrid in 1651, Solorzano Pereira's *Emblemata*, illustrates the comparison. Praz's literary examples include book 5 of Sidney's *Arcadia*, which uses Montaigne's words, "les dieux s'esbattent de nous à la pelote, et nous agitent à toutes mains," and he mentions Saint Teresa's statement in her autobiography (chap. 30) that she seemed to see devils playing tennis with her soul.[22] As evidence that the image was used later than the seventeenth century we may quote Pamela, who in the midst of her troubles calls herself "a poor sporting-piece for the great! a mere tennis-ball of fortune!"[23]

Blake substitutes battledore and shuttlecock here—a more appropriate game for a child—and in so doing creates a visual metaphor which is even more apt to his purpose than tennis, for the shuttlecock, in addition to being "bandied" back and forth, is also more subject to the further erratic force of the wind. A double context controls the metaphor's application: a tradition of using tennislike games as emblems of chance-governed events, and the words of the poem which describe such a situation, specifically, "some blind Hand." The visual metaphor is probably born of a literary one, although there is no way to show priority in a case like this. Praz's retracing of the tennis comparison ends with a literary work: Plautus's *Captivi*.

The critics' reaction to this part of the illustration reveals an *idée fixe* about the meaning of the young girl. Hagstrum conjectures that the speaker of the poem may be the other participant in the game the girl is playing (369), and refers to the "clear sexual implications already present in both word and design" (370). This line of interpretation is hard to resist, since no one wants to be accused of missing the clear sexual implications of anything. John Grant had

anticipated Hagstrum: "Even before the advent of psychoanalysis it must have been evident to people that slashing at a shuttlecock, or swatting flies, can be substitute activity for interdicted love" (611). These interpretations share an expectation which predisposes how poem and design will be read: since "The Fly" is a Song of Experience and a young girl appears in the design, Blake must be dealing with sexual matters. But there are objections to this line of interpretation, not the least of which are the poem's refusal to be easily interpreted sexually and the fact that the girl appears, not alone, but in a complex relationship with the other scene in the design and with the text. Wagenknecht handles the two scenes together by calling the girl one aspect of the Female Will to which the child must eventually move from his mother's protection: the girl is his future partner, "already, symbolically, waiting for him" (107). But Wagenknecht cannot show any convincing relationship between the girl and the speaker in the text. He divorces the design from the text and then invents a connection between the design's two parts, reading them as if they represented two separate times: one earlier scene of the boy's preparation for manhood, and another, later scene showing the girl with whom he will eventually mate. This serialization within the plate might be plausible if the "earlier" scene were on the left or if there were other examples of Blake's handling of time in this way.

The Right-hand Design

The second part of the illustration is of a woman leaning over a small boy and holding his arms as he steps forward with his right foot. Here the critics seem to find some consensus: they see in the woman's action a gesture of repression or limitation, and they very often point to other poems in the Experience group to support this interpretation. Hagstrum says that the woman "bends over the child as though in the process of smothering him with her legacy of thwarted desire" (371). Wagenknecht also uses the phrase "smothering motherhood" in his interpretation of the two female figures as aspects of the Female Will which suggest "the limitation of possibility imposed on the child by his natural condition" (107). Grant

describes the figure hovering over her boy "in a solicitous manner which seems stifling," says that her presence seems "oppressive," and eventually concludes that she is an unnecessary figure who isolates the boy and girl in the picture (610–11).

These reactions to the illustrations also seem to be conditioned by the fact that the poem is a Song of Experience; there is a critical expectation therefore that they will deal with oppression or repression, frustration (especially sexual frustration), or attempts to stifle. It cannot be denied that the context of this plate in the whole *Songs of Innocence and of Experience* is important, but it may be that these interpretations take too little account of the context rather than too much. The *effect* of the plate—the immediate impression created by the design—cannot be ignored, and here the mother-child pair strikes us as no more ominous or sinister than such pairs in "Spring" or "The Little Black Boy" or "The Ecchoing Green." Admittedly each of these illustrations from Innocence has a full, green, sheltering oak tree above the mother and child, while in "The Fly" illustration the bare tree so frequently seen in the *Songs of Experience* overhangs the two figures; we are to see all the depicted events as taking place in a hostile or at least uncaring environment. The point which needs to be made here is that there are elements of both Innocence and Experience in the design, *just as there are in the text of the poem.* The design and the poem deal with both of the contrary states and with their transcendence.

One of the more obvious aspects of the right-hand design is that it provides, in the mother's solicitude expressed physically by using her hands to guide and support the child, an opposite suggestion from the "thoughtless hand" of the first stanza. Thus there are two modes pictured: arbitrariness and protectiveness. The assumption of most of the critics that in Blake a protective mode is always a repressive mode is mistaken, but even in those terms the design can still be read as an opposition: protectiveness versus arbitrariness, or repression versus freedom. In the text one of these modes is identified with thought and the other with thoughtlessness. But happiness, as illustrated in both children's attitudes, is independent of these two modes. The text makes this point in the last two stanzas, which have received more critical attention than any other part of the plate.

The Debate about the Two Final Stanzas

The debate about the meaning of the last two stanzas begins with the first word. Kirschbaum suggested that if in "If thought is life / And Strength & Breath" means *since* and is thus an intensifier (162). Both Hagstrum (337, n. 15) and Grant (601–602) agree with Kirschbaum. Of those who hold that if means *if*, so that the stanzas are thus a conditional proposition, Alicia Ostriker admits that they are constructed as a syllogism but asserts that the conclusion does not follow from its premise and in fact, "the façade of logic in the poem is a joke"; the speaker has simply realized that he is alive, which is all that matters (22). Hirsch argues that the draft version of "The Fly" in the *Notebooks* has a more reasonable fourth stanza:

> Thought is life
> And strength & breath;
> But the want
> Of Thought is death.

Hirsch believes Blake's alteration had "disastrous results" and that, paradoxically, Blake does *not* mean that the want of thought is death (although that is even more positively asserted in the draft version): "the unmistakable implication is that my thought, and therefore my happiness, continues whether I live or die, and this is the implication Blake meant to convey" (240). Wagenknecht decides that the final two stanzas are either an ironic justification of the killing of the fly (if it is dead it has no consciousness of the fact) or are addressed to the speaker of the first three stanzas *by the fly* (but only in the first speaker's imagination). Either way the lines are ironic, having the force of "if my life or death depends on your thought, I am in trouble either way" (109–10).

While this sort of review tends to be unfair by excerpting criticism, it is nevertheless true that comments on the last two stanzas have not been successful in elucidating them. And more than any other part of the poem these stanzas seem to evoke hermetic or arcane style in commentary:

> At this point we arrive at the poem's burning center; if we penetrate to Blake's full meaning here, we not only possess the poem but the

poem possesses us. We mount the fiery chariot of inspiration, and meet the lord—and our speaker—in the air.[24]

The argument stresses the most radical version we have yet seen of the terror of dependence upon the Female Will, of what happens when the language of transcendence speaks the lexicon of immanence.[25]

The Whole Plate

The critical debate on "The Fly" was under way before any critic attempted to look at the pictorial accompaniment to the text, and thus some of the terms of the debate were already set. Few of these critics are explicit in conjecturing what the speaker means by happiness in the last stanza, because that was not part of the original discussion as begun by Kirschbaum. Neither do they point out that happiness is a clear concern of both text and design. The poem asserts that the happiness of the speaker is independent of life or death, thought or the want of it. The design shows the children's happiness independent of their two pictured modes: protectiveness on the right-hand side, and unprotected freedom (with the implication of subjection to arbitrary forces) on the left. Happiness is the final result of the unified text and design, which describes a transition from Innocence to Experience to some further synthesis.

The poem begins at a point where the speaker, who may once have been as innocent as the fly's "summer's play," has already performed the act which will take him into the state of Experience. The killing of the fly brings guilt, even though the act was "thoughtless"—or perhaps just *because* it was thoughtless, since the speaker realizes that thought is life-sustaining and is the mode of protection, the mode illustrated by the thoughtful hands of the mother in the right-hand design. The most important consequence of the killing of the fly, however, is recognition, or self-awareness, a condition in which the speaker realizes that in unthinking action he has become part of the large destructive forces where are irrational and deadly, and that he lives in their shadow just as the fly does. This stage of Experience is somehow transcended to get to the further stage of the last stanza, where the speaker identifies himself with the fly and asserts that his happiness is independent of his life or death:

Then am I
A happy fly
If I live
Or if I die.

The last stanza is the conclusion of a conditional proposition, and
the realization that thought is life and strength and breath and the
want of thought is death brings about this conclusion. Now an
awareness of personal mortality is one of the elements of the state
of Experience, but the identification of *thought* with life is what
enables the speaker to transcend the state of Experience. The critics
who have realized that the penultimate stanza is the poem's crux
have debated the meaning of *thought* at length. Kirschbaum substi-
tutes *vision* for thought (158–59); Hagstrum wishes to refine it further
into sensibility (377–78); Hirsch construes it as immortality (240);
others see it merely meaning consciousness.[26] None of these com-
mentaries looks to the poem's illustration for a gloss on the word
thought, but that is surely one of the reasons the design is there.

Thought is identified with the mode of protectiveness; it corre-
sponds to the state of innocence and is illustrated by the mother's
thoughtful hands in the right-hand design. The thoughtless or ar-
bitrary hand of stanza 1 is in contrast to this and represents a mode
of subjection to outside forces without protection. Such subjection
and lack of protection, corresponding to a state of Experience, is
represented by the unaccompanied girl and the game she plays in
the left-hand design.

When thought and the want of thought are identified in this
way, the speaker is enabled to view the states of Innocence and
Experience from the outside—to get perspective on them—and
therefore he has already transcended them. He concludes, there-
fore, not that death is unimportant, but that it is inevitable and that
he is now free of the preoccupation with it which characterizes
Experience. Seeing the two contrary states for what they are, he
finds the happiness of Innocence replaced by a newer order of
happiness which cannot be disturbed by knowledge either of per-
sonal mortality or of the external forces which have power over
men. Mark Schorer has pointed out in *William Blake: The Politics of*

Vision that this state of "reintegration" or "transcendence of experience" is not a unique vision of Blake's but has its archetype in the biblical mythology of the Fall as the origin of consciousness.[27] The transcendence of both innocence and experience, after a transition through a period of guilt, is represented in "The Fly," while the design extends the text's metaphors and helps to elucidate its terms. The reader/observer's engagement with the poem and design begins at the point where the speaker identifies himself with the fly in stanza 2. From there, a successive identification with each of the figures leads to assent to the speaker's conclusions in the last stanzas.

This discussion of "The Fly" has not mentioned threefold vision or fourfold vision or states like Beulah or Urizenic pride transcended by imagination. These terms have been avoided not because holistic criticism involving the prophetic books and Blake's other writings is wrong-headed or even inapplicable to this specific plate. But Blake's songs should be understandable within the context they create plus the tradition within which he operates. Damon points out and Grant reiterates the importance of earlier poems such as Gray's "Ode I" to the composition of "The Fly": the images of Renaissance literature and pictorial source books are equally important to the design.[28] We are getting back to a view of Blake as a strong user and transformer of tradition, and we have realized that such a view detracts nothing from Blake's genius or his vision.

More important than the context of surrounding plates or than tradition is the immediate perception of design and poem. We should trust our perception with Blake; if we cannot, we may find ourselves arguing that his designs create a mood far different from their immediate effect, and that would be to argue that Blake failed in his combination of design and poem. We must look at details in Blake's plates, but we must start from general impressions of theme created by the union of text and design. And our impressions should be modified by the rest of the individual work and by all of Blake's works, but they cannot be *predisposed* by this larger context if we are to appreciate the singularity and integrity of each plate Blake engraved.

3

Nature and Engagement

Because natural scenes are background or main subject in so much English art, it is reasonable to ask what role nature plays in the process of drawing the reader or observer into a work. The answers to this question differ according to the relationship between the natural scene and the human participants in each work and according to the kinds of natural signs which the artist chooses to depict. To get at the ways nature is used to engage us, in this chapter I offer a classification of relationships between natural scenes and human figures, show these relationships at work in a limited group of figure/nature scenes—that of children and gardens—and, finally, discuss two of the most versatile and powerful of natural signs which the artist can use: the sun and the rainbow.

Figures in Nature

Any poem or painting which contains landscape, even as portrait background, is about a relationship between man and nature, or between "scenery and society," as James Turner puts it in *The Politics of Landscape*.[1] The human figures may be present in the pictured or poem space, or they may be only standing back looking at it or reading it; the reader or observer is always an inescapable figure in the landscape. Writers on literary and pictorial art such as Turner, Ronald Paulson, John Berger, Jay Appleton, Andrew Wilton, and John Barrell have enumerated, classified, and commented on these relationships according to their several purposes.[2] My own classification draws on all their work and attempts to show how these various relationships can engage the reader/observer. The taxon-

omy that follows may seem oddly ahistorical in its choice of examples. Relationships between figures and landscapes are perennial functions that have different cycles of recurrence in different arts. Emblematic relations in poetry, for example, may be popular at the beginning of the eighteenth century, while painters use similar relations with similar subjects in the middle of the nineteenth century. This discussion ranges through more than two hundred years in finding examples.

A Taxonomy of Figure/Landscape Relationships

A frequent relation that exists between portrait subjects (or named characters in poems) and their landscape backgrounds is a *proprietary* one, especially if the land is identifiable as a particular locale. James Turner finds this relation signaled in the words used in the seventeenth century for known topography:

> "Land" and "place" are equivalent to "propriety"—meaning . . . both *property* and *knowing one's place*. The order of the universe, like the structure of society, was supposed to depend on a hierarchy of places from lowest to highest. Place is identity.[3]

The best examples in verbal art are furnished by a subgenre of topographical poetry, the country-house poem of the seventeenth century. This kind of poem comes into being in England in a century of estate confiscation and promiscuous iconoclasm, and it asserts the values of owning and belonging to the land—the values of place in the particular topographical sense as well as the social sense. Jonson's *To Penshurst* (1616) and Marvell's *Upon Appleton House* (published 1681) epitomize the kind. The poems begin with the houses, with praise for their lack of show and for their real qualities of worth; then the description moves out into the grounds. Marvell's poem, much longer than Jonson's, spends more time on the house and, significantly, its human proportion—in all things it is the relation which matters, and one's estate (the position, the land, the house) are after all only temporary:

> But all things are composed here
> Like Nature, orderly and near:

In which we the Dimensions find
Of that more sober Age and Mind,
When larger sized Men did stoop
To enter at a narrow loop;
As practising, in doors so strait
To strain themselves through *Heavens Gate*.

[Lines 25–32]

Jonson is less concerned with spiritual propriety or estate and more concerned with the broad beech and oak of the Sidneys' woods, the sheep, bullocks, and calves, the carp in the pond, and the farmers with their ripe daughters, "whose baskets bear an emblem of themselves in plum or pear." Nature's fecundity offers the best compliment to the Sidneys, along with the tenants' happiness and the hospitality which can entertain a king at a surprise visit (lines 76–88). Social propriety's most important expression here is hospitality.

In Gainsborough's *Mr. and Mrs. Andrews* (1748–50), more than half the picture is devoted to an identifiable piece of the English coun-

Mr. and Mrs. Andrews (1748–50), *by Thomas Gainsborough.*
Courtesy of the National Gallery, London.

tryside that the Andrewses owned and farmed. The land is given such prominence not merely because of its natural beauty—Gainsborough would never have painted a picture of this farmed countryside by itself—but for what it says about its proprietors. The scene is very much like that described in *Upon Appleton House*, where Marvell compares the haycocks to rocks projecting from a calm sea and to pyramids, and then goes on to describe the cut fields and the livestock grazing in the distance. Marvell's description makes a political point about Levelers, thus reinforcing the stress these works always carry about the importance of place:

> This Scene again withdrawing brings
> A new and empty Face of things;
> A levell'd space, as smooth and plain,
> As Clothes for Lilly stretcht to stain.
> The World when first created sure
> Was such a Table rase and pure.
>
> . . .
>
> For to this naked equal Flat,
> Which Levellers take Pattern at,
> The Villagers in common chase
> Their Cattle, which it closer rase;
> And what below the Sith increast
> Is pincht yet nearer by the Beast.
>
> . . .
>
> They seem within the polisht Grass
> A Landskip drawn in Looking-Glass.
> And shrunk in the huge Pasture show
> As Spots. . . . [Lines 441–46; 449–54; 457–60]

Marvell refers to painting twice in these lines: once to Lely the portrait painter and once to landscape. Marvell reminds us that the improved countryside is itself a work of art and that fine art is a point of reference for the people who are depicted here. The Levelers threaten both sorts of art, because they see land only as money rather than a social and artistic expression of the proprietors. Fine art—all of it—is a reproach to the Levelers and all of it risks being destroyed. In class conflicts all art in fact is seen to reflect the

property relationships we are discussing: hence the secular icono-clasm of the Civil War in England, which cannot be explained solely by hatred of the established church and its images.

In the seat of the Fairfaxes as well as that of the Sidneys and the Andrewses, the land's improvement speaks for them, but not solely because it is farmland and benefits others as well as themselves. Land can be "cultivated" in more ways than with a plow, and its cultivation reflects that of its owners, in the rustic Ipswich way of the Andrewses, or the more polished and literary way of the Sidneys. The landscape could be woods instead of fields and the relation would still hold. The land's state argues for the people's generosity, gentility, and propriety in all its senses.

The intended or ideal audience for such works consists of the subjects themselves or their heirs. Our entry into these works begins with finding the subjects to be surrogates for ourselves. To the extent that we approach the ideal audience we identify ourselves with the subject, finding the landscape not only picturesque, but also a source of pride and responsibility.

If the proprietors are taken out of the picture entirely, as is the case with Constable's *Wivenhoe Park* (1816), the observer assumes their place, and in the work which successfully engages, perceives with their own proprietary attitudes. We do not have to know of the childlike eagerness with which the owners of Wivenhoe Park kept adding to the things Constable had to include in his painting (he was forced to attach strips to the sides of his original canvas to broaden his view; hence the rather odd 22-inch by 40-inch pro-portions of the picture).[4] The picture charms because of its naivety, and we respond in kind. The house sits at the exact center of the picture, and the horizon divides the picture vertically into halves. The fence occupies just half of the foreground, the full depth of the lake just the other half. Between the black cow and the white cow grazes a black-and-white cow. Our pleasure in all this is simple and unalloyed.

In Reynolds's *Lady Elizabeth Delmé and Her Children* (1780), the gen-tility is less rustic than that of the Andrewses, and the setting at once more controlled and less particularized; the trees form a sheltering canopy over the pyramidal family group, complete with faithful dog. The pleasant prospect leads the eye off into the right distance

Wivenhoe Park, Essex (1816), by John Constable.
Courtesy of the National Gallery of Art, Washington, Widener Collection.

but does not detain it, because there is something not quite real about this background. In this picture by Reynolds, in the late Gainsborough, and in Romney, the relation between the figures and the landscape is one of *formal harmony*. In Gainsborough's *The Morning Walk* (1785; National Gallery, London), for example, there is no real attempt to paint recognizable trees—the hues of sky and leaves as well as the light and dark masses are there merely as accents and foils for the black-and-white forms of the newly married couple, Mr. and Mrs. Hallett. George Romney's *Miss Willoughby* (1783) is another such picture in which the whole landscape background is subjugated to picturing a harmonious relation between the subject and the surroundings. The background is a contrast in which everything is arranged by the painter. The diagonal line of the hillside, roughly paralleled by the girl's left forearm, echoes the tilt of her head; the composition of the picture is carefully balanced and these main elements played against the main vertical and horizontal axes of the picture. The colors also affect harmony and balance. The three main colors—the pink of the sash and flesh, the blue of the sky, and the yellow of the hillside—are each subdued primaries so

Lady Elizabeth Delmé and Her Children (1780), *by Sir Joshua Reynolds.*
Courtesy of the National Gallery of Art, Washington, Andrew W. Mellon Collection.

that the palette's whole range is used but in muted hues and with each of these subdued primaries occupying an almost equal area of the picture space. The picture uses a simple subject to depict natural and human harmony in purely formal terms without a recognizable tree or other natural feature. (See illustration on p. 41.)

The poetic equivalent to the formal harmonies of such pictures is Pope's *Windsor Forest* (1713), where the foreground figures, the two Williams (and by implication the third) and Queen Anne, are set off by a landscape background that is not particularized. In the Windsor of Pope's source, Sir John Denham's *Cooper's Hill* (1655), we can recognize landscape features as well as the poet's own vantage point. Pope's Windsor is arranged for effects of balance, contrasts, parallels, and antitheses, ending in harmonious order:

> Here Hills and Vales, the Woodland and the Plain,
> Here Earth and Water seem to strive again,
> Not Chaos-like together crush'd and bruis'd,
> But as the World, harmoniously confus'd:
> Where Order in Variety we see,
> And where, tho' all things differ, all agree.
>
> [Lines 11–16]

Pairs of lines compare the landscape's features to human behavior:

> Here waving Groves a checquer'd Scene display,
> And part admit and part exclude the Day;
> As some coy Nymph her Lover's warm Address
> Nor quite indulges, nor can quite repress.
>
> [Lines 17–20]

The features of the landscape are enumerated without adding up to a familiar locale; their descriptive worth is in their comparison with other fruitful places on the earth now, with famed places of classical antiquity, and with place which is seen as reflecting the reign of a beneficent ruler:

> There, interspers'd in Lawns and opening Glades,
> Thin Trees arise that shun each others Shades.
> Here in full Light the russet Plains extend;

There wrapt in Clouds the blueish Hills ascend:
Ev'n the wild Heath displays her purple Dies,
And 'midst the Desart fruitful Fields arise,
That crown'd with tufted Trees and springing Corn,
Like verdant Isles the sable Waste adorn.
Let India boast her Plants, nor envy we
The weeping Amber or the balmy Tree,
While by our Oaks the precious Loads are born,
And Realms commanded which those Trees adorn.
Not proud Olympus yields a nobler Sight,
Tho' Gods assembled grace his tow'ring Height,
Than what more humble Mountains offer here,
Where, in their Blessings, all those Gods appear.
See Pan with Flocks, with Fruits Pomona crown'd,
Here blushing Flora paints th' enamel'd Ground,
Here Ceres' Gifts in waving Prospect stand,
And nodding tempt the joyful Reaper's Hand,
Rich Industry sits smiling on the Plains,
And Peace and Plenty tell, a STUART reigns.

[Lines 21–42]

Readers engaged with the poem perceive it as representing the area around Windsor, but not in any sense having to do with their recognition of a particular scene. Windsor's formal qualities are abstracted from the scene; its variety, order, and harmony grace the verse, even as they should and do grace the political scene under Anne.

Pope's use of landscape differs from that in his model, John Denham's *Cooper's Hill*. In Denham the landscape bears an *emblematic* relation to its figures: particular places stand for qualities and events. Denham, as noted earlier, paints a recognizable picture of the hill from which he observes Saint Paul's, on its hill in the city (lines 14–24), Windsor Castle (lines 39–64), and Saint Anne's Hill, with its ruins of Chertsey Abbey (lines 112–15). Cooper's Hill is Denham's Parnassus:

So where the Muses and their traine resort,
Parnassus stands; if I can be to thee
A Poet, thou Parnassus art to me.

[Lines 6–8]

The other locations in the poem are emblems with political referents. Saint Anne's hill represents the luxury and lust of Henry VIII, who destroyed Chertsey Abbey and confiscated its riches.[5] Saint Paul's, "Preserv'd from ruine by the best of Kings" (line 24), clearly represents an opposite quality of royal protection for true religion. Windsor, "Thy mighty Masters Embleme" (line 47), stands for the monarchy itself. Denham's method throughout the poem is to find such specific correspondences:

> My eye descending from the Hill, survaies
> Where Thames amongst the wanton vallies strayes.
> Thames, the most lov'd of all the Oceans sonnes
> By his old Sire, to his imbraces runnes,
> Hasting to pay his tribute to the Sea,
> Like mortall life to meet Eternity.
>
> [Lines 159–64]

Another seventeenth-century example of this emblematic relation is Dryden's use of the supposed discovery of the true purpose of Stonehenge in a complex emblematic scheme in his *Epistle to Dr. Charleton* (1663). Stonehenge was thought by Charleton to be a place of coronation for Danish kings. Dryden turns the monument into an emblem of protection (because it supposedly was one of the young Charles's refuges after the battle of Worcester) and then restoration—itself restored to its true meaning by Charleton's researches:

> STONE-HENG, once thought a Temple, You have found
> A Throne, where Kings, our Earthly Gods, were Crown'd.
> Where by their wondring Subjects They were seen,
> Joy'd with their Stature, and their Princely meen.
> Our Soveraign here above the rest might stand;
> And here be chose again to rule the Land.
> These Ruines sheltred once His Sacred Head,
> Then when from Wor'sters fatal Field He fled;
> Watch'd by the Genius of this Royal place,
> And mighty Visions of the Danish Race.
> His Refuge then was for a Temple shown:
> But, He Restor'd, 'tis now become a Throne.
>
> [Lines 47–58]

Stonehenge is not a natural feature, though it sometimes has the appearance of one. Moreover, Dryden goes far toward suggesting that the place is some sort of divine creation, as he builds up images associated with godhead, wonder, superiority, sacredness, and divine watchfulness.

Emblematic pictures may be found from the work of Hogarth on throughout the period treated in this book. Despite Ronald Paulson's thesis that by the end of the eighteenth century English art had moved from emblem to expression, from "a 'readable' structure of meaning in a work of art to the 'aesthetic' pleasure of an immediate psychological response to a visual stimulus," emblematic pictures were probably never more popular than in the nineteenth century.[6] An example from mid-century is a historical picture which uses another emblem associated with the protection of Charles during the Civil Wars: the so-called royal oak—an oak tree in Boscobel Wood which was another brief hiding place for Charles after the disastrous battle of Worcester. Charles himself described the closeness of his escape, relating the events of September 6, 1651: "we . . . went and carried some victuals up . . . bread and cheese and small beer . . . and got up into a great *Oake* that had been lopped some 3 or 4 years before and so was grown out very bushy. . . . While we were in the tree we see soldiers going up and down in the thickest of the wood searching for men that were escaped."[7] The romance of this particular episode turns the oak into an emblem not only of shelter (an ancient association because of its shape and the great size it can attain) but more specifically of Royalist protection, and thus John Everett Millais uses it in *The Proscribed Royalist 1651* (1853). Millais's Royalist, presumably escaping from Worcester, finds shelter within the tree's base. A Puritan girl, with rather a fancy satin dress for a Puritan, brings him food and receives thanks in the form of a gentlemanly kiss of the hand. The danger of the situation or confusion at the gallantry of the Cavalier causes her to look anxiously to see if anyone is watching. Millais adds the zest of a possible Montague and Capulet romance to the already adventurous situation. The oak provides a complete enclosure for the Cavalier in this picture, but in William Shakespeare Burton's *A Wounded Cavalier* (1856), the emblem has been reversed, and the oak is a narrow tree into which is thrust the broken sword blade of the very pale Royalist, who does not look long for this world. Only a few

The Proscribed Royalist 1651 (1853), by Sir John Everett Millais.
Private collection. Photo courtesy of Christie's, London.

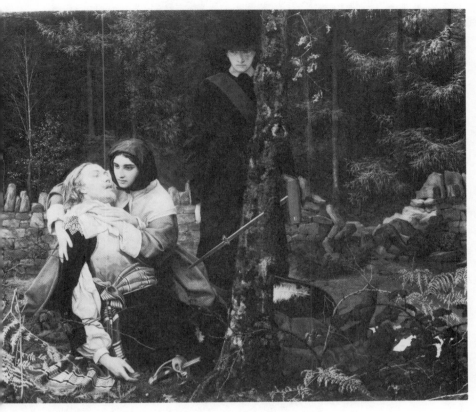

A Wounded Cavalier (1856), by *William Shakespeare* Burton.
Courtesy of the Guildhall Art Gallery, Corporation of London.

dead leaves hang from one small broken branch of the tree, whose state reflects both that of the Cavalier and of the Royalist cause.

Learned associations of the emblem shade into natural associations of the symbol in the use of significant landscape in Arthur Hughes's *The Long Engagement* (1859), which has a background landscape of spring, youth, and growth. Its figures are a woman and her clergyman betrothed, who wait uncertainly for the living which will allow them to marry. In most of his pictures Hughes paints a closely observed but conventional background in which the ivy, wild roses, and ferns of this picture are repeated without clear necessity or

The Long Engagement (1859), by *Arthur Hughes*.
Reproduced by permission of the Birmingham Museum and Art Gallery.

effect, but here all these living things almost take over the picture space in symbolic mockery of the subjects. "Our awareness of nature growing, blossoming, and reproducing," writes Allen Staley, "heightens the poignancy of the enforced sterility of the two protagonists."[8]

A large category of relations between figure and landscape can be broadly labeled *philosophical*. This category includes most "pure" landscape pictures and much of the nature poetry of the romantic poets, but it subtends everything from a sacramental response to nature to a scientific interest in natural phenomena to a kind of vague uplift felt in nature's presence. The sacramental relation—the "natural sublime," in which nature's awesome features reproduced in a work lead the reader/spectator's mind to ideas of an omnipotent creator—will be discussed in the last sections of this chapter on natural signs, along with the scientific interest in nature, which was a distinctive feature of English art from the time of Newton until that of Darwin. Characteristic of all forms of the philosophic relation is the view of nature as teacher. The artist attempts to make the reader or observer present at a natural scene capable of educating and changing its audience; the knowledge or wisdom gained may be moral, metaphysical, physical, or aesthetic. In romantic poems such as Coleridge's *This Lime Tree Bower My Prison* (1797), Wordsworth's *Tintern Abbey* (1798), and Shelley's *Mont Blanc* (1816), the landscape is invested with meaning, but its significance needs discovery rather than mere recognition. Poems and also pictures of this kind tend to be about memory and time, and their strategy for involving the observer often includes a surrogate observer for us in the author/artist or another figure such as Wordsworth's "friend"—his sister Dorothy. A characteristic of romantic landscape vision, to use Karl Kroeber's phrase,[9] aside from the search for meaning, is the buried recognition that it is at least partly a construct of perception itself and that nature has a life that is genuinely beyond the life of man. The poets often admit to projection of meaning: in *Mont Blanc* Shelley's "source of human thought" brings a tribute of waters "with a sound but half its own," and Wordsworth writes in *Tintern Abbey* that his love for nature includes what his senses half-create and what they perceive. The reader or observer can also project meaning, and this possibility makes for an entry into the work. But though it is

allowed in these works that meaning is not given or prior to the encounter between the observer and nature and that it may be partly subjective, there is also some insistence on its nonsubjectivity. This usually involves an attempt to connect with other human experience, as the main figure turns outward to someone else in the poem or picture for confirmation of an impression and assurance that the derived meaning is not an accidental, random, or solipsistic one. Thus at the end of *Tintern Abbey* Wordsworth turns to his sister Dorothy, and what he reads in her voice and look is confirmation that her reaction to this scene is identical to his own earlier response to it:

> in thy voice I catch
> The language of my former heart, and read
> My former pleasures in the shooting lights
> Of thy wild eyes.
>
> [Lines 118–21]

Tintern Abbey begins with a statement of the landscape's connection with thought and feeling:

> Once again
> Do I behold these steep and lofty cliffs,
> Which on a wild secluded scene impress
> Thoughts of more deep seclusion; and connect
> The landscape with the quiet of the sky.
>
> [Lines 4–8]

Wordsworth emphasizes that it is a remembered as well as a present landscape and its memory is sharp and real:

> Though absent long,
> These forms of beauty have not been to me,
> As is a landscape to a blind man's eye.
>
> [Lines 24–26]

Wordsworth may mean a painted landscape in line 26—one which recreates the remembered place. His own poem imitates the composition of a landscape, as James L. Hill has noticed: he puts himself in the foreground, under a sycamore, "allowing the viewer to 'enter'

the picture space through a human figure in the foreground"; he then gradually completes the middle distance and the distant trees, where smoke assures the human presence from near to far plane. "The scene has been placed before us as an organic harmony; and the aesthetic reaction to it which follows is appropriately and literally organic—it is consciously proposed as a theory of physiological response to a work of art, to 'beauteous forms.' "[10] Wordsworth's poem's picture is a "picture of the mind" (line 63); while he sees the real landscape he recalls his memory's and projects into the future:

> And now, with gleams of half-extinguish'd
> thought,
> With many recognitions dim and faint,
> And somewhat of a sad perplexity,
> The picture of the mind revives again:
> While here I stand, not only with the sense
> Of present pleasure, but with pleasing
> thoughts
> That in this moment there is life and food
> For future years.
>
> [Lines 60–67]

The distinction between the landscape of memory and the real landscape ceases when we examine the poem as artifact. For us, the poem, like a painting, is a "picture of the mind" which is a construct of memory and perception working on hints which the artist gives. But in the poem's conclusion, the fact that Dorothy Wordsworth's present experience coincides with the poet's past ones validates both their reactions to nature. No distinction is made between present nature, nature in art, or nature in memory when the poet assures us that "Nature never did betray / The heart that loved her" (lines 124–25).

Karl Kroeber has suggested that a fitting picture to be paired with *Tintern Abbey* is Constable's *The Cornfield* (1826). Both, according to Kroeber, use specific place to represent time. The Constable painting depicts one moment in time (it is one of several pictures Constable exhibited with the title *Landscape: Noon*) but also a continuum:

the picture shows a young boy in the foreground, an adult hunter and farm laborers in the middle distance, and a church in the far distance, in a "diagonal progression from youth to the hope of life beyond death." Youth has the foreground, where the space seems widest, but the grain field widens still more as the lane leads into the center of the picture. (See illustration on p. 21.)

> Old structures built by men, the fence protruding into the path, the dams in the stream, even the path itself in the foreground, prepare the eye for the distant church, as does the plow in the middle distance. The very grain field which so abruptly cuts off the path is centered so as to focus our attention on its artificiality in contrast to the pure natural growth of the foreground trees and the far-distant wooded hills. The grain, an annual crop, is in every aspect, including that of time, the midpoint, the nexus, of man's relation to nature.[11]

Kroeber points out that it is not so easy to say what Landscape: Noon. The Cornfield is a picture of. Its title reveals a location and a time rather than a subject, as does Wordsworth's title Lines Composed a Few Miles above Tintern Abbey on Revisiting the Banks of the Wye During a Tour. July 13, 1798. Like Wordsworth's poem, the picture is about different perspectives on time and nature; it draws us in by the attraction of its funneling diagonals, by the surrogate figures which represent stages of our lives, and by the absolutely convincing light and air of noon.

Children in Gardens

Constable's painting shows a boy drinking from a brook in a verdant and wooded landscape, while the future of work and death stretches away to the center and right, in cultivated fields and town. The boy will lead us into a special case of figure/landscape combinations—that of children in gardenlike landscapes or actual gardens, an idyllic combination that seems able to shut away precisely those associations of time and mortality Constable has made explicit in The Cornfield. Surprisingly, those associations are not shut away in many pictures and poems where children are shown or described in gardens, even where the apparent intent is merely the making of a charming portrait. The associations are not conveyed only by the

children or their surroundings, but as in Constable's picture, also by the juxtaposition of youth and age. If the second element is not in the work, it is supplied by the reader/observer.

There are only a limited number of conventions for treating children—alone rather than in full family groups—in the English sister arts. A very few painters show their subjects against neutral or dark backgrounds: thus John Opie's painting of his son (Tate Gallery) and Raeburn's *Master Alexander MacKenzie* (Nelson Gallery, Kansas City) both have almost black backgrounds. A few others paint them in indoor groups—childish equivalents of conversation pictures as in Hogarth's *The Graham Children* (1742, Tate Gallery). Another possibility puts the child in fancy dress: Reynolds paints one child as Henry VIII, another as a gypsy fortune teller. But the most frequent convention in verse and paint is that of showing the child in a *garden*, in the sense of a place bounded or enclosed in some way, where vegetation is encouraged by man. Poems about children in gardens include Hopkins's "Spring and Fall" as well as Marvell's "The Picture of Little T.C. in a Prospect of Flowers." Blake's two nurses' songs about children on the green are relevant, as is the section from Arnold's "Stanzas from the Grande Chartreuse" with children "reared in shade beneath some old-world abbey wall." In paintings the child is usually alone and will often have in lap or hand flowers of a plainly cultivated sort, as in Gainsborough's *Master John Heathcote*, Sir Thomas Lawrence's *Miss Murray*, or Sir Joshua Reynolds's *Lady Caroline Howard*. The garden wall itself may be visible, as in Lawrence's *Miss Murray*. In some pictures the garden is a more spacious expanse of estate—an example is *May Sartoris* by Frederic, Lord Leighton.

What engagement strategies distinguish these examples of children in landscapes? All of the expected associations are there. These children are images of freshness and innocence; they evoke ideas of the inhabitants of Eden before the Fall. These gardens are not wild—there is *cultivation* here and careful breeding which the flowers and the children show equally. Most of the poets and painters who created these works show childhood as a hothouse period during which there must be protection from the rough winds that shake the darling buds of May.

But the enclosure which is implicit or explicit in these works

Master John Heathcote (c. 1771), by Thomas Gainsborough.
Courtesy of the National Gallery of Art, Washington. Given in memory of Governor Alvan T. Fuller by the Fuller Foundation.

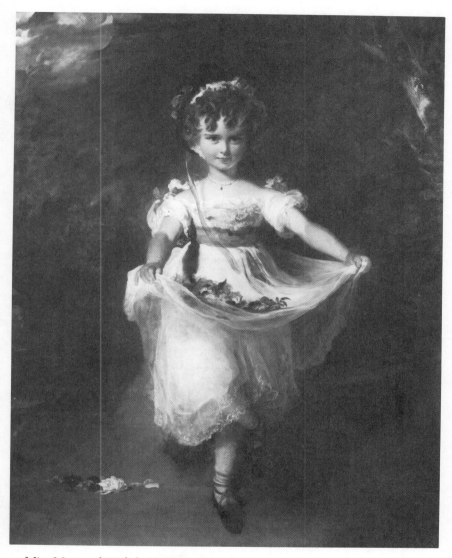

Miss Murray (1826), by Sir Thomas Lawrence.
Courtesy of the Greater London Council as Trustees of the Iveagh Bequest, Kenwood.

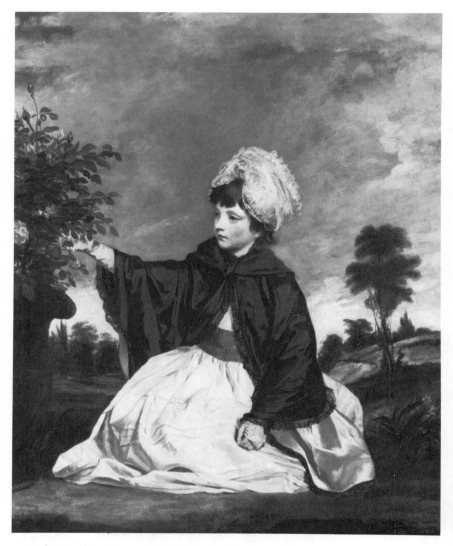

Lady Caroline Howard (1778), by Sir Joshua Reynolds.
Courtesy of the National Gallery of Art, Washington, Andrew W. Mellon Collection.

can be ambiguous—protecting but also inhibiting, as in Blake's Experience poems such as "The Garden of Love," where "Thou shalt not" is written over the door of the garden's chapel, and priests in black gowns bind with briars the joys and desires of the speaker, who used to play on an open green where there is now the garden and chapel.

Eden implies a fall, and these works hint at the end of innocence, too. Much more surprising, though, is their persistent iteration of themes of change, transience, and mortality. Death and youth are the coupled images of these poems and pictures, sometimes blatantly paired and sometimes very subtly. These features—death and youth, innocence and its loss—are part of the structure of the artist's depiction of the human situation, but the situation is not merely the child in the landscape. The structure includes the fact that the human situation is embodied in an art form. The child in the landscape is not melancholy or a memento mori, but the child in the picture or poem is never alone: he or she is always observed by an older spectator or reader. Sometimes there is an older companion within the work, as in Hopkins's "Spring and Fall," but every child/landscape in art contains at least an implied contrast between youth and age when an observer reads it or stands before it. This main contrast, ever present, leads to associated contrasts of freshness and its fading, innocence and its loss, vigorous life and inevitable death, whether early or late.

All of these elements are overt in Andrew Marvell's "The Picture of Little T.C. in a Prospect of Flowers," published in 1681. The little girl is depicted in a garden whose greenery enchants itself at her beauty (lines 25–26), while she performs the Edenic task of naming the creation (lines 4–5) and goes farther, subduing it to her use:

> See with what simplicity
> This nymph begins her golden days!
> In the green grass she loves to lie,
> And there with her fair aspect tames
> The wilder flowers, and gives them names; 5
> But only with the roses plays,
> And them does tell
> What color best becomes them, and what smell.

Who can foretell for what high cause
This darling of the gods was born? 10
Yet this is she whose chaster laws
The wanton Love shall one day fear,
And, under her command severe,
See his bow broke and ensigns torn.
 Happy who can 15
Appease this virtuous enemy of man!

O then let me in time compound
And parley with those conquering eyes,
Ere they have tried their force to wound;
Ere with their glancing wheels they drive 20
In triumph over hearts that strive,
And them that yield but more despise:
 Let me be laid
Where I may see thy glories from some shade.
Meantime, whilst every verdant thing 25
Itself does at thy beauty charm,
Reform the errors of the spring;
Make that the tulips may have share
Of sweetness, seeing they are fair;
And roses of their thorns disarm; 30
 But most procure
That violets may a longer age endure.

But, O young beauty of the woods,
Whom nature courts with fruits and flowers,
Gather the flowers, but spare the buds, 35
Lest Flora, angry at thy crime
To kill her infants in their prime,
Do quickly make the example yours;
 And ere we see,
Nip in the blossom all our hopes and thee. 40

Marvell suggests the child might even improve on the creation,
"Reform the errors of the spring" (line 27) and give tulips scent,
violets "a longer age" (line 32), and roses freedom from thorns (line
30).

Her "simplicity" (line 1), "fair aspect" (line 4), youth, and in-
nocence are presented first. We don't know how old little T. C. is,

but she seems very young—an infant who is just beginning her "golden days." Yet Marvell does not neglect to look forward to a time when she will not be so innocent:

> Yet this is she whose chaster laws
> The wanton Love shall one day fear,
> And, under her command severe,
> See his bow broke and ensigns torn.
> Happy who can
> Appease this virtuous enemy of man!

This and the image of the girl driving her chariot wheels over the hearts of those who do not yield to her, and despising those who do, seems iconographically muddled, as if Marvell had Venus driving Athena's chariot. But the iconography is at the borders of the portrait; we know Marvell wants us to read his poem as if it were a portrait of T. C. in a landscape, because otherwise he would not have called it a *picture* of her in a *prospect*.

The most startling part of the poem is its last stanza:

> But, O young beauty of the woods,
> Whom nature courts with fruits and flowers,
> Gather the flowers, but spare the buds,
> Lest Flora, angry at thy crime
> To kill her infants in their prime,
> Do quickly make the example yours;
> And ere we see,
> Nip in the blossom all our hopes and thee.

The invocation to the child is really an invocation to Flora and Fortuna: "Gather the flowers, but spare the buds." The child is identified with those who may have power over her, such as the fates and Flora. The possibility of her dying young is not prepared for and has the greater shock value. It seems to want explaining, and Marvell's editor tries, by suggesting that T. C. is Theophila Cornewall, in whose family several infants had already died.[12] It is arguable, on psychological grounds, whether these circumstances would make it more or less likely that Marvell would bring up the

subject at all. In any case it does not matter whether T. C. is Theophila Cornewall or not. The poem gives us an unflinching reminder that in Marvell's time, a child stood about an equal chance of dying before late adolescence as of surviving to any later age. The bills of mortality in the 1700s show consistently that the number of those dying in the first two decades of life equals or exceeds the combined number of all those dying in every subsequent decade up to the age of 110. The deaths in the first decade of life very nearly equal all the others by themselves.

The linking of youth and mortality is a theme that rarely reflects the actual death of infants; it points to other losses, and examples may be found throughout this period, as in any other. Blake not only brings the ideas of youth and death together but adds his own theme about the deadliness of artificial confinement and repression in poems such as the two Nurses' Songs and "The Garden of Love." The sheltered forest glade in which the children of Arnold's "Stanzas from the Grande Chartreuse" are reared is in actual fact "a close of graves" and the whole section an elegy to lost opportunities for action.[13] Gerard Manley Hopkins's speaker, in the context of a walk through a pleasant grove with a young child, speaks of how her grief will turn to a colder attitude and she will learn about "the blight man was born for."

But finding images of mortality or even of loss of innocence in a painting one has commissioned to display a son or daughter in a floral paradise of childhood—that seems more surprising somehow than finding such images in a poem and seems much for the benevolent patron to take. Yet the images are there. They are not blatant; the painter does not depict the child contemplating a grinning skull or dressed like Donne in its own shroud. The signs of these associations in paintings tend to be much less obvious than those in Marvell's poem, for example. In some pictures they may be absent—not every painter is as alert to these possibilities of subject as is Reynolds or Lawrence, any more than every poet is as alert to them as are Hopkins, Blake, Marvell, Thomas, and Arnold. But every portrait painter knows he or she fashions a memorial for the subject. If interest in either the painting or the sitter outlasts his or her death, the picture will live on as a memorial. With children's portraits there is an extra emphasis on mortality. The sitter will

surely die eventually, as will any portrait's subject. The sitter may die young, and the artist's consciousness of this possibility is to be glimpsed in all of the works treated here. But a further certainty is the death of the child *as child*: even if the sitter lives to a ripe age, there will be loss and transformation greater than that in a young adult's merely getting older.

The pictures discussed here are not grouped chronologically, but so as to show certain other progressions in their arrangement. The sitters in each successive portrait increase in age: the first is about four years old and the last sixteen. There is a progressive increase in the amount of black in the costumes. In none of these cases does this color have to do with dress intended to indicate mourning—that is, literal mourning for a member of the sitter's family, for the black does indicate figurative mourning. The costumes are important because of their very simplicity. Very young children during this period were often dressed—boys and girls alike—in a sashed white shift or chemise. A blue or pink sash was used for either girls or boys. Though the painters have little to do with it the dress convention supports the point that the children are seen as not far from immortality, in one direction or the other; they are as sexless and undifferentiated as angels and dressed appropriately in white. When the children are slightly older they will be costumed as little adults, but in the meantime small accessories of dress such as caps and mantles and ribbons assume more importance because of the conventional sameness. A third characteristic is the background of the pictures: an increasing particularity of landscape, a more representational or identifiable natural scene in its individual trees and shrubs, is evident as we proceed through this sequence of pictures. The significance of background is complex. In emblematic terms the landscape equals the sitter's time of life: the garden is childhood. But it is also a literal background with a possibility for its own narrative and philosophic content. And formally, it enters into various color and composition relationships with the foreground subject.

Gainsborough's *Master John Heathcote* was painted about 1771, in the latter part of the artist's time of residence at Bath. It depicts a child (1767–1838) about four years old. The landscape is totally imagined, but Gainsborough has tried to place the child in it rather

than using the trees, shrubs, and hillside simply as backdrop. In the picture (now in the National Gallery of Art, Washington) the child has some nondescript flowers in one hand and a large feathery black hat in the other. Gainsborough's picture is a null or base point for this little survey; his Heathcote is innocent and sweet but his garden is neither real nor bounded, and the black hat, though incongruous enough to draw some attention to itself (is it possible to imagine this boy *wearing* that hat?), is not an obtrusive part of the picture. But it is curious once noticed. A similar black hat, but with large white plumes, is held by Jonathan Buttall, also in the right hand, in Gainsborough's *Blue Boy*, but in that picture the hat completes a Van Dyck costume. In this picture it does not make literal sense, but figuratively points to adulthood and to death.

Lawrence's *Miss Murray* is a step further along in recognition of the serious possibilities of the subject. Louisa Georgiana Murray, who was four when the picture was exhibited at the Royal Academy in 1826, is depicted not as handmaiden or rival of Flora as little T. C. is in Marvell's poem, but as Flora herself, dressed in pure white complemented by a plum or raspberry ribbon and sash. It is a charming picture but is not without its ominous details: though it has purple streamers, Louisa's bonnet is black and she wears it instead of merely carrying it. Her black-bonneted head is at the darkest center of the picture's dark woody background, painted by an artist renowned for the sparkle and brightness of his pictures, which often sport bright red or bright blue backgrounds.

Miss Murray's garden is a bounded one; she is walled either into or out of it by the crenelated stonework behind her, which may be battlements of a building or the garden wall. It is hard to tell whether we are looking down at the garden or out at it—a confusion caused by the obscurity of the background rather than the lack of particularity, for the background is more particular than that of the Gainsborough painting, despite its obscurity. But beyond the light which the child seems to generate herself, the darkness is enveloping. The sense of enclosure and the darkness contracting around the child are the most ominous features of the picture.

As Flora, the girl extends her frock apron to form a precarious basket for her pansies. Some of the fresh blossoms have not kept favor with Flora and are discarded at the lower left; as in Marvell's

lines the child becomes identified at once with Flora and with her flowers, which may bloom and be gathered, fall by the wayside, or be nipped in the bud.

Lady Caroline Howard was seven when she was painted by Sir Joshua Reynolds in 1778. She sits on her heels in a landscape still partly ideal but containing some very particular roses which she might be instructing (in Marvell's words) "What color best becomes them, and what smell." The roses are not growing wild, nor are they, strictly speaking, growing in this garden at all: they are confined in a funereal urn and Lady Caroline is reaching for a bud, though a fully opened blossom is plainly visible near her hand. She wears the conventional child's frock sashed, as Heathcote's is, in blue. Lady Caroline is a little older than Heathcote and wears a fancy bonnet but also a black shawl or jacket, which might suggest mourning except for the lack of accompanying black ribbons in the bonnet and corroborating historical details in her family's history. The child is depicted as serious, though not sad—the lack of smiles means nothing in any of these pictures, since there was no convention of smiling portraits. In this picture it is the child's black shawl and the picking of the rosebuds which sound the ominous notes.

In Frederic Leighton's *May Sartoris* (1860) the black has taken over almost the whole costume and the child is an adolescent of sixteen, but she still looks very much the child dressed in a grown-up's clothes. The main relief from the black of her costume is provided by her blood-red scarf; it is hard to avoid the suggestions of the child's imminent rush into maturity, of loss of innocence, of menstrual and hymeneal blood. The landscape too is interesting. It is the most carefully realized landscape of the group of pictures we have looked at, with a beautifully painted cut oak in the foreground behind Miss Sartoris and a cottage, hayfield, and windmill in the background. Though the landscape is meticulously representational, its colors and composition function admirably as pure foil for the girl's figure. The balanced diagonals and muted neutral colors are as effective a designed backdrop as any of Gainsborough's outright constructs of landscape. But the composition and color contrasts merely heighten the main contrast between the young girl and the autumn landscape, spring and fall. Here the subject is not spring as Flora but spring as mourning Margaret, grieving at the

death of the year, fallen leaves, the felled oak. There is no explicit speaker here to tell her what sights she will come to colder or that it is May Sartoris she mourns for. But these thoughts are implicit in our role as spectators. (See illustration on p. 39.)

Outside Eden: Children Excluded from Gardens

An opposite juxtaposition of images, in pictures and poems depicting poor children *excluded* from gardens, becomes increasingly important at the end of the eighteenth century and through the reform movements of the nineteenth century. This exclusion theme reflects a growing social consciousness and conscience. It begins with sentimentality and condescension in Gainsborough's pictures of rural poor children in the 1780s—cottage girls and beggar boys in their rags. George Crabbe had already identified some of the problems of the rural poor in *The Village* (1783), though he did not single out the child as victim of enclosure and urbanization. John Barrell, in *The Dark Side of the Landscape: The Rural Poor in English Painting 1730–1840*, says that Crabbe and Gainsborough tend to show us the poor as a given aspect of nature, subject to sympathy but not to change:

> Both depict the poor as degraded, as indeed they had become by the process of transforming a paternalist into a capitalist economy; but the sympathy of both men presents itself as a sort of moral compensation for the effects of that process. They become more expansively benevolent in proportion as they represent the poor as more repressed, and congratulate the very classes that were responsible for the repression of the poor for the humane concern they feel at the results of their own actions.[14]

Barrell believes that landscape painting and poetry from 1730 to 1840 consist of "a process of continually substituting one version of Pastoral for another." He is especially hard on Constable, and one of his examples is a picture that illustrates the exclusion theme: *Dedham Vale* (1828, National Gallery of Scotland, Edinburgh) shows a gypsy mother nursing a baby in the foreground. We ought to see her plight as pathetic and feel sympathy for her, but instead, writes Barrell, "we hardly notice her—we look through her with less

concern than we do through the figures in Claude's landscapes."[15] But Constable's Olympian neglect of the human figures in favor of his landscape is not typical. There is progress in social awareness reflected in art forms and possibly affected by them as well—works which involve the spectator, stir emotion, and perhaps even inspire guilt. Blake's outrage at social evils is evident before the turn of the century in *Songs of Innocence and of Experience* (1794). "The Garden of Love," in addition to its tale of repression, also reflects the evils of enclosure: the speaker, where he once played on the common green, now finds an enclosed garden and restrictions. Likewise, the "Holy Thursday" and "Chimney Sweeper" pairs, as well as "London," carry a clear message about poverty, the new displaced poor in the cities, and the abuse of children. By the time of Victoria's accession, English art, especially visual art, begins to produce memorable images of social conditions that were displacing and destroying children. In *Recreating the Past: British History and the Victorian Painter*, Roy Strong writes that although the Victorians had an obsession with the theme of violated childhood, they did not wish to see children actually hurt or in pain.[16] Moreover, there was pressure from picture buyers for beautiful scenes rather than ugly ones. One solution was to paint beautiful landscapes and then show the children as somehow shut out from them. One example is Millais's *The Blind Girl* (1856). Ruskin describes *The Blind Girl* in one of his later essays, "The Three Colours of Pre-Raphaelitism":

> The common is a fairly spacious bit of ragged pasture, with a couple of donkeys feeding on it, and a cow or two, and at the side of the public road passing over it, the blind girl has sat down to rest awhile. She is a simple beggar, not a poetical or vicious one;—being peripatetic with musical instrument, she will, I suppose, come under the general term of tramp; a girl of eighteen or twenty, extremely plain-featured, but healthy, and just now resting, as any one of us would rest, not because she is much tired, but because the sun has but this moment come out after a shower, and the smell of the grass is pleasant.
>
> The shower has been heavy, and is so still in the distance, where an intensely bright double rainbow is relieved against the departing thunder-cloud. The freshly wet grass is radiant through and through with the new sunshine; full noon at its purest, the very donkeys

The Blind Girl (1856), by Sir John Everett Millais.
Reproduced by permission of the Birmingham Museum and Art Gallery.

bathed in the raindew, and prismatic with it under their rough breasts as they graze; the weeds at the girl's side as bright as a Byzantine enamel, and inlaid with blue veronica; her upturned face all aglow with the light that seeks its way through her wet eyelashes (wet only with the rain). Very quiet she is—so quiet that a radiant butterfly has settled on her shoulder, and basks there in the warm sun. Against her knee, on which her poor instrument of musical beggary rests (harmonium), leans another child, half her age—her guide—indifferent, this one, either to sun or rain, only a little tired of waiting.[17]

The myriad of visible natural features in the picture creates pathos: here are these beautiful sights, and the blind girl is unable to see them. The rich variety of sight features in this picture has its iconographic source in the Allegory of Sight pictures of the Renaissance, such as those of Jan Brueghel (1568–1625).[18] Allegories of the Senses are usually garden scenes containing a sensory *plenum*, a fullness of stimuli created by the landscape, animals, birds, and plants, and by their various colors, stripes, spots, and dapples. In a collaboration

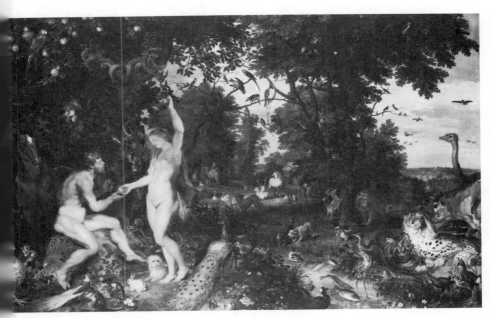

Paradise (c. 1620), by Peter Paul Rubens and Jan Brueghel.
Courtesy of the Mauritshuis, The Hague.

between Jan Brueghel and Rubens, the Allegory of Sight subject is combined with a temptation scene, and the result, *Paradise* (c. 1620), emphasizes loss and exclusion in ways similar to Millais's picture. Brueghel's meticulously painted animals, trees, flowers, and birds convey fully and colorfully what is at stake as Rubens's Eve hands one apple to Adam and plucks another for herself. Eden is already lost; the many-colored striped and spotted creatures, the trees with "fruit burnisht with Golden Rind" and the bright birds in them have already been forfeited, and this scene forecasts the expulsion, when Adam and Eve will be shut out from the garden's *plenum* of delight. Millais's subject is also shut out from a garden, unable to enjoy the scene both because of her poverty and her blindness. The garden is not Eden but an English landscape, painted partly at Icklesham near Winchelsea and finished near Perth. But the blind girl's exclusion from the garden landscape, guiltless as she is, is no less pathetic. Exclusion pictures are reversals of expulsion scenes in some ways. Unlike Adam and Eve (but like Cain and Abel), the children have never been in the garden. Where Adam and Eve are guilty individuals who bear the guilt for all of society's ills, the children are guiltless individuals and all of society bears the guilt for their exclusion. Here the blind girl's poverty and her blindness both offer potential reproaches to society. Her itinerant status means she has not been provided for in a particular village or parish and hints at the displacement of so many in the move to the industrial cities. We do not know the cause of her blindness, but a common enough cause of congenital blindness was venereal disease in the parents, to which repressive social measures and prostitution contributed, and to which Blake had alluded in "London":

> But most thro' midnight streets I hear
> How the youthful Harlots curse
> Blasts the new-born Infants tear
> And blights with plagues the Marriage hearse.
>
> [Lines 13–16]

Even the rainbow, a traditional sign of hope, can only increase the irony and pathos of the blind girl's situation; she may feel the sun's return, as Milton talks in book 3 of *Paradise Lost* of feeling its "sovran

vital Lamp," but for her as for him, the sun "Revisit'st not these eyes."

John Brett's *The Stonebreaker* (1858) is also a strikingly beautiful picture, so much so that we tend to ignore its force in the immediate beauty of the background. Allen Staley writes of this picture that "the landscape . . . is so lovely that it requires an act of intellect for us to think of the picture as an image of exploitation rather than of idyllic rural life."[19] The location in which the young boy who is the subject of the picture works is a ridge across a valley from Box Hill, a scenic area in Surrey where the outing takes place in Jane Austen's *Emma*. The place is celebrated also by Keats and other poets.[20] Behind the boy's head a railway embankment is just visible, the South Eastern line, opened in 1849, and presumably the line for which the boy labors and can expect to labor until he is too old or too crippled to work. (See illustration on p. 20.) Marcia Pointon has discussed how *The Stonebreaker* manages to suggest the length of the boy's life and further extremes of time:

> Stonebreaking was an occupation for the very young or for those in extreme old age. The existence of this youthful stonebreaker implies, therefore, a whole lifespan. His youthfulness raises for us a mirror image of old age. We recall Landseer's picture of 1831 in which a young girl brings lunch to her stonebreaker grandfather and Courbet's *Stonebreakers* (1851) in which an elderly man and a very young boy work side by side. Henry Wallis's *Stonebreaker* (1857) is a Carlylian figure who has actually died with his hammer in his hand. The rosy-cheeked health of our stonebreaker simply serves to reinforce the inevitable sense of man's life-span which is so very brief in comparison to the only recently understood geological time-span, evidence of which is seen in the "stony forms of the dead existing millions," lying behind and before his solitary figure.[21]

Like the blind girl, the stonebreaker too is shut out from a garden landscape recalling an original garden with guiltless inhabitants. David Cordingly recently discovered sketches and studies for *The Stonebreaker* in a private English collection. On one of these sketches, dated August 7, 1857, Brett has written two comments. One of them is "The wilderness of this world." The other is "Outside Eden."[22]

The exclusion theme becomes a serviceable metaphor for ex-

pressing outrage at social evils. While enclosure, industrialization, and mechanization create more luxury, the guiltless and especially the young are exploited and thrust out of this new paradise. Some mid-century artists such as Millais and Brett manage to convey these ugly truths without sacrificing beauty of landscape or audience appeal in the process. We are drawn into the natural beauty of the scenes and allowed to enjoy them almost before we discover the pictures' subjects and perceive that they are barred from the same pleasure we take in these gardenlike landscapes.

Signs in Nature

We are accustomed to thinking of some natural phenomena as unequivocal signs when they appear in art: the storm reflects moral strife and inner turmoil in *The Tempest* and *King Lear*; spring signals rebirth in countless works. But there are too many possible symbolic referents for most natural events. Even where a specific biblical text glosses a natural feature such as the rainbow, the pressure of daily, topical occurrence erodes any sacramental meaning. There is too much water in our lives for it always to seem baptismal. The stars can be malignant or benign, the moon constant or inconstant— representing chastity or lunacy or man's conquest of nature. Both the sun and the rainbow are signs of many faces in English iconographic history, but they are both also capable of great power in engaging us in the natural scene being depicted, forcing our participation or assent.

The Suns of Milton, Thomson, and Turner

Ronald Paulson, investigating aesthetic, political, and philosophical associations of the sun in an article on Turner, found a long list: life, God himself or spiritual insight (this association deriving from Milton), truth (Plato), and various political significations such as the Sun King and the sun of man's reason (a true light for Paine, a false one for Burke).[23] In fact the sun links poetry and painting not because of an unequivocal meaning as sign, but because it is what E. H. Gombrich calls a "metaphor of value," consistently associated with sublimity in the practice of certain poets and artists and be-

coming for them almost a signature.[24] A literary tradition emphasizing the sublimity of light and the sun stretches back at least as far as the first century A.D. to Longinus, whose treatise on sublimity uses as an example of greatness of conception and simplicity the Genesis verse "Let there be light."[25] Gombrich points out that light and divinity are almost universally linked in religious art. A more specific locus describing the sun and light as the most sublime displays of the material world is the work ascribed to Dionysius the Areopagite, or the Pseudo-Dionysius.[26] These Neoplatonic treatises, very influential in medieval philosophy and aesthetics, argue that the sun and light carry the mind anagogically from the material to the immaterial world. The actual provenance of these treatises is less important than the use to which they were put by men such as Thomas Aquinas and Abbot Suger of Saint-Denis. The latter argued, both in his written words and in his practice in furnishing the Abbey Saint-Denis, that art which reproduced the effects of the sun had a profound religious function, leading the mind upward to the spiritual light of truth and ultimately to God.

In England among the artists who most powerfully used the sun's metaphoric and literal potential were John Milton, James Thomson, and J. M. W. Turner. A clear sequence of influence connects the three, and in the work of each the sun can be seen as a device to draw observers in and involve them, evoking feeling and directing interpretation.

The greatest English poet of the sun and light is Milton. But Milton takes light and all its associations for a personal device, using it to point not only to paradoxes of blindness and sight/insight, but to keep the poet's own tragedy ever in the same frame with his hero's. Samson, "Eyeless in Gaza at the mill with slaves," describes his fate in lines whose internal rhymes play upon *light/might/night/sight*:

> O loss of sight, of thee I most complain!
> Blind among enemies, O worse than chains,
> Dungeon, or beggary, or decrepit age!
> Light the prime work of God to me is extinct,
> And all her various objects of delight
> Annull'd, which might in part my grief have eas'd,
> Inferior to the vilest now become

Of man or worm; the vilest here excel me,
They creep, yet see; I dark in light expos'd
To daily fraud, contempt, abuse and wrong,
Within doors, or without, still as a fool,
In power of others, never in my own;
Scarce half I seem to live, dead more than half.
O dark, dark, dark, amid the blaze of noon,
Irrecoverably dark, total Eclipse
Without all hope of day!
O first created Beam, and thou great Word,
"Let there be light, and light was over all";
Why am I thus bereav'd thy prime decree?
The Sun to me is dark
And silent as the Moon,
When she deserts the night,
Hid in her vacant interlunar cave.
Since light so necessary is to life,
And almost life itself, if it be true
That light is in the Soul,
She all in every part; why was the sight
To such a tender ball as th' eye confin'd?
So obvious and so easy to be quench't,
And not as feeling through all parts diffus'd,
That she might look at will through every pore?
Then had I not been thus exil'd from light;
As in the land of darkness yet in light,
To live a life half dead, a living death,
And buried; but O yet more miserable!

[*Samson Agonistes*, lines 67–101]

The word *sight* occurs twice in the passage; *light*, eight times. For Milton, the sun was more than the source of light. It was a natural metaphor for God:

How oft amidst
Thick clouds and dark doth Heav'n's all-ruling Sire
Choose to reside, his Glory unobscur'd,
And with the Majesty of darkness round
Covers his Throne

[*Paradise Lost*, 2.263–67]

In some passages the sun is more than metaphor; it is a sacred object and identified directly with God, as in the apostrophe to the sun at the beginning of book 3 of *Paradise Lost*:

> Hail holy Light, offspring of Heav'n first-born,
> Or of th' Eternal Coeternal beam
> May I express thee unblam'd? since God is Light,
> And never but in unapproached Light
> Dwelt from Eternity, dwelt then in thee,
> Bright effluence of bright essence increate.

The sun for Milton can be an ironic reminder of blindness, a metaphor for God, God himself, and the inspiration for poetry as both internal illumination in the mind of the poet and also that which illumines all of creation.

All these associations, except for that concerning blindness, are there in Milton's eighteenth-century imitator James Thomson, whose subject in his long blank-verse poem *The Seasons* (1730) is the natural world, but a world in which nature's wonders "exalt the soul . . . to heavenly musing" (*Winter*, lines 4–5). Thomson directly imitated the two passages from *Paradise Lost* above; the one from book 2 becomes in Thomson:

> The clouds commixed
> With stars swift-gliding, sweep along the sky.
> All Nature reels: till Nature's King, who oft
> Amid tempestuous darkness dwells alone,
> And on the wings of the careering wind
> Walks dreadfully serene, commands a calm.
> [*Winter*, lines 195–200]

Milton is not the sole source of the lines; the metaphor of God's walking on the wings of the wind comes from Psalm 104 and was a popular eighteenth-century illustration of the sublimity of scripture.[27] Thomson changes Milton's invocation to light in book 3 also, treating light and the sun rather more scientifically and beginning with the somewhat surprising assertion of light's material nature:

> Prime cheerer, Light!
> Of all material beings first and best!
> Efflux divine! Nature's resplendent robe,
> Without whose vesting beauty all were wrapt
> In unessential gloom; and thou, O Sun!
> Soul of surrounding worlds! in whom best seen
> Shines out thy Maker! may I sing of thee?
>
> [Summer, lines 90–96]

Not only prior to the rest of creation, light is also a prior condition for our appreciation of it, and "prime cheerer" for poets, artists, and all who could not see the beauty of creation without light. Thomson sees light itself as a sublime object. The sun, as the source of light, is the best indicator of its infinite maker, because of its magnitude and brightness; its very thought recalls the inadequacy of humans and the line continues with the humility of Thomson's petition, echoing Milton's, "may I sing of thee?" Light is the first and best "Of all material beings." Newton, after vacillating between a wave theory and a corpuscular theory on the propagation of light, had endorsed the corpuscular, and hence material, view in the *Opticks* (1704). Thomson follows Newton here, as elsewhere. Marjorie Hope Nicolson has recorded, in *Newton Demands the Muse*, how poets throughout the eighteenth century versified the revelations about light and color contained in Newton's *Opticks*. James Thomson was the most avid celebrator of Newton. Thomson's subject matter was the natural phenomena and atmospheric effects during the passage of the year, and he was interested not only in the accuracy which Newton's theories lent his versifying; he was transported by all the sublime occurrences of nature—those scenes and happenings which gave evidence of nature's vast power, size, or magnificence. This natural sublime, or "aesthetics of the infinite" as it has been called by Nicolson, had its touchstones catalogued by writers and critics early in the eighteenth century. Joseph Addison described in the *Spectator* the kinds of natural scenes calculated to produce sublimity. The critic John Dennis included among such scenes mountains, tempests, the ocean in turmoil, and heavenly bodies such as the sun.[28]

Thomson's interest goes beyond the sun's rays to fascination with the colors of the spectrum and their explanation in the *Opticks*;

light itself becomes a source of beauty as well as of illumination. The characteristics of light are sources of the sublime: light is awe-inspiring, boundless, coeternal with the Creator, and generative of all life forms as well as (Thomson suggests) mineral wealth.[29] Numerous passages celebrate the sun's rising, emerging from mist or from cloud, shining in midday "refulgent" or "effulgent" splendor, and setting.

Like Milton and Thomson, Joseph Mallord William Turner saw the sun as the source of all the beauty of the world; his "great insight," in Ronald Paulson's words, was that "landscape painting was about the sun."[30] In the first two decades of the nineteenth century, Turner painted many landscapes which included the sun. The results were pictures such as the *Sun Rising through Vapour* (1807) and *Dido Building Carthage: the Rise of the Carthaginian Empire* (1815). The debt to Continental painters such as Cuyp and especially Claude Lorrain is evident in these pictures; Turner acknowledged it by bequeathing the *Dido* to the nation on condition that it hang next to Claude's *The Embarkation of the Queen of Sheba*. In the third and fourth decades of the century Turner's sun landscapes show no trace of his early formulaic and imitative method. Those pictures for which he is best known date from this period: the scenes at Petworth and Norham, the sunrises and sunsets of luminescent whites, reds, yellows, and blues. If there is pictorial indebtedness or influence in these paintings, it is subsumed in the handling of light and color of whose originality Kenneth Clark says, "there is nothing else remotely like it in European art."[31]

Between these periods, in the 1820s, Turner is developing an art of engagement which will use the sun as the singular magnet of the observer's attention. This is the period immediately after his first visit to Italy and leading into the second. Late in the decade Turner began to visit regularly at Petworth Park, whose beauty, according to Clark, "freed Turner's colour sense from its last restraints."[32] The period is one during which Turner begins painting pictures with an exclusive or near-exclusive concentration on the sun: *Mortlake Terrace* (1827), the Petworth Park sunsets of 1828–29, *Regulus* (1828, reworked 1837), and *Ulysses Deriding Polyphemus* (1829). *Mortlake Terrace* and *Regulus*, particularly in their treatment of the sun, not only represent a move beyond the earlier reliance on the formulas of painters such as Claude; they owe as much to Turner's reading of English

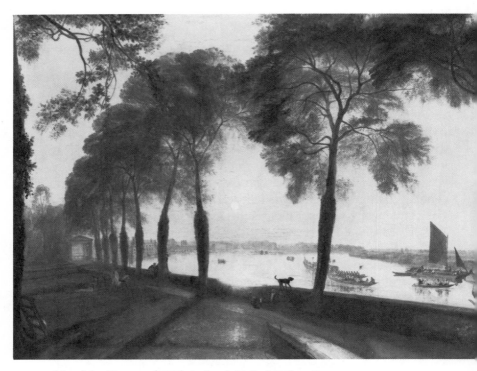

Mortlake Terrace (1827), by Joseph Mallord William Turner.
Courtesy of the National Gallery of Art, Washington, Andrew W. Mellon Collection.

poets as they do to his gradual discovery of his own pictorial language of light and color. Turner aimed at sublimity, in the sense that word was understood by eighteenth- and nineteenth-century men of arts and letters; he was much influenced by the work of Milton and James Thomson, English poets whose aim was also the sublimity he himself sought; both poets extolled, among other natural scenes and objects calculated to produce the sublime, the sun and its attendant effects of light. These were major themes with Thomson, whose influence on Turner can be demonstrated and whose striving for scientific accuracy in the descriptive treatment of light and refraction affects Turner's style as well as his choice of subject.

Ann Livermore, Jack Lindsay, and Jerrold Ziff have written about Turner's debt to Milton and Thomson.[33] Quotations from Thomson

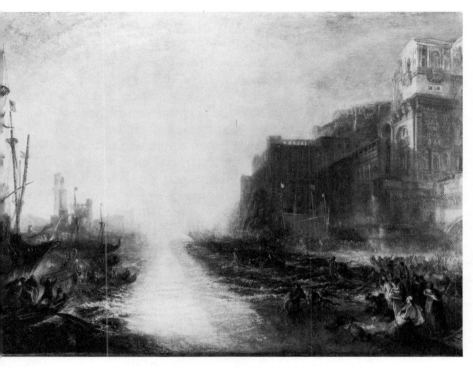

Regulus (1828, reworked 1837), by Joseph Mallord William Turner.
Courtesy of the Tate Gallery, London.

and, less often, from Milton accompany Turner's exhibited pictures starting before the turn of the century. These quotations vary in length but almost always concern the sun, as in the single line which accompanies Frosty Morning (1813), "The rigid hoar frost melts before his beam," and the five lines which Turner conflates from a seventeen-line passage in Spring (lines 189–205), to accompany his picture of Buttermere Lake with a Rainbow (1798):

Till in the western sky the downward sun
Looks out effulgent—the rapid radiance instantaneous strikes
Th' illumin'd mountains—in a yellow mist
Bestriding earth—The grand ethereal bow
Shoots up immense, and every hue unfolds.

Turner frequently quotes Thomson in his notebook when comparing poetry and painting, and he devotes considerable space in one of his Royal Academy lectures (he was professor of perspective) to an analysis of lines from Milton and Thomson.

Turner interprets specific lines from Thomson's poetry in the *Cottage Destroyed by an Avalanche* (1810), which refers to a passage in *Winter* (lines 414–23), and *Slavers Throwing Overboard the Dead and Dying* (1840), which is based on two passages in *Summer*. But not only *The Seasons* was tapped for material: Turner exhibited a picture in 1834 called *The Fountain of Indolence*, after Thomson's allegorical poem *The Castle of Indolence* (1748), and the comparison of modern and ancient Rome in Thomson's *Liberty* may have inspired the companion pictures of these subjects which Turner finished in 1838 and 1839. The most direct homage to the poet is undoubtedly Turner's attempt over many years to write a Thomson-like blank verse poem, *The Fallacies of Hope*, short, not very coherent passages of which Turner sometimes included in exhibition catalogues with his pictures. Turner also tried half a dozen drafts of a poem based on Thomson's *An Ode on Aeolus's Harp* in his versebook, and in 1809 he exhibited in his own gallery *Thomson's Aeolian Harp*, a pictorial combination of Thomson's ode with a memorial equivalent of William Collins's *Ode Occasion'd by the Death of Mr. Thomson*. The picture shows nymphs decorating Thomson's grave as in Collins's poem. The foreground scenery, pastoral and Poussinesque, includes a piping shepherd boy, while the background is a contemporary view of Richmond on the Thames, where Thomson lived and died.

With *Mortlake Terrace, the Seat of William Moffatt, Esq. Summer's Evening* (1827), we see a unique transition point in Turner's development, as his own conviction of the sun's power as subject takes dominance over those features of the composition which critics have seen as borrowed from Ruisdael, Claude, or Canaletto's Thames views.[34] Turner begins here a concentration on the sun as primary subject which will last for the remaining twenty-four years of his life. He did not have to paint this picture into the sun, as Graham Reynolds has pointed out. This is the second of two pictures painted for William Moffatt of his house on the Thames; the first picture (1826) shows the house itself in early morning light, but when Turner came to paint the scene in late afternoon, he turned around, leaving the

house completely out of the picture and concentrating on the sun.[35] Turner here goes beyond conventional ways of treating the scene derived from Claude. He had used such techniques before, but he had also criticized them, as he was critical of other painters' methods of handling the sun—for example, Poussin's.[36] The main feature of this rejection of convention is a faithfulness to the sun's actual appearance, what its refracted rays do to the parapet, the grass, the water, and the entire atmosphere. Turner certainly was familiar with Newton's exposition of light refraction in the *Opticks*, but he was far more familiar with Thomson's poetry, which described "the mountain's brow / Illumed with fluid gold" and how the sun lit up "the dew-bright earth and coloured air."[37]

Turner substitutes faithfulness to the facts of refraction for Claudian formulas as he shows us the sun's rays biting into the Thames parapet and suffusing the scene at Mortlake. The picture was recognized as deriving from Claude but at the same time surpassing what Claude could do: the French critic Théophile Thoré wrote that "everything seems to be luminous with its own light and to throw its own rays and sparks. Claude, the master of luminosity, has never done anything so prodigious!"[38]

Also making the picture notable is the dog on the parapet: it is a piece of paper touched with paint and varnished over, visibly standing out from the surface when the painting is examined at an angle. Two stories compete to explain the dog.[39] One, coming from Turner at third hand, is that Turner himself added the dog because he felt a dark accent there would increase the picture's tonal perspective. According to the other story, the animal painter Sir Edwin Landseer, thinking that the picture needed a focal point, cut the dog from paper and stuck it on the canvas one day after the Royal Academy annual exhibitions, while Turner was at lunch. Turner returned, looked at it, touched it with black paint and varnished it. Though the latter story is more romantic and has the more reliable source in Frederick Goodall, that Turner applied the paper himself may be more likely. He is known to have directly applied small cutout sketches and then painted over them in *Childe Harold's Pilgrimage* (1832) and *The Golden Bough* (1834).

Mortlake Terrace, though praised by Thoré, attracted much adverse criticism in London. It seems to be the picture with which the critics

began their twenty-year refrain that Turner had lost his powers—and thus it has another claim to be called a transition picture, ushering in those works now considered his greatest triumphs.

The impression of the sun's effects in *Mortlake Terrace* is one way of involving the observer in the picture; *Regulus* (1828, exhibited 1837) uses another strategy. In this picture, which has a superficial resemblance in composition to the *Dido Building Carthage* and the *Decline of the Carthaginian Empire* of 1815 and 1817, Turner puts the observer in the place of the picture's subject.

Regulus was a Roman general in the First Punic War. When he was captured by the Carthaginians, they sent him to Rome with instructions to arrange a peace and an exchange of prisoners. Regulus told the senate to refuse the Carthaginian terms, and then he bravely returned to Carthage. In punishment the Carthaginians, before killing him, cut off his eyelids and exposed him to the sun, thus blinding him. John Gage was the first modern critic to discuss how Turner in this picture has turned the observer into the subject; *we* are Regulus:

> The figure of Regulus himself has completely disappeared; Turner shows not the valour of the man, but the means of his terrible torture. . . . The effect of the sun in Turner's picture, advancing from the horizon like "the powerful king of day" he was, consuming the port of Carthage and lapping the water greedily with his rays, so that the foreground bathers cower and fly before him, makes the otherwise laconic and enigmatic title perfectly clear.[40]

This explanation of how the picture works has satisfied most Turner scholars, including his most recent cataloguers Martin Butlin and Evelyn Joll, but at least one writer, Andrew Wilton, is skeptical; he says that this reading of the picture "misinterprets the embarkation subject, and presupposes a use of quasi-cinematic techniques hardly congruent with early nineteenth-century attitudes to the way a picture works."[41] Wilton here reminds us that the embarkation of Regulus was a common subject in the period, but neither this nor the fact that a later engraving of Turner's picture was called *The Embarkation of Regulus* are really arguments against Gage's reading. Turner called the picture simply *Regulus*. Moreover, as I hope I have

been able to show, "early nineteenth-century attitudes to the way a picture works"—and eighteenth-century ones as well—included receptivity to the observer's involvement in the picture, because these artists trained and expanded their audience's attitudes about how pictures work. Even a contemporary critic of Turner's who was puzzled by not finding Regulus in the picture's foreground nevertheless acknowledged that the "sun absolutely dazzles the eyes," and another saw what Turner had done to the Claudean formula: "Turner is just the reverse of Claude; instead of the repose of beauty—the soft serenity and mellow light of an Italian scene—here all is glare, turbulence, and uneasiness."[42]

In Turner's later pictures faithfulness to the behavior of light is, finally, adherence to the truth of its appearance from one point of view at one time. In the last pictures the sun takes over the canvas in a celebration of sensationalism—of the senses' due triumph over what the mind may insist is present in terms of naturalistic detail. The empirical approach, in other words, leads inevitably to an impressionistic result. And the observer is drawn in to the core of light whose base surrounds him and whose apex is the sun.

Thomson and the other poets and writers on sublimity free Turner's innate sense that while avalanches, storms, and great fires may be one road to the sublime, so is the faithful recording of the most diurnal of events—the rising and setting of the sun. Then the visits to Petworth in the late 1820s and early 1830s, as Clark notes, free Turner's color sense. The resulting paintings, created over the last two decades of Turner's life, have been compared to things as diverse as Wagner's music and a schizophrenic's dreams, but they have inarguably changed our way of looking at atmospheric effects and our way of looking at art. Turner's achievement changed nineteenth-century artists' practice, certainly, since anyone after him could unblushingly concentrate on changing light for its own sake, or build up color from a white ground as a watercolorist does (both the Pre-Raphaelites and the Impressionists follow these hints). But more significantly he changed aesthetic response to the sun and to pictures which seek to draw their observers into them. As Ronald Paulson has written, "with the sun he takes on the greatest of all natural authority symbols, removes its veil, makes it his own artistic subject/signature."[43]

The Rainbow's Iconographic Spectrum

The rainbow is another natural image, like the sun, whose signification we would like to have clear and unequivocal. But even more than the sun, this natural sign has been preempted by intellectual and aesthetic history to adorn party flags and provide emblems for different artistic causes. The rainbow has been a sign of very different relationships between man and what surrounds him, from the controlling suggestions of Newtonian science to the humbling ones of sublime or sacramental nature. When George Landow investigated the Victorian background of rainbow iconography in 1977, he subtitled his article "A Problematic Image," and the adjective is no less true for earlier periods.[44] Sometimes the rainbow's significance depends on texts, and at other times it is purely a pictorial matter. But it is always an arresting image, which makes engagement easier, and though its beauty might seem sufficient in nature or in art, it also seems to cry out for interpretation—to present itself as a sign.

The use of the rainbow as natural sign begins with Genesis 9:11–17, where the rainbow is established as a seal or sign of a covenant that God will not destroy the world by water again as he had done in the great Deluge:

> And I will establish my covenant with you; neither shall all flesh be cut off any more by the waters of a flood; neither shall there any more be a flood to destroy the earth.
>
> And God said, This is the token of the covenant which I make between me and you, and every living creature that is with you, for perpetual generations.
>
> I do set my bow in the cloud, and it shall be for a token of a covenant between me and the earth.
>
> And it shall come to pass, when I bring a cloud over the earth, that the bow shall be seen in the cloud.
>
> And I will remember my covenant, which is between me and you and every living creature of all flesh; and the waters shall no more become a flood to destroy all flesh.
>
> And the bow shall be in the cloud; and I will look upon it, that I may remember the everlasting covenant between God and every living creature of all flesh that is upon the earth.
>
> And God said unto Noah, This is the token of the covenant, which I have established between me and all flesh that is upon the earth.

Thus the rainbow is a sign of hope because it comes at the end of a catastrophe with the promise that it will not be renewed. From the New Testament perspective, the rainbow is even more hopeful because it is a reminder that God's next judgment of man will be tempered by the fact of Christ's Redemption.

Landow says this context is already moribund by the Victorian period. He points out that if we (or Victorian spectators) encounter a landscape with a rainbow, we can appreciate it as landscape, but we are somewhat puzzled if we find the artist has entitled it *The Seal of the Covenent*. In order to use the biblical iconography successfully, Landow says the painter must provide a "second image" or symbolic key in the picture "to signal the way we are to take the rainbow." According to Landow, the painter can use a rainbow "merely as a visual motif"—that is, purely representationally without iconographic context, or he must take pains to make obvious that he is using the biblical context. He can also cynically deny that the rainbow is a symbol of hope—but this is still with reference to the traditional, biblical context.[45]

The problem with Landow's thesis is that the Genesis passage is only one of many literary and pictorial contexts which we may need in order to see what the rainbow is doing in a particular work. Like the sun, the rainbow can easily be adopted as a political symbol, and this had already occurred in early seventeenth-century England. Then again, the tremendous interest in the natural sublime by eighteenth- and nineteenth-century poets can be as important for interpreting representations of nature as the biblical context is. A scientific development is also important in understanding some rainbows in poetry or painting, namely, Newton's discoveries about light and color described in his *Opticks*, published in 1704. Some rainbow pictures may "mean" no more than homage to earlier painters, while others use the rainbow in a very private iconography that has little to do with the Genesis passage but yet is not purely representational either. And finally, the rainbow may be only part of a larger, nonscriptural iconographic scheme depending on pictorial sources, as is true with Millais's *The Blind Girl*.

The Rainbow portrait of Elizabeth I at Hatfield House is evidence of an early secularizing tendency in the iconography of the rainbow in England. In this anonymous portrait of around 1600, many allegorical and symbolic details adorn the queen's costume and head-

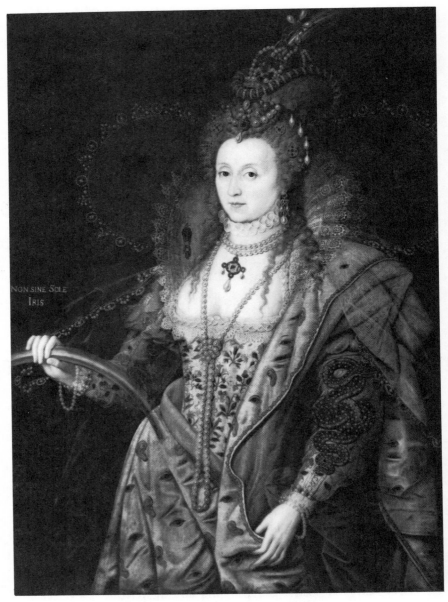

Elizabeth I, the "Rainbow Portrait" (c. 1600), by an unknown painter.
Courtesy of Hatfield House, Hatfield, Herts. Photo courtesy of the Courtauld Institute.

dress, but the most striking feature is the rainbow which Elizabeth holds in her right hand as it arcs from the side of the picture until it is lost in the bright orange of her dress. Frances Yates, who has the most complete and reasoned discussion of the picture, relates it to Catherine de Médicis's use of the rainbow as her device—signifying peace—and with the Ditchley portrait (National Portrait Gallery, London) with its background of storms on one side and the sun on the other: "The idea of sunshine after storms which the 'Ditchley' picture shows naturalistically by depicting the storm vanquished by the sun in the sky is the same as that expressed in emblematic form by the rainbow and its motto in the Hatfield portrait."[46] Both Yates and Roy Strong believe that the poems Sir John Davies addressed to Elizabeth in 1599, the *Hymns to Astraea*, are important in understanding this picture's imagery.[47] The hymns are acrostic poems in which the first letters of the lines of each stanza spell out ELISA BETHA REGINA, and they provide glosses for the imagery of not only this picture, but all of Elizabeth's portraits. Thus the spring flowers on the front of Elizabeth's dress in this portrait can be seen not only as personal compliments to the queen but as alluding to the "state's faire spring"; as Davies writes in the third hymn:

> E arth now is greene, and heaven is blew,
> L ively Spring which makes all new,
> I olly Spring doth enter,
> S weete young Sun-beames do subdue
> A ngry, aged Winter.
>
> B lasts are mild, and Seas are calme,
> E very medow flowes with Balme,
> T he earth weares all her riches,
> H armonious birdes sing such a Psalme
> A s eare and hart bewitches,
>
> R eserve (sweete Spring) this Nymph of ours
> E ternall garlands of thy flowers,
> G reene garlands never wasting;
> I n her shall last our *states* faire spring,
> N ow and for ever flourishing,
> A s long as heaven is lasting.

The "rainbow" portrait's motto—*Non sine sole iris*—no rainbow without the sun—offers a meaning for sun and rainbow unmediated by the biblical text in Genesis. The Latin name for the rainbow—*iris*—is a reminder of the rainbow's significance in classical mythology: Iris, the messenger of the gods, descended to earth by means of the rainbow. The fact that the Hatfield House portrait's rainbow ends at the queen herself is a reference to her as divinely appointed and in touch with heavenly counsel. She is the sun which accompanies the rainbow and ends the storm.

> R oyall *Astraea* makes our Day
> E ternall with her beames, nor may
> G rosse darkenesse overcome her;
> I now perceive why some do write,
> N o countrie hath so short a night,
> A s England hath in sommer.
>
> [Hymn 6]

Of course the appearances of the sun and rainbow both betoken hope as in the Genesis text, but this is an inevitable and indirect reference to the Old Testament context, diluted in a strongly political statement about the queen's power and ability to bring peace.

Aside from political contexts, the rainbow can be used as part of a personal system of images, as one artist's homage to another painter, or as an aesthetic metaphor for color in another artist's work. These uses of the rainbow occur in the works of Blake, James Ward, and James Gillray.

The Genesis gloss does not help much when the rainbow becomes incorporated into a private iconography and mythology such as that of William Blake. Foster Damon attempts to simplify Blake's practice in *A Blake Dictionary*: "The RAINBOW is commonly accepted as a symbol of hope, and so Blake uses it."[48] The rest of the *Dictionary* entry discusses rainbows mainly in *The Four Zoas*, *Milton*, and *Jerusalem*, but even in these works Blake's practice is more cryptic than Damon admits. David Wagenknecht calls the rainbow a "trebly ambiguous" image for Blake in *Milton*, because it refers simultaneously to the covenant after the Flood, repressed sexuality after the Fall, and Albion's Tomb.[49] Despite the ambiguities, it is clear that here are uses of the rainbow neither traditionally iconographic nor merely representational.

Rainbows in Blake's illustrations of texts other than his own are also diffcult to interpret. In the Dante illustrations, *Beatrice Addressing Dante from the Car* (1824–27) has a rainbow background which seems to be associated in some way with vanity, as are the peacock feathers, familiar in more traditional iconography. But why is there a rainbow at all in *The Death of the Virgin* (c. 1805)? And although the bright green of the rainbow in *The Four and Twenty Elders* (c. 1805) has a textual justification in Revelation 4:3, why are the colors upside down? It is possible Blake thought the colors actually occurred that way, from red upward to violet, since drawing from nature was not something he considered important. There is a very stylized version of this red-up-to-violet rainbow again in *Satan Smiting Job with Sore Boils* (c. 1826–27). The most likely explanation is that Blake is deliberately turning the colors over in an apocalyptic inversion of the rainbow. No literary or pictorial precedent will easily explain these uses of the rainbow.

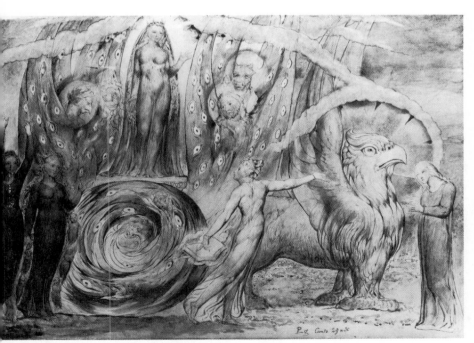

Beatrice Addressing Dante from the Car (1824–27), *by William Blake.*
Courtesy of the Tate Gallery, London.

Homage to an earlier painter may be a significant motive in rainbow paintings, as Landow observes, pointing to the Rubens *Landscape with a Rainbow* (c. 1635) as an influence on pictures by Paul Sandby and J. T. Linnell[50] A pre-Victorian painter influenced by the Rubens rainbow landscape is James Ward (1769–1859); his *Eildon Hills with the Tweed* (1807) is in the National Gallery of Scotland. We know that Ward imitated the Rubens *Chateau de Steen* in his *Fighting Bulls with a View of St. Donat's Castle* (1803, Victoria and Albert Museum), and he was also struck by the Rubens rainbow picture, which was in England after the turn of the century and which represents another part of the chateau's grounds.[51] A look at the Rubens rainbow picture will show how closely Ward has followed it: though the composition is reversed, a long diagonal (the river Tweed in Ward, the grain field in Rubens) leads to a middle-distance plateau in the center of the picture; foreground figures and the largest landscape masses occupy the side opposite the diagonal. With the Eildon picture we have the application of several earlier, successful for-

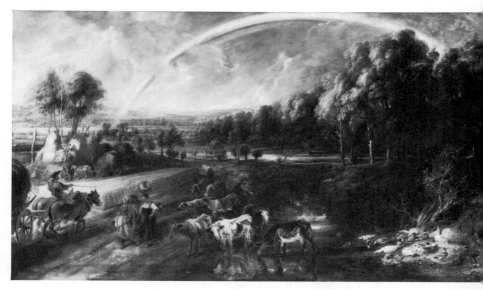

Landscape with a Rainbow (c. 1635), by *Peter Paul Rubens.*
Reproduced by permission of the Trustees of the Wallace Collection, London.

Eildon Hills with the Tweed (1807), *by James Ward.*
Courtesy of the National Galleries of Scotland, Edinburgh.

mulas (with the hope that some of the Rubens prestige will accompany them) to a local, recognizable scene.

Homage and satire and another apocalyptic vision, all using a rainbow, combine in a remarkable print by James Gillray, *Titianus Redivivus;—or—The Seven Wise Men Consulting the New Venetian Oracle* (1797). There Gillray ridicules seven Royal Academy artists taken in by a confidence woman. A key to the print is given in Wright and Evans's *Historical and Descriptive Account* of Gillray's prints, published together with his *Works* in 1851: "In the year 1797, a young female pretender to art, a Miss Provis, professed to have discovered the long-lost secret by which Titian and the other great artists of the Venetian school produced their gorgeous colouring, and, by dint of puffing and other tricks, she succeeded in gaining the faith of a large portion of the Royal Academy." The popular press, responsible for most of the puffing, is represented by the winged jackass (instead of Pegasus) drinking from Miss Provis's pot of paint. Names of newspapers and many "Puffs" are written on the wings of the jackass.

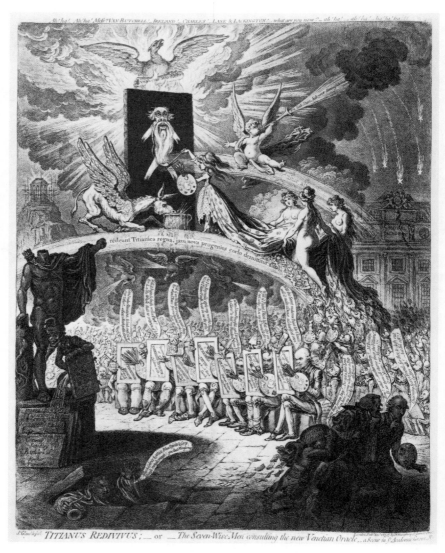

Titianus Redivivus;—or—The Seven Wise Men Consulting the New Venetian Oracle (1797), by James Gillray.

Reproduced from the collections of the Library of Congress, Washington.

Seven of the academicians are said more especially to have been her dupes, Farringdon, Opie, Westall, Hoppner, Stothard, Smirke, and Rigaud. Until her discovery was exploded, this lady sold it in great secret for a very high price. She would now probably have been entirely forgotten, but for the pencil of Gillray, who exposed her and her dupes to ridicule in this caricature. In the upper part of this bold picture the lady artist is dashing off a daring subject with extraordinary effect of light and shade, her long ragged train ending in the immense tail of a peacock. The three naked Graces behind her, in the original coloured copies of this caricature, are painted of the gayest hues. She is leading the crowd of academicians by the nose over the gaudy rainbow to her study to behold her specimen of Venetian art. On one side, the buildings erected for the Royal Academy at Somerset House are falling into ruin, while on the other the Temple of Fame is undergoing repair. Below, we are introduced into the interior of the academy, where the luckless seven occupy the foremost seats, deeply immersed in studying the merits of the new discovery.[52]

John Harvey has perceived that Gillray is alluding here to the apocalyptic triumph of the dunces at the end of Pope's *Dunciad*.[53] He compares "Fame's posterior trumpet," which summons the nations at the beginning of book 4 of the poem to the four winds, which are all "posterior trumpets," under the rainbow in Gillray. The scene is one of climactic chaos as the "Venetian Manuscript" rises Phoenixlike from its own flames, dispersing the clouds, and the stars (Michelangelo and Raphael among them) fall from the sky. In Pope the scene is described thus:

> She comes! she comes! the sable Throne behold
> Of *Night* Primaeval, and of *Chaos* old!
> Before her, *Fancy's* gilded clouds decay,
> And all its varying Rain-bows die away.
> *Wit* shoots in vain its momentary fires,
> The meteor drops, and in a flash expires.
> As one by one, at dread Medea's strain,
> The sick'ning stars fade off th' ethereal plain;
> As Argus' eyes by Hermes' wand opprest,
> Clos'd one by one to everlasting rest;
> Thus at her felt approach, and secret might,
> *Art* after *Art* goes out, and all is Night.

> [Lines 629–40]

Gillray's rainbow similarly becomes part of the apocalypse of art, but its signification includes the traditional one of hope, in this case delusive and aroused by a confidence scheme instead of a divine covenant. In addition, the rainbow functions as homage to the real achievement of Titian, whose reputation for coloring, Gillray implies, is secure against frauds.

The rainbow also figures in the intellectual history of these centuries by providing a feature for the eighteenth-century debate about the sublime and the beautiful and by becoming the object of combined scientific and aesthetic interest after the publication of Newton's description in the *Opticks* (1704) of the way colors were produced by refraction of white light. Despite Ruskin's remark that no one who knew optics could feel the same pleasure in a rainbow as an unlettered peasant,[54] and despite Keats's chagrin that "the touch of cold philosophy" had unwoven the rainbow, there were many eighteenth- and nineteenth-century poets and painters whose aesthetic pleasure in the contemplation of rainbows had been increased by Newton's *Opticks*. Marjorie Hope Nicolson's study of the effect of the *Opticks* on poetry does not stop with the eighteenth century but discusses Shelley, for example, and his intellectual pleasure and delight in the new beauty lent the rainbow by the explanation of its natural laws.[55] As noted earlier, among eighteenth-century celebrators of Newton, James Thomson, author of *The Seasons*, was the best known and most enthusiastic. Here Thomson apostrophizes Newton in a passage from *Spring*:

> Meantime, refracted from yon eastern cloud,
> Bestriding earth, the grand ethereal bow
> Shoots up immense; and every hue unfolds,
> In fair proportion running from the red
> To where the violet fades into the sky.
> Here, awful Newton, the dissolving clouds
> Form, fronting on the sun, thy showery prism;
> And to the sage-instructed eye unfold
> The various twine of light, by thee disclosed
> From the white mingling maze.
>
> [Lines 203–12]

Both Constable and Turner quote Thomson on the rainbow when exhibiting their pictures, but with different intents and effects.

Constable uses a quotation from *Summer* with his *Salisbury Cathedral from the Meadows*, exhibited in 1831:

> As from the face of Heaven the scatter'd clouds
> Tumultuous rove, th' interminable sky
> Sublimer swells, and o'er the world expands
> A purer azure, through the lightened air
> A brighter lustre and a clearer calm
> Diffusive tremble: while as if in sign

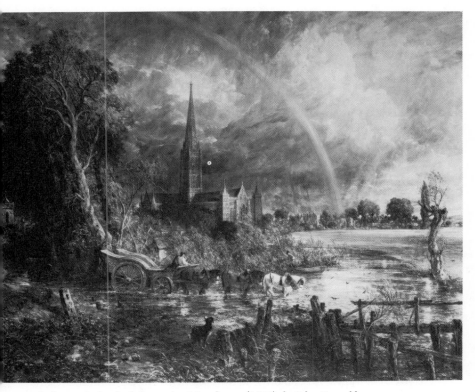

Salisbury Cathedral from the Meadows (1831), *by John Constable.*
Private Collection.

Of danger past, a glittering note of joy
Set off abundant by the yellow sky
Invests the fields and nature smiles revived.

[Lines 1223–32]

Constable's concerns with nature's smiles and note of joy show clearly enough his interest in the present scene's beauty rather than in the sublimity of the storm just past. We would never guess from these lines alone that lightning from the preceding storm had killed a young country girl. The passage's and the picture's emphasis is on serenity and beauty. What the picture also shows is how close and scientific a student of the rainbow Constable was. He made well over a dozen watercolor and oil sketches, studies, and finished works depicting the rainbow. For almost every subject which he studied from different angles and under differing atmospheric conditions—Hampstead Heath, Stonehenge, Salisbury Cathedral—there is a finished work which includes a rainbow. In *English Landscape Scenery*, a book of mezzotints of Constable's landscapes with the painter's own commentary, he summarized the results of his careful investigation of rainbows: for example, he notes that the noon rainbow reveals only a small part of the circle and therefore is best seen in winter when the sun is lower, that a rainbow cannot be shown foreshortened or obliquely but must parallel the picture plane, and that when multiple rainbows are visible, the order of colors alternates—a simple observation but one that can be forgotten by even the most careful of painters, such as Turner or Millais.[56] "Painting is a science," wrote Constable in his last lecture at the Royal Institution in Albemarle Street, "and should be pursued as an enquiry into the laws of nature. Why then, may not landscape painting be considered as a branch of natural philosophy, of which pictures are but the experiments?"[57]

Turner's rainbow landscapes, starting with *Buttermere Lake* (1798), including a waterfall scene on the Rhine at Schaffhausen (1806), and ending with a reworked early picture called *The Wreck Buoy*, exhibited in 1849, all are more clearly in the sublime mode than are Constable's milder scenes. The rainbow is more closely associated with storms, mountains, and the ocean in an angry mood. Turner's effects connect with those of Thomson and other poets whose descriptions of natural phenomena of great size or power were seen as

expanding the mind's conception by association—Nicolson's "aesthetics of the infinite." A psychological phenomenon associated with this idea of a "natural sublime" is the "religious sublime"—the conviction that looking at (or hearing about) vast prospects and scenes of great power will bring to mind the omnipotence of God. Descriptions of this religious sublime may be found in various theological writers of the seventeenth to the nineteenth century, such as Thomas Burnet, John Ray, William Wollaston, William Derham, and William Paley.[58] We know from the testimony of contemporary critics that Thomson's poetry was seen as reproducing these effects of the natural and religious sublime and we know from testimony in Turner's time that pictures were so seen: "Painting leads the mind to contemplation of the infinite and varied beauties of creation, and directs the thoughts of Nature up to Nature's God."[59] It should be emphasized that the rainbow, treated as an aspect of the natural sublime, can have a religious meaning and a divine reference, but its iconography works differently from any allusion to the covenant after the Deluge. Aspects of the natural sublime—oceans, mountains, storms or their accompanying atmospheric effects such as the rainbow—point to God not by alluding to a specific biblical text but by reminding observers, by their impressive scope, power, or beauty, of the omnipotence and boundless goodness of a creator. For Turner the divine reference never seems to have been important: nature was her own divinity. But he definitely wished to show nature's power and vastness. If he could not show the rainbow and its preceding storm together, he could at least juxtapose the rainbow with astounding mountain scenery or show the sea still in turmoil as in The Wreck Buoy.

Turner's scientific interest in the rainbow can be seen in a picture not immediately recognizable as a rainbow at all: the 1843 Light and Colour (Goethe's Theory)—the Morning after the Deluge—Moses Writing the Book of Genesis. Turner alludes to the Old Testament covenant but has other uses for the rainbow. These verses, from Turner's own blank verse poem (which imitates Thomson's style) The Fallacies of Hope, accompanied the picture's exhibition:

> The ark stood firm on Ararat; th' returning sun
> Exhaled earth's humid bubbles, and emulous of light,
> Reflected her lost forms, each in prismatic guise

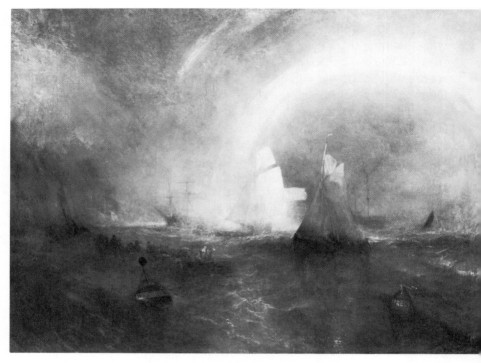

The Wreck Buoy (1849), *by Joseph Mallord William Turner.*
Courtesy of the Walker Art Gallery, Liverpool.

> Hope's harbinger, ephemeral as the summer fly
> Which rises, flits, expands, and dies.

As Martin Butlin and Evelyn Joll comment, Turner "transformed the rainbow of the Covenant into scientifically-induced prismatic bubbles."[60] In fact modern critics are in general agreement that this picture and its companion, *Shade and Darkness—The Evening of the Deluge,* constitute a reaffirmation of Newton's theories about light and color.[61] Turner here refutes Goethe, whose color theory had attacked Newton. Goethe argued that color was produced by *light and dark;* Turner demonstrates the truth of Newton's description of each bubble of water in the air becoming a prism to refract a beam of light into the whole spectrum of color.

A last example of how the rainbow can work in a picture is furnished by Millais's *The Blind Girl* (1856), which we examined briefly

earlier in this chapter. Landow is convinced that this picture exemplifies his dictum that an artist could signal his intention to use the religious significance of the rainbow—that is, the Genesis covenant of hope—by inserting another symbolic element in the picture. In *The Blind Girl*, writes Landow, that other element is the "traditional emblem of the soul," the butterfly:

> The young girl sits with her back to the rainbow, oblivious to the beauties that have captivated the artist, while the younger child, her companion and guide, looks back at the glorious sight behind

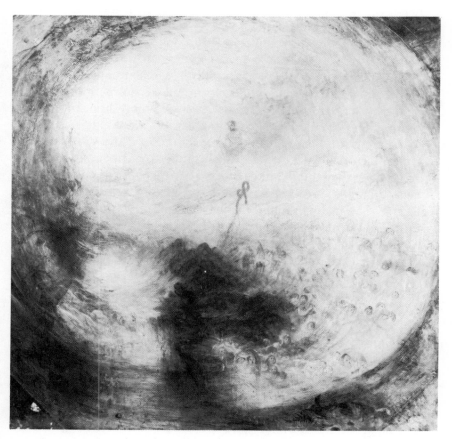

Light and Colour (Goethe's Theory)—the Morning after the Deluge—Moses Writing the Book of Genesis (1843), *by Joseph Mallord William Turner.*
Courtesy of the Tate Gallery, London.

them. Millais thus asserts that in the world to come Christ will raise the child with new and better vision. Again, it is only the presence of the second image of the butterfly that can persuade us that the painter intends us to read the rainbow as a sign of Christian dispensation.[62]

But this does not describe Millais's intention or our perception of this picture. What we react to is the irony and pathos of the situation. The Christian sentiment which Landow describes—the hope for the child's eventual vision in a happier world to come—may have been part of a Victorian spectator's reaction, but it was inspired by his own piety, not by the rainbow.[63] We have the testimony of one Victorian observer of the picture—Ruskin. And although Ruskin writes about *The Blind Girl* in several places and at some length in "The Three Colours of Pre-Raphaelitism" (1878; quoted earlier in this chapter), his reading of the picture makes no mention of the rainbow as a covenant sign or assertion of a more hopeful future for the blind girl. If, as Landow himself says, "we may take Ruskin . . . as typical of Victorian attitudes toward the rainbow," then the typical Victorian reaction was not as Landow describes.[64]

And yet the rainbow does function in an iconographic scheme here, though the reference is not to the Genesis covenant after the Deluge. The many beautiful natural sights in the picture, of which the rainbow is only one, create pathos: here is nature's gorgeous bounty and the girl is unable to see it. In the traditional genre of painting packed full of birds, beasts, flowers, and attractively colored landscape features, the Allegories of the Senses, beautiful paintings as well as natural sights are often included. But Millais's alfresco composition does not admit of such indoor treats for the eye. On the other hand, he can include a rainbow—not for its association with divine covenants, but simply because the beauty and color of the rainbow remind us forcibly what is always true—that it is a joy to be able to see.[65] Here the other girl in the picture is a repoussoir figure who looks back into the landscape, drawing our gaze there, but she does not really *see*; she is as uncaring as the other girl is unable to see. But she leads us to see and draws us into the picture.

There is a literary analogue to the way this picture works in the invocation to the third book of *Paradise Lost*, a portion of which we have already looked at. Milton begins by invoking light:

Hail, holy Light, offspring of Heav'n first-born,
Or of th' Eternal Coeternal beam
May I express thee unblam'd? Since God is Light,
And never but in unapproached Light
Dwelt from Eternity, dwelt then in thee,
Bright effluence of bright essence increate.
Or hear'st thou rather pure Ethereal stream,
Whose Fountain who shall tell? before the Sun,
Before the Heavens thou wert, and at the voice
Of God, as with a Mantle didst invest
The rising world of waters dark and deep,
Won from the void and formless infinite.

[3.1–12]

Light is introduced and praised, compared to God himself, and has as it were its pedigree traced for us. Then with a shock we come to realize that the praiser of light is unable to see it:

Thee I revisit now with bolder wing,
Escap't the *Stygian* Pool, though long detain'd
In that obscure sojourn, while in my flight
Through utter and through middle darkness borne
With other notes than to th' *Orphean* Lyre
I sung of *Chaos* and *Eternal Night*,
Taught by the heav'nly Muse to venture down
The dark descent, and up to reascend,
Though hard and rare: thee I revisit safe,
And feel thy sovran vital Lamp; but thou
Revisit'st not these eyes, that roll in vain
To find thy piercing ray, and find no dawn;
So thick a drop serene hath quencht thir Orbs,
Or dim suffusion veil'd.

[3.13–26]

We are struck with the irony of the best poet of light's being himself blind. Nature's beauty strikes us the more because of his affliction:

Thus with the year
Seasons return, but not to me returns
Day, or the sweet approach of Ev'n or Morn,
Or sight of vernal bloom, or Summer's Rose,

Or flocks or herds, or human face divine;
But cloud instead, and ever-during dark
Surrounds me. . . .

[3.40–46]

The beauty of the scene and the pathos of the blind poet's situation work together in these lines. So in Millais's picture the natural beauty of the scene, of which the rainbow forms only one part, intensifies the pathos we feel for the blind girl.

4

Engagement and the Problems of Realism: The Pre-Raphaelite Experiment

The Pre-Raphaelites tried to establish a school of English art with engagement as its goal, and for a brief time, they succeeded. Their "special and particular doctrine," according to William Morris, was "in one word, Naturalism. That is to say the Pre-Raphaelites started by saying, 'You have Nature before you, what you have to do is copy Nature and you will produce something which at all events is worth people's attention.'"[1] In the Pre-Raphaelites' program, the careful copying of nature would establish the conviction that what the observer heard or saw in the art work was real—an accurate description or depiction of reality. Moreover, the result would be something "worth people's attention," convincing observers that what it depicted mattered, engaging them, entangling them, and catching them up in this illusive reality so that they must, for the time they allow the suspension of disbelief, think and feel on its terms. "Let us go on a bold track," said William Holman Hunt (1827–1910) to John Everett Millais (1829–96), "some one must do this soon, why should not we do it together? We will go carefully and not without the teaching of our fathers: it is simply fuller Nature we want."[2] Dante Gabriel Rossetti (1828–82), the third member of the original Pre-Raphaelite group, echoes the rallying

143

cry of nature in his preface to the second number of *The Germ*, the magazine which was the Pre-Raphaelites' manifesto and where Rossetti's first poetry was published. He wrote that their plan was "to encourage and enforce an entire adherence to the simplicity of Nature."[3] The appeal to nature was often described in terms of simplicity: Hunt expressed it as "a childlike submission to Nature" (132) and a "child-like reversion from existing schools to Nature herself" (125).

Of course, radically different styles and approaches can be justified by invoking nature, which is appealed to by artists as diverse as Da Vinci and Pope, to pick two examples whose quotations are used together to introduce one of Hunt's chapters (chapter 6). Hunt and his friends recognized that "every art adventurer . . . declares that Nature is the inspirer of his principles" (137). The Pre-Raphaelite adventurers' principles included shunning the conventions of existing schools and those which were seen as meretricious imitations of the facility of Raphael—hence the group's name. Also included was a search for a new realism. When Hunt, Rossetti, and Millais came together in the late 1840s, the English artistic world was in the midst of a debate about what realism was and what its purpose might be. The three men had differing attitudes about realism, and their practice—in painting for all three and in poetry also for Rossetti—shows how complex an artistic goal realism is and how fraught with problems for the artist who tries to use it to draw his audience in. The group's failures can be as instructive as its successes in showing the relationship between realism and engagement.

The brief alliance of Hunt, Rossetti, and Millais produced work that the three might never have done in isolation. But although Pre-Raphaelitism had a lasting effect on landscape art in England, in most respects the movement was short-lived, and it gave way to aestheticism and other trends in poetry and painting which had little regard for engagement.

Raphaelitism and Reaction

Hunt wrote that it was the Pre-Raphaelites' intention "to eschew all that was conventional in contemporary art" (125), and he saw the

scorned conventionality as a legacy of Sir Joshua Reynolds's influence—"Sir Sloshua," as he was known to the Pre-Raphaelite Brotherhood. When Hunt went beyond Reynolds to those whom the first president of the Royal Academy inherited from, his own personal knowledge failed and he depended on his reading of Ruskin. Ruskin had reversed Reynolds's assessment (in the *Discourses on Art*) of the Italian schools, and Hunt adopted Ruskin's revaluation (91). Ruskin saw the Venetian school as superior because of an emblematic and narrative strength in the pictures which is lacking in the Bolognese school. For Hunt as for Ruskin, the Venetians are not great because of their skill as colorists but as conveyors of sacred narrative, while the Carracci and Guido Reni and their followers were more interested in "improving" nature, idealizing faces and figures with ancient statuary as models, and paying more attention to stability in composition than to narrative and symbolism. This academic, or neoclassical, school which begins with the Bolognese culminates in the French painters Gaspard and Nicolas Poussin (though Ruskin excludes some of Nicolas Poussin's landscapes from his scorn). This pedigree of conventionality Hunt gets from Ruskin and enthusiastically repeats to Millais in one of their first long conversations about how the young artists will proceed (90–91). Hunt elsewhere talks about a direct line of influence from the Bolognese through Le Brun up to Sir Joshua Reynolds (137). Raphael himself is not blamed for the conventions which begin from imitation of his facility—"Pre-Raphaelitism is not Pre-Raphaelism," as Hunt wrote (135). Raphaelitism was an expression for all that was mere convention and "the stereotyped tricks of decadent schools," either in Italian and French painters of the past or as preserved in English Academy practice (107). In the autumn of 1847, Millais and Hunt discussed the kinds of conventions they felt were holding artists back. Hunt reports his own words:

> We have, as an example of trammels, the law that all figures in a picture should have their places on a line describing a letter S—the authorities for convention finding this ground plan in Raphael's groups. . . . Again, should the several parts of the composition be always apexed in pyramids? Why should the highest light be always on the principal figure? Why make one corner of the picture always in shade? For what reason is the sky in a daylight picture made as

black as night? and this even when seen through the window of a chamber where the strong light comes from no other source than the same sky shining through the opposite window. And then about colour, why should the gradation go from the principal white, through yellow, to pink and red, and so on to stronger colours? [87–88]

For an example of how the Pre-Raphaelites' own practice differed from the conventions against which they were reacting, let us compare a Rossetti annunciation with one by the foremost seventeenth-century inheritor of the Raphaelite tradition, Nicolas Poussin (1594–1665). Poussin's *Annunciation* was painted in 1657 and is fairly representative of seventeenth- and eighteenth-century pictures with religious subjects which a visitor to a gallery in Rossetti's time would have seen. Rossetti's *Ecce Ancilla Domini!* was completed in 1850 and differs in practically every respect except subject from Poussin's painting. (See illustration on p. 26.)

Differences of color strike us first. The Poussin annunciation is in subdued shades. The Rossetti canvas is more white than anything else,[4] but its few colors are intense, bright, and—most important—primary: bright red, bright blue, bright yellow. The predominance of white tends to further emphasize the already emphatic colors, and the whole canvas becomes a revolutionary statement against academic handling of both light and color. Although there is a principal light coming from the left, the figures are equally lit with diffuse sunlight as if it were an exterior scene. The colors are heightened not only by their being outlined in white, but by being painted over a wet white ground as was the common Pre-Raphaelite practice.[5]

Rossetti's style makes symbolic features work also as realistic picture elements: where the dove in the Poussin canvas is a flat projection surrounded by a nimbus of light, in Rossetti's picture it becomes a real bird, flying in at a real window. But the realism of *Ecce Ancilla Domini!* is primarily in the figures—not merely in the modeling or drawing of them, but in the way the whole composition forces the beholder to react to them. The Poussin is organized horizontally, in a stable composition, and the Virgin and angel occupy separate spaces, not impinging on each other. This tends to emphasize the otherness of the angel, which is further pointed up

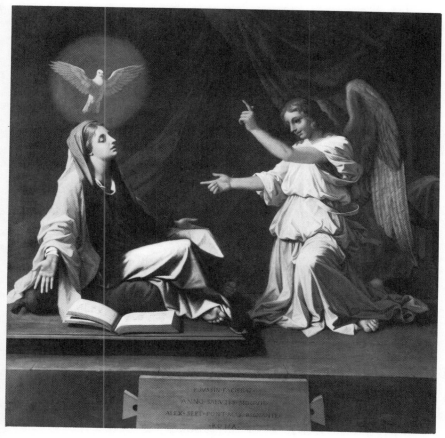

The Annunciation (1657), by Nicolas Poussin.
Courtesy of the National Gallery, London.

by the difference in color in the clothing. Everything is changed in Rossetti's picture: the composition is vertical, volatile, tending to force the figures together so that they impinge on each other's space. Rossetti insists on the physical presence and nearness of the two— their similar white garments allow us to see one bare arm of each, and the composition has these in contact, though they do not actually touch.

Where Poussin paints stylized faces, so that neither Mary's age nor the sex of the angel are at all obvious, Rossetti draws real

portraits of a young girl and a young man. His sister Christina sat for the portrait of Mary, and although several models were used for the angel, the completed face seems to be that of his brother William.[6] The "pre-Raphaelitism" of the picture is historically correct here. Sir Joshua Reynolds writes in his notebooks from Florence that it was "the ancient custom" to have the heads of religious pictures like Masaccio's or Raphael's *Adam and Eve* painted as portraits.[7] Poussin's picture shows that the practice did not survive into post-Raphaelite seventeenth-century painting of this sort: the idealized faces of his Mary and angel might have been painted from the same model, who is in any case only a living lay figure on which features taken from classical statuary can be superimposed. But Rossetti's intention was not historical accuracy; everything has been arranged so that the viewer reacts in ways which Poussin has consciously avoided provoking. Where Poussin keeps the level spiritual and conveys Mary's submission by her posture, Rossetti gets us to respond to those parts of the situation where pure spirituality leaves off. The left hand of the angel is raised in a mollifying gesture; Mary is not sure about exactly what is going on. We see her, having awakened in her bed, clothed in her nightgown; there is a young man in her room who, although he seems to be supported by a small yellow chromate fire, also seems to be as much flesh and blood as she, and he has just announced that when he leaves today she will be pregnant. Rossetti wrote in one of the sonnets attached to his first picture on Mary (1849; "Mary's Girlhood: For a Picture," 1. 9–14) that the element of faith subdues fear for her:

> So held she through her girlhood; as it were
> An angel-watered lily, that near God
> Grows and is quiet. Till, one dawn at home
> She woke in her white bed, and had no fear
> At all,—yet wept till sunshine, and felt awed:
> Because the fullness of the time was come.

But Mary seems frightened in *Ecce Ancilla Domini!* and we can sympathize with her fear. We are drawn in by human sympathy and the not-quite-submerged sexual aspects of the scene. The composition of these pictures also affects the spectator. The Poussin fends us off, as the scene is on a raised dais and it is as if we are on one side of a

sanctuary wall with the angel and Mary on the other. The Rossetti scene appears to be already in spectator space and draws us in. As a recent structuralist critic, Mary Ann Caws, writes, in the Rossetti "the observer is plunged directly into the announcement" by the picture's composition and style.[8] Thus Rossetti showed how reaction against the trammels of convention could produce a picture which drew the beholder in. Part of the revolt against convention here expresses itself in a new realism, but we may not generalize Rossetti's practice in this picture as typical of the other Pre-Raphaelites, nor as a stylistic phenomenon isolated from other artistic developments of the mid-century.

Realism and the Mid-century Debate

The strongest appeal for realism in the mid-nineteenth century is made *about* painting and *in* poetry. In Robert Browning's "Fra Lippo Lippi" the title character makes the argument. He is one who thinks the animal in man is important: "Come, what am I a beast for?" he asks (line 80). He thinks observation, rather than knowledge of conventions or a talent for them, is the place where art begins and recounts his own experience as illustration:

> ... when a boy starves in the streets
> Eight years together, as my fortune was,
> Watching folk's faces to know who will fling
> The bit of half-stripped grape bunch he desires,
> And who will curse or kick him for his pains—
> Which gentleman processional and fine,
> Holding a candle to the Sacrament,
> Will wink and let him lift a plate and catch
> The droppings of the wax to sell again,
> Or holla for the Eight and have him whipped—
> How say I?—nay, which dog bites, which lets drop
> His bone from the heap of offal in the street—
> Why, soul and sense of him grow sharp alike,
> He learns the look of things, and none the less
> For admonition from the hunger pinch.
>
> [Lines 112–26]

The passage illustrates the realistic observation which is its subject, and follows an ironic scene demonstrating the recruiting policies of the Carmelites who take Lippi in: "the good fat father" gives the starving boy food and then asks him whether he is ready to renounce the world. The boy chooses the bread over the world (lines 91–101). The Carmelite Prior, canny and worldly, perceives the boy's talent for observation and drawing, and puts it to use. When he sets Lippi to decorate the Carmelite church and the boy paints what he has observed, people marvel at how true to life his frescoes seem. They begin to see real people there:

> "That's the very man!
> Look at the boy who stoops to pat the dog!
> That woman's like the Prior's niece who comes
> To care about his asthma: it's the life!"
>
> [Lines 168–71]

Either Lippi has painted real portraits—including that of the Prior's niece/mistress who comes to "care about his asthma"—or has simply introduced his brothers to a technique so much more realistic than any they are used to that they are led to see real portraits there. In any case a controversy ensues. The learned insist that this is not the purpose, the "mark of painting." They suggest there is witchcraft or a "devil's game" involved in Lippi's startling realism. Their argument is that the painter's job is not to show the material world, but transcendent, spiritual truths—what in fact cannot be painted in any realistic way. They cannot even agree on a metaphor for what they wish him to paint:

> Your business is to paint the souls of men—
> Man's soul, and it's a fire, smoke . . . no, it's not . . .
> It's vapor done up like a newborn babe—
> (In that shape when you die it leaves your mouth)
> It's . . . well, what matters talking, it's the soul!
> Give us no more of body than shows soul!
>
> [Lines 183–88]

They want the material or realistic subsumed in the symbolic; they want a style which almost denies the presence of the mundane as a means of asserting, symbolically, that the mundane has no eternal

or divine reality. Lippi's answer is that the breathing flesh must contain the symbol, but he goes further still:

> Why can't a painter lift each foot in turn,
> Left foot and right foot, go a double step,
> Make his flesh liker and his soul more like,
> Both in their order? Take the prettiest face,
> The Prior's niece . . . patron-saint—is it so pretty
> You can't discover if it means hope, fear,
> Sorrow or joy? won't beauty go with these?
> Suppose I've made her eyes all right and blue,
> Can't I take breath and try to add life's flash,
> And then add soul and heighten them threefold?
> Or say there's beauty with no soul at all—
> (I never saw it—put the case the same—)
> If you get simple beauty and naught else,
> You get about the best thing God invents:
> That's somewhat: and you'll find the soul you have missed,
> Within yourself, when you return him thanks.
>
> [Lines 205–20]

Browning here lays out the main terms of a fierce and complex mid-century debate about realism in art. One position in this debate had its roots in the romantic poets' insistence on the value of individual percepts. Blake rejected the opinion of Sir Joshua Reynolds in the *Discourses* that "generalization . . . is the great glory of the human mind"; for Blake each individual bird was "an immense world of delight," and, "If the doors of perception were cleansed every thing would appear to man as it is: Infinite."[9] Wordsworth also felt that everything that lived was holy, and that "the meanest flower that blows can give Thoughts that do often lie too deep for tears."[10] For these men in their different ways, there was no "simple beauty," no "beauty with no soul at all," any more than there was for Lippi. The soul was effectively revealed by showing as much of the body's beauty and particularity as art could capture.

Another position, important as background for Browning's "Lippi," was that of the Frenchman Alexis François Rio, whose book that was translated as *The Poetry of Christian Art* achieved great influence in England during the 1840s. As David DeLaura has written, Rio brought into the arts, "the polemical point of view of neo-Catholi-

cism," arguing that "the intimate connection between art and piety" during late medieval times "was fatally compromised in the fifteenth century, especially by the Medici, who sponsored a fleshly and pagan 'naturalism' that destroyed 'the centre of unity' from which earlier Italian painting had proceeded."[11] Rio's position is simplified in the Carmelites' reaction to Lippi's frescos; too real flesh and blood are quite from the mark of painting: "Give us no more of body than shows soul."

Another crucial position was that of Ruskin, who assimilated what he wished from both the previous ones. Though minor details of his view of realism changed over the years, Ruskin was remarkably consistent in its major features, coming to them during the time he idolized Turner, long before the Pre-Raphaelite Brotherhood was formed, holding to them through disappointments and quarrels with the members and with his own wife's leaving him for Millais, and recapitulating them much later in his lecture "The Three Colours of Pre-Raphaelitism" (1878). Ruskin believed with Wordsworth that the meanest flower, or, in the case of Millais's *The Blind Girl*, the lowliest blind beggar, can give "thoughts that do often lie too deep for tears" (he quotes Wordsworth's lines in "The Three Colours"), and he also believed that painting "things as they are or were . . . is at first better, and finally more pleasing" for the spectator than painting them according to some formula. On the other hand, he believed there was more to the world of reality than appearances, that "things as they are" must include "the spectral, no less than the substantial reality."[12] Moreover, while Ruskin rejected the Catholic bias of Rio's thesis and the specific claim that art declined with Michelangelo's and Raphael's attention to the fleshly, he did believe that artists before Raphael attempted to depict things as they were, "the actual facts of the scene . . . irrespective of any conventional rules of picture making," and that "after Raphael's time did *not* this, but sought to paint fair pictures rather than represent stern facts."[13]

This last idea, together with Ruskin's approval of the Pre-Raphaelites' detailed painting from nature, brought him to their defense against hostile criticism in 1851. Several years before, Hunt had sat up most of the night with a borrowed copy of the first volume of *Modern Painters*.[14] In Ruskin, Hunt found reinforcement for his own ideas about "the power and responsibility of art," and

he also adopted Ruskin's confident upsetting of Reynolds's accepted judgments about the Italian schools of painting.[15] Hunt tried with enthusiasm to interest Millais and Rossetti in Ruskin's ideas (with which they were certainly in general sympathy), and Ruskin tried to make both Millais and Rossetti his protegés. The realism about which their contemporaries were arguing came to mean something different for each of the original Pre-Raphaelites.

Reversion to Whose Nature?

In what sense does *Ecce Ancilla Domini!* represent "a child-like reversion to nature" as well as a revolt from convention? The short answer is, in Rossetti's sense. The painting represents only one of the Pre-Raphaelites' approaches to realism.

In a useful article on reactions to the Pre-Raphaelites and attitudes about early Italian painting in England, Robyn Cooper discriminates among different senses of *nature* in art discussions in the mid-nineteenth century:

> First, there was the Vasarian relativist technical conception of the "truth to nature" of the earlier masters. . . . Second . . . the sense of artlessness. The distinction was one between primitive simplicity and childlike naivety, on the one hand, and modern theatricality and sophistication on the other. . . . A third and related meaning . . . saw the "natural truth" of earlier masters in terms of a directness of apprehension and exactitude of imitation of individual aspects of inanimate and human nature, and this was sometimes contrasted with the idealizing and generalizing representations of later artists. Finally, with the rise of the purist or Christian devotion to earlier art we find a suspicion of the technical progress of art and of the growing enthusiasm for nature (especially the naked human form) as contributing to the decay of Christian art in the Renaissance. In this case "natural" has a pejorative significance through its association with the material and secular.[16]

These four meanings of natural can be used to distinguish attitudes about realism among Rossetti, Hunt, and Millais, and it will be convenient to use Cooper's shorthand designations for them (429):

nature can mean "illusionistic techniques," "the artless (as opposed to the artificial)," "the individual and specific (as opposed to the general)," and "the material (as opposed to the transcendental)." The main emphasis of romantic realism in the Blake and Wordsworth examples quoted earlier is the individual and specific. What Rio deplored in Renaissance painting was primarily nature as the material, crowding out the spiritual and transcendental.

Rossetti

For Rossetti, a return to nature meant primarily artlessness and rejection of the kinds of conventions we have seen in Poussin. To a limited extent it also meant close observation and imitation of individual forms, but it should be emphasized that this never means for Rossetti "painting from Nature" in the painstaking, leaf-by-leaf manner to be observed in the work of Hunt or Pre-Raphaelite followers such as Brett or Hughes. Rossetti's one recorded attempt at *plein air* painting was abandoned before it was finished; Hunt remembers how he found Rossetti "in a mortal quarrel with some particular leaf which would perversely shake about and get torn off its branch when he was half way in its representation" (237). Ruskin tried to get Rossetti outdoors to paint, with humorous and exasperating results, as these three letters, all dated October 1855, show:

> Dear Rossetti,
> If I were to find funds, could you be ready on Wednesday morning to take a run into Wales, and make me a sketch of some rocks in the bed of a stream?
>
> Dear Rossetti,
> I never should think of you sitting out to paint from Nature. Merely look at the place; make memoranda fast, work at home at the inn.
>
> Dear Rossetti,
> You are a *very* odd creature, that's a fact. I said I would find funds for you to go into Wales to draw something I wanted. I never said I would for you to go to Paris, to disturb yourself and other people, and I won't.[17]

Rossetti's realism is not that of "sitting out to paint from Nature," and it also has to struggle with his penchant for symbols. At his best

Rossetti succeeds in reconciling his strong taste for symbols with a directness of manner that keeps them under control. He knew that symbols could obscure and diffuse a picture's impact. In his sonnet on Saint Luke, the painter "Who first taught Art to fold her hands and pray," he writes how Art then freed herself from symbols:

> Scarcely at once she dared to rend the mist
> Of devious symbols: but soon having wist
> How sky-breadth and field-silence and this day
> Are symbols also in some deeper way,
> She looked through these to God and was God's priest.
>
> [Lines 4–8]

Probably both his leaning toward and his leeriness of symbols can be traced to his father's influence: Rossetti was steeped in Dante and other early Italian poets from infancy, but he was also steeped in his father's lifelong attempt to find a secret political allegory and evidence of a vast conspiracy in Dante's works.[18] In *Ecce Ancilla Domini!* Rossetti manages to employ symbols without allowing them to usurp attention. There are many symbols in this painting: the colors and flower on the embroidery, the three lilies with one bloom still only a bud (these explicated in the sonnets attached to the earlier *Girlhood of Mary Virgin*; see chapter 1), the fire beneath the angel's feet as opposed to the tiny fire in the lamp, and so on. But the picture's main effect is not dependent on symbolism, and we are not kept from absorption in the picture by puzzling or arcane elements.

Of the original Pre-Raphaelite group only Rossetti wrote poetry. The range of his poetry reflects the various problems we have seen in attempts at pictorial realism and engagement: struggles to reconcile the symbolic and the naturalistic, attempts to bring the human and bodily forward from the divine in religious subjects, efforts to reveal the way "sky-breadth and field-silence and this day" can have central importance in a work. Rossetti's poetry can be precious, but at its best it reflects the promises of the introductory sonnet to *The House of Life* (1881):

> A Sonnet is a moment's monument,—
> Memorial from the Soul's eternity
> To one dead deathless hour. Look that it be,

Whether for lustral rite or dire portent,
Of its own arduous fulness reverent:
Carve it in ivory or in ebony,
As Day or Night may rule; and let Time see
Its flowering crest impearled and orient.

A Sonnet is a coin: its face reveals
The soul—its converse, to what Power 'tis due:—
Whether for tribute to the august appeals
Of Life, or dower in Love's high retinue,
It serve; or, 'mid the dark wharf's cavernous breath,
In Charon's palm it pay the toll to Death.

Not only the sonnets but all Rossetti's poems intertwine the themes of life, love, and death. The close natural description of "Silent Noon," for example, marks a moment "when twofold silence was the song of love.":

The pasture gleams and glooms
'Neath billowing skies that scatter and amass.
All round our nest, far as the eye can pass,
Are golden kingcup-fields with silver edge
Where the cow-parsley skirts the hawthorn-hedge.
'Tis visible silence, still as the hour-glass.

Deep in the sun-searched growths the dragonfly
Hangs like a blue thread loosened from the sky:—
So this wing'd hour is dropt to us from above.

[Lines 3–11]

The hour is winged but the hour-glass is still: it is the minute perception of each detail that brings time to a halt as much as it is the silence and the stillness—this in addition to the poem's power to make the past "dead" hour also present and "deathless." This strain of particular natural description is no Pre-Raphaelite invention: it was the pride of the romantics and was carried on by Tennyson, who gave even more emphasis to the minute detail in natural description. Carol Christ, in describing "the aesthetics of particularity" in Tennyson's "Mariana," connects the emotional state of the implied narrator ("Although the poem is not put in Mariana's mouth"

the tone "makes us feel it is her perception" we are given), the minuteness of observed detail, and "the way the landscape continually reminds us of the passage of time. . . . The poem presents not just a landscape but a peculiar mode of perceiving landscape."[19] The epiphanic natural scene, the moment in which natural features become bathed in transcendent import, is a feature of English poetry from Blake to Hopkins. But unlike Blake or Tennyson or Hopkins, Rossetti is alone in affirming that the moment can be sacred without being transcendent:

> The wind flapped loose, the wind was still,
> Shaken out dead from tree and hill:
> I had walked on at the wind's will,—
> I sat now, for the wind was still.
>
> Between my knees my forehead was,—
> My lips, drawn in, said not Alas!
> My hair was over in the grass,
> My naked ears heard the day pass.
>
> My eyes, wide open, had the run
> Of some ten weeds to fix upon;
> Among those few, out of the sun,
> The woodspurge flowered, three cups in one.
>
> From perfect grief there need not be
> Wisdom or even memory:
> One thing then learnt remains to me,—
> The woodspurge has a cup of three.

The natural detail in "The Woodspurge" (1870) is connected with death or with love or both, but the grief is unnamed. Nature does not foster moral vision or seeing into the secret life of things, wisdom, or the philosophic mind. The detail—"the woodspurge has a cup of three"—and the moment are celebrated in the poem, for though not a sonnet it too is a "moment's monument." The poem does not engage us with the speaker's grief, nor is there more than the hint of a pathetic fallacy (the wind that is "Shaken out dead from tree and hill")—the woodspurge does not reflect a human mood but merely *is*, and that is where we become engaged, with the undeniable thereness of the flower and its form.

"Jenny" shows Rossetti's experiments with a different kind of realism and engagement. The rhetorical strategy in this poem forces the reader past sympathy with the poem's narrator to identification with him. This is an uneasy and unstable identification which alternates with a distancing of reader from speaker and with the reader's criticism and unfavorable judgment of the speaker. Nevertheless the poem's readers—including female readers—are made to share the guilt of Jenny's sexual exploitation. The reader is engaged and brought into the poem through a number of strategies of which the surface train of thought of the narrator is only the most obvious. The prudent and prudish omission of the overtly salacious and of anything which actually names Jenny's occupation—"what thing she is"—constitutes another strategy. But the most powerful strategy works through a combination of religious and art imagery in the transformation of Jenny from Magdalene to Virgin.

Our initial impression of the narrator, who has forsaken his books for the company of a prostitute, marks him as not much of a scholar and still less a gentleman. But he perceives that something is to be learned from Jenny and comments to the sleeping girl:

> You know not what a book you seem
> Half-read by lightning in a dream!
>
> [Lines 51–52]

The narrator wonders what Jenny is thinking as she sleeps. He imagines that she is thankful for a rest from "envy's voice at virtue's pitch," "the pale girl's dumb rebuke," and the "wise unchildish elf" who points her out, "what thing she is," to his schoolmate. But what she most needs rest from, he thinks, is "the hatefulness of man, / Who spares not to end what he began." This is the first point at which the narrator's moral musings are directed inward toward himself as guilty and responsible for Jenny's fate.

The narrator imagines an idyllic rural past for Jenny, when she would dream about the city she knows so well now. He imagines her future too:

> When, wealth and health slipped past, you stare
> Along the streets alone, and there,

Round the long park, across the bridge,
The cold lamps at the pavements edge
Wind on together and apart,
A fiery serpent for your heart.

[Lines 149–54]

The speaker's condescending recognition that Jenny sleeps just as any other woman sleeps (line 177) leads him to think of his cousin Nell (lines 185–202) and to imagine a future in which Nell's children might be in Jenny's situation and need her children's charity (lines 210–14). In the next hundred lines, in the middle of the poem, Rossetti, having brought narrator and reader to a wider social and historical view of Jenny's "case," now effects a moral reversal, shifting the burden of shame from Jenny to the speaker and the implied observer. But he effects this change not merely through the speaker's surface thoughts: from the beginning of the poem a series of images has worked to rehabilitate Jenny in the mind's eye, purifying and even sanctifying the picture which the reader creates of her.[20]

When Rossetti rhymes the girl's name with *guinea* in the first couplet of the poem, he suggests that it is the pet form for *Virginia* rather than for Jennifer or Jane or Genevieve.[21] But his purpose is not irony; the name connects with other images which suggest the virgin in Jenny. Jenny is Magdalene not only by profession but iconographically by the emphasis on her long hair (lines 10–11, 47, 174, 340), a traditional sign for this New Testament figure.[22] But she is transformed from Mary Magdalene to Mary Virgin by an early line in the poem which echoes the annunciation: "Poor shameful Jenny, full of grace" (line 18). It is a reversal of the theme of *Ecce Ancilla Domini!* spoken by a definitely unangelic speaker (though a Gabriel speaks through him) to an unaware, sleeping Jenny rather than a waking, watchful Mary, recording an all-too human rather than divine past and future and a soul state wrought by male sin rather than female purity.[23] The biblical echoes that concern virgins do not end until the end of the poem, when the dawn finds Jenny's lamp still alight, "Like a wise virgin's" (line 316), and the narrator and reader decamp, leaving Jenny indeed virginal for this encounter at least.

Between these references to virgins, other biblical echoes are

scattered through the poem. Jenny's "lazy lily hand" (line 97) leads to the lilies of the field (lines 100–10) and fled roses lead to "the naked stem of thorns" (line 120) which links passion and suffering, loosely connecting Jenny with Christ, sinful with expiatory passion.

The religious references join in the poem's center with art imagery showing Jenny as art object or model and emphasizing the role of the maker. The speaker first seems to suggest that blame is assignable to God for Jenny's situation:

> —what to say
> Or think,—this awful secret sway,
> The potter's power over the clay!
> Of the same lump (it has been said)
> For honour and dishonour made,
> Two sister vessels. Here is one.
>
> [Lines 180–84)

The thought shakes him; he says it "makes a goblin of the sun" (line 206). But when he speaks of the painter placing "Some living woman's simple face"—perhaps Jenny's—in a "gilded aureole," he says that such pictures have the power to show men what God can do in forming nature, but that Jenny's fate has been wrought by man:

> What has man done here? How atone,
> Great God, for this which man has done?
>
> [Lines 241–42)

Jenny's face comes to be seen, as it might be by Raphael or Leonardo, as fit for a picture "For preachings of what God can do" (line 240). God has modeled the "real" Jenny; man has made her "case"—is the artist of her sin and prostitution. Lust is man's creation, and the narrator sees it when he looks at Jenny with his mind's eye:

> Yet, Jenny, looking long at you,
> The woman almost fades from view.
> A cipher of man's changeless sum
> Of lust, past, present, and to come,

> Is left. A riddle that one shrinks
> To challenge from the scornful sphinx.
>
> [Lines 276–81]

It is an inward look that gives him that view; Jenny's "stilled features" are the same long throat and "pure wide curve from ear to chin" that might inspire Raphael. Jenny's face is a work of divine art, but her situation is a human creation which narrator and reader find first a book, then a picture, and finally a mirror.

So much for the poem's male readers. A serious argument could be made, however, that "Jenny" is not a poem aimed at male readers at all. For one thing, in this poem with its salacious subject there is a complete absence of salacious detail from the beginning—even from the epigraph. The Merry Wives of Windsor scene to which Rossetti alludes in the epigraph contains some fairly explicit bawdry: double entendres and sexual metaphors abound as the Welsh schoolmaster asks his pupil for the "focative" case, and then for the genitive case of hic, which is horum. Mistress Quickly interrupts: "Vengeance of Jenny's case! Fie on her! Never name her, child, if she be a whore" (IV, i, 53–54). Rossetti quotes only "Vengeance of Jenny's case! Fie on her! Never name her, child." In fact Jenny's case is never explicitly named—"what thing she is." Nor is the milder word prostitute used. Aside from a line early in the poem mentioning "Love's exuberant hotbed" (line 13) there is no language in the poem that overtly images passion. The subject may be racy; the language is not.

Partly what identifies Jenny as whore are the references to money throughout the poem, and these tell us more about the speaker than about Jenny:

> Lazy laughing languid Jenny,
> Fond of a kiss and fond of a guinea
>
> [Lines 1–2]

> Whose person or whose purse may be
> The lodestar of your reverie?
>
> [Lines 20–21]

The speaker pretends to know Jenny's dreams (line 364), but these are his own imaginings. In fact, money in the poem is connected to

a cluster of images of gold coins (lines 2, 226), golden hair (lines 10–11), golden skin (line 50), golden sun (line 224), the "gilded aureole" of a saint (line 230), and gold coins again, this time a shower of them in Jenny's hair in a self-flattering allusion identifying the speaker with Zeus and Jenny with Danae (lines 374–77). At several points in the poem this golden image cluster becomes a vehicle for the transference of "guilt"—there is the possibility of a pun, but the speaker talks more about shame than guilt, though much about gilt. One point, already mentioned, is that at which Jenny's face is seen as suitable model for a saintly image, with a gilded aureole. At another point just before, gold turns into the more precious commodity of time:

> How Jenny's clock ticks on the shelf!
> Might not the dial scorn itself
> That has such hours to register?
> Yet as to me, even so to her
> Are golden sun and silver moon,
> In daily largesse of earth's boon,
> Counted for life-coins to one tune.
> And if, as blindfold fates are toss'd,
> Through some one man this life be lost,
> Shall soul not somehow pay for soul?
>
> [Lines 220–29]

In the passages from line 207 to line 249 the speaker asks several important questions which indicate a transference of guilt from the poem's subject to its narrator and readers. The first question asks whether in the future Jenny's and Nell's destinies might not be reversed in their offspring (lines 211–13). The second asks whether soul shall "not somehow pay for soul" (line 229), and the third asks:

> How atone,
> Great God, for this which man has done?
>
> [Lines 241–42]

Immediately after these questions the narrator exclaims:

> If but a woman's heart might see
> Such erring heart unerringly
> For once!
>
> [Lines 250–52]

The narrator concludes that this can never be and no chaste woman can view Jenny's state with propriety. He says this in a passage which unites the flower images which have characterized Jenny (a fresh flower, lillies, roses) with the book image of learning and recognition, used since the poem's beginning, and with the book as an image of enclosure. The enclosure images of the poem, such as the narrator's "captive hours of youth" (line 25) when he was captive in a different sort of book, the rose shut in a book, and the toad within the stone (lines 282–97), all point to the fact that the poem's subject is actually an enclosed drama—a psychomachia which begins as the narrator's but ends as the reader's also:

> Like a rose shut in a book
> In which pure women may not look,
> For its base pages claim control
> To crush the flower within the soul;
> Where through each dead rose-leaf that clings,
> Pale as transparent psyche-wings,
> To the vile text, are traced such things
> As might make lady's cheek indeed
> More than a living rose to read;
> So nought save foolish foulness may
> Watch with hard eyes the sure decay;
> And so the life-blood of this rose,
> Puddled with shameful knowledge, flows
> Through leaves no chaste hand may unclose:
> Yet still it keeps such faded show
> Of when 'twas gathered long ago,
> That the crushed petals' lovely grain,
> The sweetness of the sanguine stain,
> Seen of a woman's eyes, must make
> Her pitiful heart, so prone to ache,
> Love roses better for its sake:—

Only that this can never be:—
Even so unto her sex is she.

[Lines 253–75]

The gentleman, protesting too much, says it "can never be" so often that we are likely to forget *what* can never be: a chaste woman's confrontation with Jenny herself, rather than with this chastened image of her in the poem. For in this guise pure women may indeed read the text of Jenny's history, see that she is as other women, see her erring heart unerringly, and more. I am suggesting that the reader's reaction is more than sympathy, pity, compassion, fellow-feeling; it is assumption of guilt for Jenny's case. For the female reader this can only come, not in the recognition that she could easily have been in Jenny's place, but in the recognition of who benefits from the exchanges of prostitution, in gold coins or whatever other "offerings nicely plac'd" which "But hide Priapus to the waist" (lines 368–69). Cousin Nell, reading the poem with an open mind and that "pitiful heart, so prone to ache," will not escape the realization that prostitution is the necessary underground basis for the exaltation of such "pure women" and the reverence in which she herself is held. The male reader, the female reader, and the narrator—we have all enjoyed Jenny's favors and share the guilt of her sexual exploitation. That Rossetti manages this identification with the narrator even though we begin and end our visit with him thinking he is pompous, priggish, and self-absorbed is a measure of the poem's complexity. That complexity may be what led Graham Hough to declare Rossetti's dramatic monologues "as good as anything of Browning's of the same kind, with perhaps the evidence of a less commonplace mind behind them."[24]

"The Blessed Damozel" is a no less bold but less successful experiment, not, like "Jenny," with precedents in Browning or, like "The Woodspurge," drawing on a tradition of romantic nature description. When Rossetti installs in heaven a fleshly, love-longing lady who expects the approval of Christ and Mary for her bodily reunion with her lover and their lovemaking in the shadow of the Holy Ghost's "mystic tree," he brings together spirit and body in a way more reminiscent of Dante's poetry, where "imagery drawn from religion is used to express an earthly love."[25] An English precedent is Donne, although when Donne talks about his lovers' can-

onization or writes that it would be "profanation of our joys To tell the laity our love," the religious or clerical is only one among many metaphors. Blake's general attitude that the flesh is holy comes closer to Rossetti's spiritualization of bodily love here, and Rossetti certainly echoes Blake, most notably in the thirteenth stanza:

> When round his head the aureole clings,
> And he is clothed in white,
> I'll take his hand and go with him
> To the deep wells of light;
> As unto a stream we will step down,
> And bathe there in God's sight.
>
> [Lines 73–78]

In "The Chimney Sweeper" from *The Songs of Innocence* there is also a vision of the young, newly dead, bathing in a stream and shining in the sun, then mounting on clouds in God's sight. Innocence—in Rossetti's case the innocence of love—brings about a return to the garden, although the earthly lover of the blessed damozel has doubts about his worthiness (lines 99–102). Children and lovers are the fit inhabitants of ordinary, mundane gardens, where the surroundings image their protection and transient state. But here the garden is seen as the Christian image of paradise or heaven, and it is made heaven by the sight of God.

Rossetti's identification of divine and carnal love struck his contemporaries as blasphemous, but the pictorial qualities of the poem appealed even to his severest critics. Robert Buchanan, who reviewed the fifth edition of Rossetti's *Poems* in 1871 as "The Fleshly School of Poetry," liked "The Blessed Damozel" almost in spite of himself, and the most damning thing he said about it was that it too closely resembled a picture: "The truth is that literature, and more particularly poetry, is in a very bad way when one art gets hold of another, and imposes upon it its conditions and limitations."[26] Certainly the visual imagery is impressive, especially when Rossetti imagines the view from heaven (lines 25–36), but the most memorable images of the poem are tactile—the blessed damozel's bosom making the bar she leans on warm—or auditory—she speaks, "as when the stars sang in their spheres," the other lovers speak their "heart-remembered names," there is a bird's song, bells,

singing to the music of citherns and citoles, and at the end, the sound of tears.

The blessed damozel's heaven is rendered in terms of sensible and earthly qualities, just as Mary's spiritual revelation is rendered in nonspiritual terms in Ecce Ancilla Domini! And it is not surprising that this would be perceived as blasphemous, though from our perspective it becomes an illustration of modern sensibility. From our point of view the poem comes across as—for lack of a better word—quaint; but not because Rossetti treats heaven in an earthly way. It is our fortune—for good or ill—to be convinced that there is no other way to look at heaven. Wallace Stevens's modern woman, in "Sunday Morning," expresses this realization, along with our sense of loss that it should be so:

> Is there no change of death in paradise?
> Does ripe fruit never fall? Or do the boughs
> Hang always heavy in that perfect sky,
> Unchanging, yet so like our perishing earth,
> With rivers like our own that seek for seas
> They never find, the same receding shores
> That never touch with inarticulate pang?
> Why set the pear upon those river-banks
> Or spice the shores with odors of the plum?
> Alas, that they should wear our colors there,
> The silken weavings of our afternoons,
> And pick the strings of our insipid lutes!
> Death is the mother of beauty, mystical,
> Within whose burning bosom we devise
> Our earthly mothers waiting, sleeplessly.

With some variations of bosom temperature and the attitude of the poet toward all this, the ideas are remarkably alike. We do not feel it ridiculous that Rossetti should need the senses to convey an idea of heaven any more than we are surprised or dismayed that Milton needs them in Paradise Lost. But Rossetti has chosen to describe, in earthly terms, a heaven of fake mythology, where the departed literally joins a heavenly choir and there is golden architecture with characters and stage props from a child's Sunday-school play: clouds, handmaidens, angels flying past.

Rossetti is not at his best either up in heaven or out in nature.

Even Robert Buchanan would probably agree that he is much more engaging when indoors—looking closely at female faces waking or asleep. But the attention and close observation he devoted to female models—Elizabeth Siddal, Annie Miller, Alexa Wilding, Fanny Cornforth, and especially Jane Morris—became almost the obsession for him that biblical typology was for Hunt. The memorable images of Rossetti's later career are all pictures in which these women usurp the entire picture space: *Venus Verticordia* (1868), *Veronica Veronese* (1872), *Proserpine* (1877), *Astarte Syriaca* (1877), *La Donna della Finestra* (1879), *La Pia de'Tolomei* (1880), and *The Day Dream* (1880). The last five pictures are all done with Jane Morris as model. These pictures are striking images, in a frankly sexual way; they command attention, but without engaging the observer. They are deliberately timeless images, much less able to draw us in than the slighter pen and pencil portrait sketches of Jane Morris and Elizabeth Siddal that Rossetti did earlier. Rossetti's paintings of Jane Morris are never portraits; he cannot leave the real face alone. He continually poses in his mind his ideal woman, which perhaps Jane Morris came closest to realizing in a model. The subjects of the late paintings, whether from Dante or mythology, do not matter and scarcely change the main figure's attitude or dreamy eyes. *The Day Dream* is a title that fits all of these pictures, for they are all dreams, but of the sort where we always feel ourselves spectators rather than participants.

Hunt

For William Holman Hunt, realism and a return to nature meant partly artlessness but much more a fanatical attention to authentic detail. Early in his account of Pre-Raphaelite working habits, Hunt writes that when the members agreed to use "the utmost elaboration" in their pictures, it was merely for training, and that they "should not have admitted that the relinquishment of this habit of work by a matured painter would make him less a Pre-Raphaelite" (150). In fact Hunt himself never relinquished this method of working but stuck to his minute delineation of natural features until his death in 1910. When this method works, for example in Hunt's *The Hireling Shepherd* (1851), it really does affect the viewer with the con-

Proserpine (1877), by Dante Gabriel Rossetti.
Courtesy of the Tate Gallery, London.

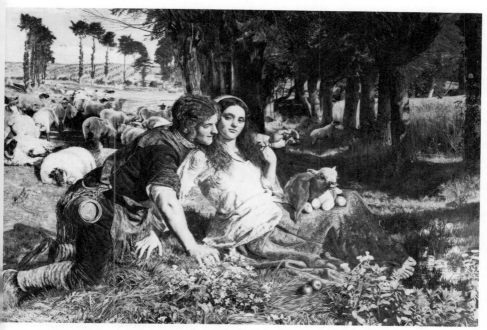

The Hireling Shepherd (1851), *by William Holman Hunt.*
Courtesy of the Manchester City Art Galleries.

viction that everything that lives is holy. Even the bucolic romance Hunt shows us he invests with beauty. We are aware that all the details of the grain field, the green apples and the meticulously painted death's head moth fit into a sermon about neglect of the flock, but they remain engrossing as field and apples and moth. Carol Christ, in her book on particularity in Victorian art, describes the effect of such a painting:

> The detailed representation of even the smallest objects . . . makes each one a possible focus of contemplation. The paintings thus imply a symbolic view of the world, in which each object can become instinct with meaning. By thus singling out each object, the Pre-Raphaelites build into their painting stylistically the impetus to a sacramental view of reality. At the same time the naturalism of the portrayal pushes what had been a symbol toward status as a natural object, the sheer quantity of detail pulls it back toward status as a

symbol. Images are thus poised precariously and deliberately on the brink between being aesthetic objects and being natural objects. Such portrayal reflects an assumption about the way man perceives. Faced with a world of natural objects instinct with symbolic meaning, man can understand that meaning, by intensity of contemplation. The conscious elaboration of detail in Pre-Raphaelite art reveals just such a consciously symbol-making effort. Far from producing a fatal lack of integrity of focus, the combination of allegorical and highly realistic details suggests the process of symbolic perception.[27]

Rossetti's observation that "sky-breadth and field-silence and this day / Are symbols also in some deeper way" was his way of expressing this notion of how realism and symbolic perception can exist together. But Hunt, like Rossetti, had to struggle with a tendency to let symbols take over, especially religious symbols. In Ruskin, Hunt found an authority for combining realistic detail with elaborate sacred iconography.[28] In such paintings as The Light of the World (1856) and The Finding of the Saviour in the Temple (1860), Hunt, as Ruskin himself saw, attached "too great importance to the externals of the life of Christ."[29] Divine history as expressed in arcane symbols gets more attention than the human and the naturalistic in these pictures, and the human is just what brings us into a picture like Ecce Ancilla Domini! It is an irony that Rossetti, far less religious than Hunt, paints the supreme religious picture of the group in his annunciation. But then Hunt, the least literary member of the group, paints The Lady of Shalott (1892), a more memorable literary picture than anything Rossetti did, and one of the best of the Pre-Raphaelites' works in that kind, along with Millais's Isabella (1849), Mariana (1851), and Ophelia (1852).

Another obstacle to engagement in Hunt's work is proliferation of detail. His pictures can be busy, with details so conspiring for attention that the surface of the picture closes and the observer cannot enter. Hunt's modern life, "fallen" woman picture, The Awakening Conscience (1854), rebuffs engagement both by lack of humanity and by busyness. The picture is very like a Hogarth "modern moral" subject. Everything in the room is a sign: the Woman Taken in Adultery is the picture over the piano; the bird in the cat's grip reflects the human situation, and so on. But the picture is very unlike Hogarth

in being completely humorless and somehow unsympathetic to human beings and their follies. Moreover the room gives the appearance of being so full of gimcrackery that there is simply no physical space inviting us to enter the picture. (See p. 28.)

Millais

For John Everett Millais realism and attention to nature meant partly observation, but also, for him more than for any of the other Pre-Raphaelites, truth to nature in painting meant the illusionistic techniques developed in the High Renaissance. Millais, as Ruskin recognized immediately, was the most talented painter England had had since Turner; he absorbed conventions so easily and rapidly that he was able to turn out finished pictures on a contract arrangement, one every two days or so, when he was in his teens.[30] Thus it was somewhat ironic that he found himself in a group where convention was denounced.

Millais was capable of devoting himself to a close study of nature, and he took to it with a much better spirit than Rossetti, but there is evidence that it was not his bent. When Millais was taken off to Scotland by Ruskin to paint the latter's portrait in the midst of nature, the result was a fairly conventional picture, and Millais's observation seems to have been mostly of Effie Ruskin, who left her husband a few months after this trip and later married Millais.[31] When he wanted some yellow in his *Ophelia* (1852), Millais painted in daffodils, and would apparently not have noticed the disparity with the other, full-summer flowers had not Tennyson pointed it out to him.[32] But he corrected this and also his second rainbow in *The Blind Girl*, which he had originally painted in the same color sequence as the first rainbow, again apparently not having observed that the colors are reversed in a second, reflected rainbow.[33]

Millais demonstrated very early his mastery of the Hunt-like, typological subject from the life of Christ (*Christ in the House of His Parents*, 1849), the simple and apparently artless religious picture in the manner of *Ecce Ancilla Domini!* (*The Return of the Dove to the Ark*, 1851), and the historical genre picture (*The Proscribed Royalist 1651* and *The Order of Release 1746*, both 1853). His paintings on literary subjects are

probably the most remembered images of the mid-century: Isabella (1849), Mariana (1851), and Ophelia (1852). He had more consistent success than the other Pre-Raphaelites at what they attempted and at what they could not do. When, as in The Blind Girl, Millais created an image which engaged the observer, the effect may be seen to be far from artless and to depend heavily on pictorial traditions. Some of his paintings where we merely watch someone else's sentiment—The Violet's Message (1854), for example, or The Rescue (1855)—fail to involve us. But generally speaking, Millais's pictures tend to have more depth, figures more convincing in their three-dimensional substance, and surfaces less decorated than other Pre-Raphaelite pictures.

Critics often see Millais's later career as a sad decline.[34] In fact he painted a number of distinctive portraits—of Carlyle, Tennyson, Gladstone, Disraeli, Lillie Langtry, Newman—and some fine historical pictures. For years Millais's The Boyhood of Raleigh (1870) and The Princes in the Tower (1878), along with many other fine Victorian paintings, were used to illustrate history books. That practice fell into disfavor after the Second World War, and the reputation of the pictures declined also. But now there is evidence of the returning popularity of these pictures.[35] Millais's technical talent never declined, though he turned away from the kinds of subjects he and Hunt and Rossetti had earlier painted.

One reason for Millais's facility was his instinctive and probably unconscious realization of the impossibility of the "innocent eye" which Ruskin and Hunt wished the painter to bring to nature.[36] The difficulties in the idea of innocent seeing are commonplaces these days, and most writers who refer to them cite E. H. Gombrich's discussion of Ruskin's idea in Art and Illusion. Gombrich concludes that "the problem of illusionist art is not that of forgetting what we know about the world. It is rather that of inventing comparisons which work."[37] Millais's comparisons work, and are good demonstrations that the nonexistence of the innocent eye was clearly known before this century. William Morris talks of this instinctive knowledge in his 1891 address on the Pre-Raphaelites:

> No doubt in the early days of Pre-Raphaelitism, it was rather the fashion to decry the use of any sort of convention. But as a matter

of fact every work of Art, whether it is imitative or whether it is suggestive, must be founded on some convention or other. It seems to me that the real point of the thing—and that I think the Pre-Raphaelites understood instinctively—is that that convention shall not be so to say, a conventional convention. It must be a convention that you have found out for yourself in some way or another, whether that has been deduced from history, or whether you yourself have been able to hit upon it by the light of nature. In any case, this you must understand, that it is absolutely impossible to give a really literal transcript of nature.[38]

Millais had a talent for finding effective conventions. Of course one of the things which makes a convention acceptable or unacceptable is fashion, as the recently ended half-century eclipse of Victorian painting demonstrates. Appreciation for the power of engagement in Millais's best pictures will continue to rise.

Problems of Realism and the End of the Experiment

The Pre-Raphaelites tested the limits of realism and in doing so uncovered not only contradictions in the theory of direct portrayal of nature but also obstacles to engagement in the assiduous carrying out of a realistic program. Some of these problems have already been mentioned. For Hunt and Rossetti there was the struggle to find a system of notation that kept the symbolic under control and in service of the naturalistic. At the same time Hunt wanted to avoid the material's getting the better of the spiritual in his painting. Too much detail could crowd out the possibility of engagement. Convention could not be avoided, but too hackneyed conventions could put off the reader or observer and trammel the artist.

When each object is painstakingly drawn as in a typical early Pre-Raphaelite picture the whole field of view is in focus. Distant detail of near and far is not proportionally less distinct. One possible effect is a hankering for the indistinct, which, as in Turner and the Impressionists, can be more realistic than unrelenting clarity in the sense

of reproducing what is actually seen. Too much distinct detail ultimately causes us to react to some Pre-Raphaelite canvases as pictures rather than as real scenes; although this reaction would have delighted Whistler or Matisse, it is not what the Pre-Raphaelites were aiming for. The distinctness of so many details has another effect: the equal visual stress on each object can make the observer feel in the lack of emphasis a disorientation and abulia about where the eyes are to come to rest.

Beyond matters of style there were also problems of range and scope which impeded engagement in Pre-Raphaelite work—both painting and poetry. The typical painting is a small easel picture with one or two figures in the near foreground, little depth, much natural detail, and bright colors. The Pre-Raphaelites scorned chiaroscuro effects, stayed away from subjects requiring large canvases and broad rather than minute treatment, did portraits only as hackwork, and painted surprisingly few pure landscapes. The poetry also tends to be limited in scope, describing a scene as tableau rather than drama, with a heated emotional atmosphere that is usually not discharged or resolved. Silence and stillness prevail; there is little action or development. The range of subjects is similar for both arts and includes medieval scenes, topics from Keats or Tennyson among modern poets, less often Dante or Shakespeare, rarely the ancients. Other possibilities are country scenes invested with symbolic import, religious subjects treated in an "early Christian" rather than full Renaissance fashion, "fallen" women, and some historical events. These sufficed to produce good work as the movement was getting under way, but the growth of developing talents needed more variety of subjects.

Although the Pre-Raphaelite Brotherhood early included more than the three original members and continued to attract converts well into the last quarter of the nineteenth century, it was a fairly short-lived movement.[39] It had lasting effects on English landscape art, but its immediate impact was absorbed by other trends in poetry and painting, trends characterized by aloofness rather than absorption and critical examination of surface rather than engagement. Pre-Raphaelitism gave signs of some of these developments and probably unwittingly hastened their advent. When Rossetti bragged

that his *Ecce Ancilla Domini!* was "the ancestor of all the white pictures which have since become so numerous," he was taking credit for influence on later "mood" pictures such as those Whistler called *Symphony in White, Arrangement in Grey and Black,* and so on.[40] In his "Ten O'Clock Lecture," Whistler records a movement in his own art away from engagement. He wished to keep attention at the surface of his pictures, and to reverse people's "habit of looking . . . not *at* a picture, but *through* it, at some human fact, that shall, or shall not, from a social point of view, better their mental or moral state."[41] Whistler's characterization of this "habit" was not a bad description of the aim of the Pre-Raphaelite program, but even though the Pre-Raphaelites endeavored to bring the spectator into their pictures, they also often meticulously decorated the surfaces of them with bright natural scenes whose ornamental value influenced later vogues such as Orientalism and whose emphasis on living forms affected Art Noveau in all its media.

Impressionism was the main pictorial trend away from engagement. Impressionism took the realistic approach of the Pre-Raphaelites to its logical extension in recording a momentary view, but the record was valued for its own sake rather than for any further truths it pointed to. The poetic equivalent was a technique of verbal impressionism or verbal photography which attempted to describe a scene or define a mood and stopped there, ambitious for no further effects.

Symbolism in poetry also tended away from engagement. Rossetti's experiments with sound in "The Blessed Damozel" and Swinburne's obsession with sound certainly fit a trend, if they did not influence it, in which English poetry followed French symbolist poetry from 1880 onward.[42] Here the synesthetic effect of "colored vowels" and other sense correspondences were explored by English followers of Baudelaire, Rimbaud, and Verlaine. Music became the operative metaphor and the aspiration of poetry as it had in the *Symphonies, Harmonies,* and *Nocturnes* of Whistler's painting. The epiphany of "The Woodspurge" turned into the unpointed description of "Le Jardin," and the social questioning of "Jenny" into the decadent and depressing symbols of "The Harlot's House." Finally, a more radical turning away from engagement happened in arts after

the turn of the century. Much twentieth-century art, when it is not rigidly and narrowly conceptual, tends to have as subject either some form of alienation or isolation or some aspect of the genesis, production, display, or reception of art itself. We can assent to what such works have to say, but we cannot be engaged by them.

5

The Earnestness of English Art

The last chapter concluded by asking why English arts turn away from engagement at the end of the nineteenth century. The answer is partly that English poets and painters adopt Continental aesthetic trends such as Impressionism, Symbolism, and Ornamentalism. This answer suggests that English artists moved away from native concerns when they abandoned engagement as an artistic goal. Other observations in the past chapters also suggest that there is something distinctive about the English temperament or about English arts that makes engagement a congenial artistic goal—or at least made it so for several centuries. I argued in the introduction that the development of English empirical theories about perception is related to the development of strategies for engagement in the English sister arts. We have seen that engagement strategies characterize the English school of Pre-Raphaelitism and of landscape poetry and painting as well as the vastly different but undeniably English arts of Blake and Hogarth. Is there something specifically English about engagement in art? Certainly engagement has at times been the aim of artists in other countries.[1] But is there some feature of the English character as expressed in art which puts engagement at such a premium for such a long time in England? In answering this question we will ultimately want to ask also whether engagement matters. Is engagement a criterion of value in art? Is a poem or painting better if it engages us?

177

The Englishness of English Art

For at least three hundred years writers have played the game of dissecting the English national character as it is revealed in her various arts. In 1690 Sir William Temple attempted to prove that a nation's art and learning were connected to its climate and atmosphere as well as to characteristics of its government. He thought such natural and political features, along with a wave theory of cultural progression from east to west, helped him to explain why, "When Greece and Rome were at their heights in Arts and Science, Gaul, Germany, Britain were as ignorant as any part of Greece or Turkey can be now."[2] Temple gives little credit to any modern European arts by comparison with the ancients, but he is prepared to grant the English credit for love of liberty, which in turn gives rise to originality in the arts, especially drama.[3] His assessment of the typical Englishman as rough, idiosyncratic, liberty-loving, and outwardly splenetic but honest and forthright agrees with that of many eighteenth-century essay writers such as Addison, Johnson, and Goldsmith.[4]

By the time an English school of painting has begun to emerge in the late eighteenth century, the personal force of Reynolds and Gainsborough is felt, and their special skills are singled out for comment as English traits. Thus Edward Dayes writes at the end of the century, "Of our own nation, the love of locality and portraiture may be said to strongly mark the amor patriae, and to exhibit our charity and love for each other."[5]

Matthew Arnold takes up the game of anatomizing the English artistic character in "On the Study of Celtic Literature" (1865–66). Though he is primarily concerned with discussing Celtic language and literature and urging their study at the universities, he finds room in this long essay to weigh the Celtic with the other elements in "the composite English genius"—the Germanic and the Norman:

> The Germanic genius has steadiness as it main basis, with commonness and humdrum for its defect, fidelity to nature for its excellence. The Celtic genius, sentiment as its main basis, with love of beauty, charm, and spirituality for its excellence, ineffectualness and self-will for its defect. The Norman genius, talent for affairs as its main basis, with strenuousness and clear rapidity for its excellence, hardness and insolence for its defect.[6]

Arnold does not think those things mentioned as shaping forces by Temple (and also by Goldsmith)—kind of government and climate—important by comparison with these ethnic forces (353). The main characteristic of the English genius for him is "energy with honesty" (341). English artists (he singles out Reynolds and Turner) fall short in "*architectonicé*, in the highest power of composition," though they excel "in magic, in beauty, in grace, in expressing almost the inexpressible" (354). English painters "are a little overbalanced by soul and feeling, work too directly for these, and so do not get out of their art all that may be got out of it" (355).

Arnold soon moves to religion. Here the Celtic element is seen to have tempered the rational, or Germanic, spirit of Protestantism with emotion. Puritanism, the distinctive form of English Protestantism, "has the outside appearance of an intellectual system, and the inside reality of an emotional system: this gives it its tenacity and force, for what is held with the ardent attachment of feeling is believed to have at the same time the scientific proof of reason" (356).

The Celtic element has exerted most force in English poetry, according to Arnold, who attributes to it style, melancholy, and concern with the magic of nature (361). He insists that magic is the right word because English poets, and by extension painters, do not treat nature in a way that is either conventional or strictly realistic, but so as to keep their eye on the object without losing any of the charm, delicacy, power, and magic which escapes both the practiced and the conventional (376–78).

In this century Herbert Read looked at what is distinctive about English art in two essays published in the thirties.[7] In the first essay, "Parallels in English Painting and Poetry," he found that an early and recurring quality of English art is its linear nature, and he made a fanciful connection between this lineality and the emphatic alliteration of Anglo-Saxon verse. Other characteristics he believed peculiarly English were "narrative directness," "fierce realism" and pessimism (232–34). This last, he says, echoing Temple, is "the gloom of northern peoples in general," which "was determined by their bitter struggle against the hostile forces of nature" (234).

Read draws most of his parallels from the eighteenth and nineteenth centuries, arguing that the eighteenth-century novel and Hogarth both show "a love of the grotesque" and "a certain realistic

violence" (240). In romantic artists, especially Constable and Words-worth, Read finds a desire to reproduce "the objectivity of the visible world," a desire which "is characteristic of the English mind, as represented by the empirical school in philosophy" (246).

In the second essay, "English Art," Read identifies as essential the qualities of linear freedom (254) and a realism which is earthy and often grotesque (256–57). Working against native aesthetic values, and indeed destructive of the very "will to art," according to Read, is Puritanism, which was responsible for the virtual disappearance of the plastic arts in England between the fourteenth and the eighteenth century (260–61).

Read carefully acknowledges his debts to Arnold, but is not himself treated so graciously. Twenty years after the book publication of Read's essays, Nikolaus Pevsner, in *The Englishness of English Art*, goes over much of the same ground with not even a footnote for Read. Pevsner does not argue for one set of distinctive features, but for "polarities"—"pairs of apparently contradictory qualities" such as those represented by the techniques of Turner and Constable, or by the Decorated and the Perpendicular styles in architecture.[8] These polarities reveal "Englishness" in their concern with line in architecture and atmosphere in painting. Close observation of everyday life is another hallmark of English arts, and Pevsner traces this interest to the philosophical background (as Read had done), writing that "a preference for the observed fact and the personal experience is indeed, as is universally known, the hall-mark of English philosophy through the ages." In support he cites Roger Bacon, Duns Scotus, Occam, and Francis Bacon (46). Read and Pevsner thus agree that directness of observation and realism are distinctive features of English art, and that these are related to the empiricist strain in English philosophy. Moreover Pevsner sees that the observation and the realism are felt as moral obligations; in writing of Hogarth he remarks that to him "art is a medium for preaching," and "the most effective sermon is the recounting of what the observant eye sees around" (36). But the generalization is not limited to Hogarth: speaking of these two notions—art as sermon and effectiveness as accurately reported observation—Pevsner says, "Both are English attitudes" (36).

The most recent writer to survey "The Englishness of English Art" was Ronald Paulson, who used that title for a review of several English exhibitions in 1983.[9] Paulson makes generalizations about English art which he has illustrated elsewhere, most notably in *Literary Landscape: Turner and Constable* (1982). He argues that the landscape painters gave more than accurate transcriptions of particular locations; they also "could express conservative ideology or embody the concept of *concordia discors* or allude to Roman values of order." Paulson is writing about contemporary artists and how they carry on in traditionally English artistic ways—believing in the significance of art and refusing to trivialize it, feeling its connection with political and social views, asserting "the empiricism of English painting," continuing the allusive and parodic mode of Hogarth and Blake, insisting on the importance of narrative.[10]

> English art is never satisfied with the thing itself (as Dutch art has been) or the forms themselves (as French art) or the expression of the object or of the subject (German art): it has always pointed outward to someone else's art in a self-deprecating way, downward to the quotidian, the ordinary life of the Englishman, and upward to some unobtainable and probably inappropriate ideal.[11]

Paulson repeats the observation of others that English landscape is distinguished by its regard for particular locale and, he adds, by "its nostalgia for the English past, and its need to evoke literary associations."[12]

The common feature all these writers find in English art is an earnestness about the obligation of art to tell truth as the artist observes and feels it. This feeling has its roots in empiricism; it is another manifestation of a wish to justify and praise the evidence of the senses, which also finds expression in philosophy. But this earnestness includes a profound conviction about art's connections with life—moral, political, and social, as well as physical. It is an attitude which has often been affected by popular taste, is rarely scornful of the crowd, and remains hopeful of the wide appeal of the best art. Puritanism has helped to create this earnestness as an accultured element of the soul and as a defense against its own

charges that art is flippant, irrelevant, or base. And if it is an attitude too eager to see the aims of painting and poetry as identical (*pace* Lessing), the eagerness has enriched both arts rather than confusing their individual aims and has produced double talents such as Blake and Rossetti.

The Alliance of Taste and Virtue

When Lord Kames wrote that "a taste in the fine arts goes hand in hand with the moral sense, to which indeed it is nearly allied," he called an alliance what many of his contemporaries considered an equivalence or even an identity.[13] "From Shaftesbury onwards," according to Samuel Kliger, "taste in art had almost invariably been conceived as a species of virtue. No notion was more characteristic of English neo-classicism than the idea that taste in the fine arts is an ally of morals."[14] And there is a peculiarly English tone in the remarks about the "publick benefits" of taste which Sir Joshua Reynolds makes in one of his annual addresses to the Royal Academy:

> The art which we profess has beauty for its object. . . . [I]t is an idea residing in the breast of the artist, which he is always labouring to impart, and which he dies at last without imparting; but which he is yet so far able to communicate, as to raise the thoughts, and extend the views of the spectator; and which, by a succession of art, may be so far diffused, that its effects may extend themselves imperceptibly into publick benefits, and be among the means of bestowing on whole nations refinement of taste: which, if it does not lead directly to purity of manners, obviates at least their greatest deprivation, by disentangling the mind from appetite, and conducting the thoughts through successive stages of excellence, till that contemplation of universal rectitude and harmony which began by Taste, may, as it is exalted and refined, conclude in Virtue.[15]

These equations of taste and virtue go back, of course, at least as far as the Platonic triad of the good, the true, and the beautiful. It would be absurd to call the idea of art's moral purpose an English idea, but there was a special earnestness with which the idea was grasped

in England. The fact that Reynolds is so concerned about art's effects, while his contemporary Lessing, for example, dismisses them in the first sentence of a preface, is evidence of the earnestness. One grain of salt with which Reynolds's words must be taken is the desire of painters to establish for their art a moral foundation comparable to that of poetry. As Lawrence Lipking has observed, Reynolds is working in this passage and elsewhere to try to give painting an ideal function and significance, to try to raise its status to equal that of poetry.[16]

But in both poetry and painting we must look beyond the words to the practice of artists. There is intense and overt earnestness of purpose in the major genres of poetry in the eighteenth and nineteenth centuries: in satire, in poetry of meditation and social protest, in poetry of religious questioning such as that of Tennyson and Clough, and in landscape poetry, which leads into political observations (on the model of the *Georgics*), into contemplation of the wisdom, goodness, or sheer power of God as expressed in creation, into "a sense sublime of something far more deeply interfused," or into feelings

> such, perhaps
> As have no slight or trivial influence
> On that best portion of a good man's life,
> His little, nameless, unremembered acts
> Of kindness and of love.

English poetry has abundance of the purely beautiful and the solely capricious, but for every caprice there are many earnest poems. For every "Ode on the Death of a Favourite Cat, Drowned in a Tub of Gold Fishes" there is an Eton College ode, an "Elegy Written in a Country Churchyard" and a "Sonnet on the Death of Richard West"—and even the ode on Selima the cat has its moral.

In painting the two major English kinds have an earnestness corresponding to that of the poetry. English landscape pictures do not merely praise or identify a locale; they assert values of husbandry or hospitality, contain political or theological meanings, and make social comments or criticisms. Portraiture, too, goes beyond panegyric to assert reasons for praising its subjects and memorializing

them. Reynolds's self-portrait in the National Portrait Gallery says that here is a young painter, not too handsome, with the observation of Rembrandt and the drama of Caravaggio; his self-portrait in the Dulwich Gallery says that here is an aging painter as honest with himself as Rembrandt. His portrait of Lord Heathfield shows the man is solid and trustworthy, as secure as Gibraltar's fortress whose key he holds with its chain wrapped twice around his big hand. His portrait of Lady Elizabeth Delmé and her children urges that solidarity and ties of love enhance the personal beauty of a woman and her children.

The earnestness of English art is not always a *moral* earnestness. Sometimes it is just an assent to nature's power or beauty or inspirational significance for our lives. Sometimes it is merely an earnestness to record, to get it down right. Thus Turner, being told of someone's favorable reaction to his *Snow Storm*, was not pleased that it was "understood" or liked:

> I did not paint it to be understood, but I wished to show what such a scene was like. I got the sailors to lash me to the mast to observe it. I was lashed for four hours, and I did not expect to escape; but I felt bound to record it if I did. But no one had any business to like the picture.[17]

Testimony of the passion to record correctly can be found throughout the history of English painting and poetry. But it is not unusual for the earnestness to be expressed as moral earnestness which has as its aim purification and a beauty which is that of virtue and truth. Thus Holman Hunt talks about making "art a handmaid in the cause of justice and truth," calls the Venetian painters "prophets," and records Rossetti's speaking to Woolner about the Pre-Raphaelite resolution "to turn more devotedly to Nature as the one means of purifying art."[18] Wordsworth identifies taste with moral feelings in the "Preface to the *Lyrical Ballads*," Constable often refers to the "morality" of landscape painting in his letters, and Ruskin frequently uses beauty to mean moral beauty.

What Henry James had to say about the Pre-Raphaelites in comparing them with the Impressionists could do just as well to describe English artists' attitudes in general:

the divergence in method between the English Pre-Raphaelites and this little group [of French Impressionists] is especially striking, and very characteristic of the moral differences of the French and English races. When the English realists "went in," as the phrase is, for hard truth and stern fact, an irresistible instinct of righteousness caused them to try and purchase forgiveness for their infidelity to the old more or less moral proprieties and conventionalities, by an exquisite, patient, virtuous manipulation—by being above all things laborious. But the Impressionists, who, I think, are more consistent, abjure virtue altogether, and declare that a subject which has been crudely chosen shall be loosely treated. They send detail to the dogs and concentrate themselves on general expression. Some of their generalizations of expression are in a high degree curious. The Englishmen, in a word, were pedants, and the Frenchmen are cynics.[19]

It is ironic that just as England gets in Ruskin her most eloquent spokesman for the morality of art and the necessity of engagement, Continental influences begin to submerge the native earnestness of the English artistic character. Soon Whistler will argue, in the "Ten O'Clock Lecture," that beauty must not be "confounded with virtue," and Oscar Wilde, in his preface to *The Picture of Dorian Gray*, will grow sententious on the necessary amorality of art:

The moral life of man forms part of the subject-matter of the artist, but the morality of art consists in the perfect use of an imperfect medium. No artist desires to prove anything. Even things that are true can be proved.

No artist has ethical sympathies. An ethical sympathy in an artist is an unpardonable mannerism of style.

But we should not forget that Whistler was an American repeating French ideas, and Wilde wrote these pronouncements as preface to a novel with the most moralistic of endings.

Earnestness and Engagement

The aestheticism of the end of the last century and art's self-reference and alienation in this century are only temporary turnings away

from an indigenous English desire to engage the audience of art. A special and earnest emphasis on engagement deserves to be considered as distinctively English a feature of painting and poetry as those which Arnold, Read, Pevsner, and others have enumerated. The works of those considered in this book reveal an attitude about man's necessity to engage with his natural and social surroundings. For these artists, society is not just a theater for our amusement and detached observation but an arena where criticism is expected and change can be attempted through satire or more solemn arts of social reform. In these works the individual is not simply the focus of interest as a singular and idiosyncratic object, but a person with whom we can identify and from whom we can learn. These works locate us, as observers, in a position similar to Samuel Johnson's reader of biography, "placing us, for a Time, in the Condition of him whose Fortune we contemplate; so that we feel, while the Deception lasts, whatever Motions would be excited by the same Good or Evil happening to ourselves."[20] Writing of his favorite art form, Johnson puts his finger on the nature of engagement in all art. The works we have been examining in the preceding chapters reveal attitudes about landscape similar to those about people: landscape is not merely backdrop but helps to define its inhabitants, who may improve it or be improved by humble contemplation of its terrors and glories.

The works of these English artists have a strain of earnestness, usually tempered by humor. They show a striving for meaning in all that surrounds us, but that is a universal human quality of art. What is more distinctive here is an occasionally Philistine idea that poetry and painting are for something, and an attitude of responsibility for the world. Hogarth, Johnson, Reynolds, Wordsworth, and Ruskin, painters and poets and critics of art, all share the conviction that art must connect with the moral life. They do not speak for every English artist, but they do represent one important strain in the English temperament.

And this brings us to our final question. Is engagement a criterion of value in art? The answer must be a qualified yes. It is one, though not a sole, criterion of value. No one thinks any less of a sunset because it does not force intellectual or moral engagement, and art may simply transmit natural or formal beauty as a sunset does. There

will always be a place for art that is purely and simply beautiful, requiring no commitments of its observers. Every period needs aestheticism as well as engagement. But our waning century seems especially lacking in art that engages, and art's self-reference seems to be cutting it away from its own culture. At the active and existential end of a scale whose other end is quietism and fatalism, engagement may be sometimes out of fashion, but never out of grace. Browning's Fra Lippo says:

> we're made so that we love
> First when we see them painted, things we have passed
> Perhaps a hundred times nor cared to see;
> And so they are better, painted—better to us.
> Which is the same thing. Art was given for that. . . .
> This world's no blot for us,
> Nor blank; it means intensely, and means good:
> To find its meaning is my meat and drink.
>
> [Lines 300–304; 313–15]

The painters and poets in this book labored to find that meaning and to engulf the observer in it and its consequences.

Notes

Introduction

1. John Berger, *About Looking* (New York: Pantheon, 1980), 147–48.
2. John Reichert, *Making Sense of Literature* (Chicago: University of Chicago Press, 1977), 61.
3. Henry Home, Lord Kames, *Elements of Criticism*, 3 vols. (Edinburgh: Millar, Kincaid and Bell, 1762). Further references to this work in the Introduction will be given in the text in parentheses.
4. Eric Rothstein, " 'Ideal Presence' and the 'Non Finito' in Eighteenth-Century Aesthetics," *Eighteenth-Century Studies* 9 (1976), 307–32.
5. Robert Hughes, *The Shock of the New* (New York: Knopf, 1980), 111; George Steiner, *Language and Silence: Essays on Language, Literature and the Inhuman* (New York: Atheneum, 1977), 5; José Ortega y Gassett, *The Dehumanization of Art and Other Essays on Art, Culture, and Literature* (Princeton: Princeton University Press, 1948).
6. Illustrations have been used in English dictionaries since the wood-cuts of the 1707 *Glossographia Anglicana Nova* and the engravings in Nathan Bailey's 1721 *Universal Etymological Dictionary*. Ostensive or graphic definition is probably the oldest and still one of the most effective techniques in conveying meanings of certain kinds of words. An example of an accusatory painting is Nathaniel Hone's *The Conjuror*, submitted to the Royal Academy in 1775 and now in the National Gallery of Ireland. The picture is an accusation of plagiarism against Sir Joshua Reynolds. Hone was an Irishman who had known Reynolds in Italy, when both were studying Renaissance art. Hone's conjuror is painted from the same model Reynolds used for his famous picture from Dante, *Ugolino*. The conjuror uses his wand to bring forth a cascade of prints of the old masters, from each of which Reynolds had taken a pose or a whole composition to use in his portraits. See Ellis Waterhouse, *Reynolds* (London: Phaedon, 1973), 27–28.

7. Michael Fried discusses Diderot's "reiterated assertion that he is inside the paintings" he is reviewing, in *Absorption and Theatricality: Painting and Beholder in the Age of Diderot* (Berkeley: University of California Press, 1980), 119.

8. Ronald Paulson, "The Englishness of English Art," *New Republic*, 25 April 1983, 24.

9. Translations of Helmholtz's two papers, "Die Thatsachen in der Wahrnehmung" ("The Facts of Perception," 1878) and "Über den Ursprung der richtigen Deutung unserer Sinneseindrücke" ("The Origin of the Correct Interpretation of Our Sensory Impressions," 1894), may be found in *Helmholtz on Perception: Its Physiology and Development*, by Richard M. Warren and Rosalyn P. Warren (New York: Wiley, 1968), 207–46 and 249–60.

10. Warren and Warren, *Helmholtz*, 210.

11. *An Essay Towards a New Theory of Vision* (1709), in *The Works of George Berkeley*, ed. Alexander Campbell Fraser, 4 vols. (Oxford: Clarendon Press, 1901). Vol. 1, secs. 41–56, p. 50. Berkeley, like Locke, uses *perception* in more than one sense. As George J. Stack writes, "The description of the nature of perception, as it is presented in the *Essay Towards a New Theory of Vision*, is rather ambiguous. For, at times, Berkeley writes as if he conceived of perception as purely the passive receptivity of sensations. At other times, he describes perception as a kind of inferential activity, a spontaneous process of cognition" (*Berkeley's Analysis of Perception* [The Hague: Mouton, 1970], 48).

12. Locke's *Essay Concerning Human Understanding*, 2.9.8; Berkeley's *An Essay Towards a New Theory of Vision*, sec. 132. See also Nicholas Pastore, *Selective History of Theories of Visual Perception: 1650–1950* (New York: Oxford University Press, 1971), "Locke and Molyneux," 57–70, and "Berkeley," 71–99.

13. For example, Locke, *Essay*, 2.14.3; Berkeley, *Commonplace Book*, in *Works*, 1:58–59; Hume, *A Treatise of Human Nature*, 1.2.3. See also John Tull Baker, *An Historical and Critical Examination of English Space and Time Theories from Henry More to Bishop Berkeley* (Bronxville, N.Y.: Sarah Lawrence College, 1930), 19, 37.

14. Wolfgang Iser, *The Implied Reader: Patterns in Communication in Prose Fiction from Bunyan to Beckett* (Baltimore: Johns Hopkins University Press, 1974), 278–79; and also Iser, "Indeterminacy and the Reader's Response in Prose Fiction," *Aspects of Narrative: Selected Papers from the English Institute*, ed. J. Hillis Miller (New York: Columbia University Press, 1971), 1–45; Iser's use of some of these terms, for example, indeterminacy, is indebted to Roman Ingarden's work, especially *The Cognition*

of the *Literary Work of Art*, trans. Ruth Ann Crowley and Kenneth Olson (Evanston: Northwestern University Press, 1973); Rothstein, " 'Ideal Presence,' " 323.

15. Iser, *Implied Reader*, 275.

16. Stanley Fish, *Self-Consuming Artifacts: The Experience of Seventeenth-Century Literature* (Berkeley: University of California Press, 1972); *Is There a Text in This Class?: The Authority of Interpretive Communities* (Cambridge: Harvard University Press, 1980), 27.

17. Wolfgang Iser, *The Act of Reading: A Theory of Aesthetic Response* (Baltimore: Johns Hopkins University Press, 1978), 27–38.

18. Maynard Mack, "The Muse of Satire," *Yale Review* 41 (1951), 80–92.

19. Wayne C. Booth, *The Rhetoric of Fiction* (Chicago: University of Chicago Press, 1961), 137–38; Walker Gibson, "Authors, Speakers, Readers, and Mock Readers," *College English* 11 (1950), 265–69. Erwin Wolff, "Der intendierte Leser: Überlegungen und Beispiele zur Einführung eines literaturwissenschaftlichen Begriffs," *Poetica* 4 (1971), 141–66.

20. Iser, *Act of Reading*, 36–38.

21. Fish, *Is There a Text in This Class?*, 25.

Chapter 1: Time and Space for the Observer to Enter

1. Anthony Ashley Cooper, third earl of Shaftesbury, writes in *Characteristicks of Men, Manners, Opinions, Times* (London, 1714) that once a painter has made a choice of the moment he will depict, he "is afterwards debar'd the taking advantage from any other Action than what is immediately present, and belonging to that single Instant he describes" (3:353). James Harris, writing near mid-century, insists that "of necessity every Picture is a *Punctum Temporis* or Instant" (*Three Treatises, The First Concerning Art. The Second Concerning Music, Painting and Poetry. The Third Concerning Happiness* [London: H. Woodfall, 1774], 63). Lessing's *Laocoön* (1766) becomes a compendium, or digest, of earlier opinions on the limitations of the arts; its author writes that "painting, by virtue of its symbols or means of imitation, which it can combine in space only, must renounce the element of time entirely." (Gotthold Ephraim Lessing, *Laocoön: An Essay on the Limits of Painting and Poetry*, trans. Edward Allen McCormick [Indianapolis: Bobbs-Merrill, 1962], 77).

2. A fifteenth-century example, the illustration of Terence's *Andria* from the 1496 Strassburg edition of his plays, is reproduced as the frontis-

piece of Madeleine Doran's *Endeavors of Art: A Study of Form in Elizabethan Drama* (Madison: University of Wisconsin Press, 1964). Another example is an engraving from Geoffrey Whitney's *A Choice of Emblemes* (Leiden: Plautin, 1586): "Homo homini lupus"—an emblem of man's inhumanity to man, which shows Arion as he is being thrown into the sea by his shipmates, his harp already having been thrown over, while a dolphin watches in the foreground. Then in the left distance, he rides the dolphin and plays his harp, having been saved by this rather fancifully imagined sea-creature. The Garden of Eden section of Genesis furnished subjects for many multiple-scene paintings in Europe: Mariotto Albertinelli (1474–1515) includes four separate scenes in his Eden painting (Courtauld Institute), and there are no fewer than six scenes from the Garden in a *Paradise* by Lucas Cranach (1472–1553) which Roland M. Frye reproduces in *Milton's Imagery and the Visual Arts* (Princeton: Princeton University Press, 1978).

3. Karl Kroeber, *Romantic Landscape Vision: Constable and Wordsworth* (Madison: University of Wisconsin Press, 1975), 31.

4. Many of these series treat what Hogarth called "modern moral subjects": they call attention to problems of manners and social tyranny. The nineteenth-century examples are often sentimental as well. But not all of them preach or sentimentalize. Edward Burne-Jones painted a four-part series on the Pygmalion story in 1878. The four paintings, given the general title of *Pygmalion and the Image* (Birmingham City Museum and Art Gallery), are called "The Heart Desires," "The Hand Refrains," "The Godhead Fires," and "The Soul Attains." The sequence romanticizes the artist's work—as does the myth—but it does so without sentimentality.

5. Linda Nochlin, "Lost and Found: Once More the Fallen Woman," *Art Bulletin* 58 (1978), 140. T. J. Edelstein, "Augustus Egg's Triptych: A Narrative of Victorian Adultery," *Burlington Magazine* 125 (1983), 207.

6. Rudolf Arnheim, "Space as an Image of Time," in *Images of Romanticism: Verbal and Visual Affinities*, ed. Karl Kroeber and William Walling (New Haven: Yale University Press, 1978), 1–12.

7. George P. Landow, *William Holman Hunt and Typological Symbolism* (New Haven: Yale University Press, 1979). The quotation is from Landow's *Victorian Types, Victorian Shadows: Biblical Typology in Victorian Literature, Art, and Thought* (London: Routledge and Kegan Paul, 1980), 132. Earl Miner edited *Literary Uses of Typology from the Late Middle Ages to the Present* (Princeton: Princeton University Press, 1977). Paul Korshin's book is *Typologies in England 1650–1820* (Princeton: Princeton University Press, 1982).

8. E. H. Gombrich, "Movement and Movement in Art," *Journal of the*

Warburg and Courtauld Institutes 27 (1964), 303–304. Gombrich's article is the best written on this subject, but another helpful source is Sarah L. Friedman and Marguerite B. Stevenson, "Perception of Movement in Pictures," in *The Perception of Pictures: Alberti's Window: The Projective Model of Pictorial Information*, ed. Margaret A. Hagen (New York: Academic Press, 1980), 225–55. A very useful bibliography on the subject of time in the sister arts may be found in *Aspects of Time*, ed. C. A. Patrides (Manchester: Manchester University Press, 1976), 250–70.

9. Ronald Paulson discusses the boy/dog parallels of this picture in *Emblem and Expression: Meaning in English Art of the Eighteenth Century* (Cambridge: Harvard University Press, 1975), 208.

10. Michael Fried, *Absorption and Theatricality: Painting and Beholder in the Age of Diderot* (Berkeley: University of California Press, 1980), 4. Another example of the kind of composition described in this paragraph is John Collier's *The Pharaoh's Handmaidens* (1883; private collection). Here there are also two women, one speaking in the other's ear, the other holding the beholder's gaze. The typical Victorian beholder drawn into this picture would have gotten an added fillip from the almost-complete nakedness of the handmaidens, who wear only narrow loincloths.

11. Etienne Souriau makes the best statement of the psychological truth here: "Naturally, the ill-founded contrast between the arts of space and the arts of time has some foundation in sense. There are obviously notable differences in the manner in which time is used in one group and in the other. But what exactly are those differences? One may say: the difference is self-evident: a musical, poetic, choreographic, or cinematic work is unfolded in *successive moments*, while a pictorial, sculptural, or architectural work is seen in *its entirety in a single instant*. But this last point is *clearly false*. In the case of painting . . . no doubt a single glance which catches a view of the whole is possible, and it is even of great importance for aesthetic appreciation. But it is not sufficient. Can one appreciate the full beauty of a painting without a period of contemplation wherein successive reactions take place? . . . We see at least that in all the arts there is a 'time of contemplation' filled with successive psychic facts, more or less prolonged, and of which the aesthetic content is important" ("Time in the Plastic Arts," *Journal of Aesthetics and Art Criticism* 7 [1949], 294–95; reprinted in *Reflections on Art*, ed. Susanne K. Langer [Baltimore: Johns Hopkins University Press, 1958], 122–41).

12. *Essays of John Dryden*, ed. W. P. Ker (Oxford: Clarendon Press, 1926), 2:121.

13. Robert R. Wark, "Hogarth's Narrative Method in Practice and Theory," in *England in the Restoration and Early Eighteenth Century: Essays on Culture and Society*, ed. H. T. Swedenberg, Jr. (Berkeley: University of California Press, 1972), 162–63.

14. See, for example, Guy Thomas Buswell, *How People Look at Pictures* (Chicago: University of Chicago Press, 1935), esp. 18–31, and A. L. Yarbus, *Eye Movements and Vision* (New York: Plenum Press, 1967).

15. Locke, *Essay*, 2.14.3, 17; Dryden, *Essays*, 2:121.

16. Suzanne K. Langer, *Feeling and Form: A Theory of Art* (New York: Scribner's, 1953), 72.

17. Gombrich, "Moment and Movement in Art," 299–300.

18. Arnheim, "Space as an Image of Time," 1–2.

19. W. J. T. Mitchell, "Spatial Form in Literature: Toward a General Theory," *Critical Inquiry* 6 (1980), 539–67. Subsequent references to this article are in parentheses in the text.

20. Northrop Frye, *Anatomy of Criticism* (Princeton: Princeton University Press, 1957; reprint, New York: Atheneum, 1966), 77. The sentence is quoted by Mitchell, "Spatial Form," 553.

Chapter 2: Engaging Metaphors: Comparative Figures in Hogarth and Blake

1. William Makepeace Thackeray included Hogarth among the literary figures in his *English Humorists* (1853), and Hogarth has always attracted as much or more attention from literary scholars as from students of art. Robert Etheridge Moore treated the artist's friendships with literary men and his influence on them in *Hogarth's Literary Relationships* (Minneapolis: University of Minnesota Press, 1948). The most definitive modern works on Hogarth were written by a literary scholar, Ronald Paulson: *Hogarth's Graphic Works*, 2 vols., rev. ed. (New Haven: Yale University Press, 1970), and *Hogarth: His Life, Art and Times*, 2 vols. (New Haven: Yale University Press, 1971). This chapter owes a great deal to Paulson's notes and commentary on *The Rake's Progress*.

2. Austin Dobson, *William Hogarth*, rev. ed. (New York: McClure, 1907), 33–34; quoted in Vivian de Sola Pinto, "William Hogarth," in *From Dryden to Johnson*, the Pelican Guide to English Literature 4, ed. Boris Ford (Baltimore: Penguin, 1957), 282.

3. Peter Quennell, *Hogarth's Progress* (New York: Viking, 1956), 127.

4. Alexander Pope, *Epistle to Burlington*, lines 1–4.

5. Alexander Pope, *An Essay on Criticism*, lines 1–2.
6. See "The Painting vs. the Print," in Paulson, *Hogarth*, 1:405–22.
7. Moore, *Hogarth's Literary Relationships*, 124.
8. Alexander Pope, *Epistle to Bathurst*, lines 177–218; Paulson mentions the *Epistle to Bathurst* and also *The Tatler*, no. 249 (the adventures of a shilling) in *Hogarth's Graphic Works*, 1:161.
9. E. H. Gombrich comments on Hogarth's physiognomic theories in "The Mask and the Face: The Perception of Physiognomic Likeness in Life and Art," in *Art, Perception, and Reality*, ed. Maurice Mandelbaum (Baltimore: Johns Hopkins University Press, 1972), 36–37.
10. In *Hogarth's Graphic Works*, 1:162, Paulson refers to John Trusler's claim, in *Hogarth Moralized* (1768), ed. John Major (London, 1831), 127, that the harpsichordist was Handel.
11. "There is another set of gentry more noxious to the art than these [i.e., the critics], and those are your picture-jobbers from abroad who are always ready to raise a great cry in the prints whenever they think their craft is in danger; and indeed it is their interest to depreciate every English work, as hurtful to their trade, of continually importing shiploads of dead Christs, Holy Families, Madonas, and other dismal dark subjects, neither entertaining nor ornamental; on which they scrawl the terrible cramp names of some Italian masters, and fix on us poor Englishmen the character of *universal dupes*" (Hogarth's letter to *St. James Evening Post* of June 7–9, 1737, quoted from Austin Dobson, *William Hogarth*, 56.
12. Paulson, *Hogarth's Graphic Works*, 1:163.
13. Ian Donaldson, "The Satirists' London," *Essays in Criticism* 25 (1975), 101; the rest of the article (101–22) explores "some of the problems which flow from this notion of apparent 'truth' " (101).
14. Paulson identifies Hogarth's allusion to the elder Cibber's statues in *Hogarth's Graphic Works*, 1:170.
15. Hogarth's pictorial allusions reveal a sophistication which his home-grown bluff Englishness belies. He borrows ideas and compositions from painters as diverse as Jan Steen and Annibale Carraci, as well as Rembrandt, Raphael, Van Dyck, and others. See Joseph Burke, *English Art, 1714–1800* (Oxford: Clarendon Press, 1976), 161–62.
16. Robert W. Uphaus, *The Impossible Observer: Reason and the Reader in 18th-Century Prose* (Lexington: University Press of Kentucky, 1979), 8.
17. Geoffrey Tillotson, *On the Poetry of Pope* (Oxford: Clarendon Press, 1938), 141–59.
18. Ronald Paulson, "*The Harlot's Progress* and the Tradition of History Painting," *Eighteenth-Century Studies* 1 (1967), 70.

19. Robert F. Gleckner simply admits that he does not know how to read "The Fly" in *The Piper and the Bard: A Study of William Blake* (Detroit: Wayne State University Press, 1959), ix. S. Foster Damon, in *William Blake: His Philosophy and Symbols* (Boston: Houghton Mifflin, 1924), commented briefly on the poem at pp. 275–76 and included three sentences on the design at p. 285, but critical debate over the poem began with three pieces in *Essays in Criticism* 11 (1961): Leo Kirschbaum, "Blake's 'The Fly,' " 154–62 (further page references are in the text); F. W. Bateson, "An Editorial Postscript," 162–63; and John E. Grant, "Misreadings of 'The Fly,' " 481–86. Grant expanded his short note into "Interpreting Blake's 'The Fly,' " *Bulletin of the New York Public Library* 67 (1963), 593–615; it is to this article that parenthetical page numbers refer in this chapter. The year 1963 was also the time of Hazard Adams's discussion of the poem in *William Blake: A Reading of the Shorter Poems* (Seattle: University of Washington Press, 1963), 286–88, and Harold Bloom's even shorter treatment in *Blake's Apocalypse: A Study in Poetic Argument* (New York: Doubleday, 1963), 136–37. The next year E. D. Hirsch, Jr., gave the poem a somewhat longer look in *Innocence and Experience: An Introduction to Blake* (New Haven: Yale University Press, 1964), 236–41 (further page references are in the text). Warren Stevenson's short article, "Artful Irony in Blake's 'The Fly,' " *Texas Studies in Literature and Language* 10 (1968), 77–82, generally follows Grant (as Stevenson admits). The next full-length commentary was Jean H. Hagstrum's "The Fly," in *William Blake: Essays for S. Foster Damon*, ed. Alvin H. Rosenfeld (Providence: Brown University Press, 1969), 368–82; Alicia Ostriker briefly discussed the poem that year in "Metrics: Pattern and Variation," *Twentieth Century Interpretations of Songs of Innocence and of Experience*, ed. Morton D. Paley (Englewood Cliffs, N.J.: Prentice-Hall, 1969), 10–29 (further page references are in the text). In 1970 Michael J. Tolley and Jean Hagstrum engaged in a debate over Hagstrum's reading of "The Fly" in *Blake Studies* 2 (1970), 77–88. Other commentaries include David Wagenknecht's *Blake's Night: William Blake and the Idea of Pastoral* (Cambridge: Harvard University Press, Belknap Press, 1973), 106–10 (further page references are in the text except where ambiguity may result); David Erdman, *The Illuminated Blake: All of William Blake's Illuminated Works with a Plate-by-Plate Commentary* (Garden City, N.Y.: Doubleday, Anchor Books, 1974), 82; C. N. Manlove, "Engineered Innocence: Blake's 'The Little Black Boy' and 'The Fly,' " *Essays in Criticism* 27 (1977), 112–21; Thomas E. Connolly, "Point of View in Interpreting 'The Fly,' " *English Language Notes* 22 (1984), 32–37.

20. Wagenknecht, *Blake's Night*, has noticed the unique two-column arrangement and has suggested it implies a dialogue between two speakers (109), but he does not connect the two separate columns with the two illustrations. Grant also notices the double column and its "distinctly serpentine" dividing branches, concluding that this "device seems to imply a pictorial criticism of the action and reasoning of the unknown speaker of the poem" (608). But even though he also notices the distinct separation of the illustrations below by the two slopes of the ground and the foreground/background they help create (608), he does not connect the separate illustrations with the separate parts of the text. Hagstrum describes each side of the plate, in separate passages, and still does not connect the separate pictures with the distinct parts of the text they are intended to expand and comment upon (368–69).

21. Grant cites *Auguries of Innocence*, lines 33–34, as specific verbal echo of the Lear lines: "The wanton boy that kills the Fly / Shall feel the Spider's enmity." Damon, *William Blake*, also points out that Gray's "Ode I" on the spring compares the fly "Brush'd by the hand of rough Mischance" to man's situation (275–76).

22. Mario Praz, *Mnemosyne: A Parallel between Literature and the Visual Arts* (Princeton: Princeton University Press, 1967), 137. Muriel C. Bradbrook briefly examines the extent of the "Fortune's tennis" metaphor in "Two Notes upon Webster," *Modern Language Review* 42 (1947), 287. Professor David Bergeron has also drawn my attention to Middleton's masque entitled *The World Toss'd at Tennis* and to Quicksilver's speech on Fate's workings as a tennis game in *Eastward Ho!* by Ben Jonson, John Marston, and George Chapman (2.2.75–80). There is no corresponding tradition treating Fate's turns as a game at battledore and shuttlecock; Blake's idea is an original twist. But one of Jacob Cats's emblems does show a man and woman playing battledore and shuttlecock; with the motto *Amor, ut pila, vices exigit* (Rosemary Freeman, *English Emblem Books* [London: Chatto and Windus, 1948], 46). For a well-researched article on Blake's knowledge of emblem books, see Judith Wardle, " 'For Hatching ripe': Blake and the Educational Uses of Emblem and Illustrated Literature," *Bulletin of Research in the Humanities* 81 (1978), 324–48.

23. Samuel Richardson, *Pamela, or Virtue Rewarded* (1740; reprint, New York: Norton, 1958), 256.

24. Hagstrum, "The Fly," 3–7.

25. Wagenknecht, *Blake's Night*, 110.

26. Ostriker, "Metrics," 22, and Wagenknecht, *Blake's Night*, 109–10.

27. Schorer quotes Jung on the biblical archetype, though Jung was not comparing the myth to Blake's system (*William Blake: The Politics of Vision* [New York: Holt, 1946], 268).
28. Damon, *William Blake*, 275–76; Grant, "Interpreting Blake's 'The Fly,'" 605.

Chapter 3: Nature and Engagement

1. James Turner, *The Politics of Landscape* (Cambridge: Harvard University Press, 1979).
2. Paulson's classification appears in *Literary Landscape: Turner and Constable* (New Haven: Yale University Press, 1982), 21–60. Paulson quotes Berger, who talks about "various iconographic formulae for integrating figures and landscape. Distant figures like notes of colour. Portraits to which nature interweaves to 'dance to the music of time.' Dramatic figures, whose passions nature reflects and illustrates. The visitor or solitary onlooker who surveys the scene, an *alter ego* for the spectator himself" *About Looking* (New York: Pantheon, 1980), 77. Paulson also relies partly on Jay Appleton, whose *The Experience of Landscape* (New York: Wiley, 1975) takes a biological evolutionary view of what happens when we look at landscape: Appleton says we seek out sources of shelter and refuge, places from which we can safely observe, and this is how we enter a landscape, a process aided by spectator surrogate figures in the picture (6–8). Andrew Wilton discusses varieties of the sublime landscape in his exhibition catalogue, *Turner and the Sublime* (London: British Museum Publications, 1980), and John Barrell considers how figure/landscape combinations reveal attitudes toward the poor in *The Dark Side of the Landscape: The Rural Poor in English Painting 1730–1840* (Cambridge: Cambridge University Press, 1980).
3. Turner, *Politics*, 5–6.
4. Graham Reynolds, *Constable: The Natural Painter* (New York: McGraw-Hill, 1965), 140.
5. The best discussion of the poem is in Earl R. Wasserman's *The Subtler Language: Critical Readings of Neoclassic and Romantic Poems* (Baltimore: Johns Hopkins University Press, 1959). Brendan O Hehir makes important distinctions between the early (1642) and late editions of the poem in *Expans'd Hieroglyphics: A Critical Study of Sir John Denham's Coopers Hill* (Berkeley: University of California Press, 1969).
6. Ronald Paulson, *Emblem and Expression: Meaning in English Art of the Eighteenth Century* (Cambridge: Harvard University Press, 1975), 229.

7. "The King's Account of His Escape," William Matthews's transcription of Samuel Pepys's shorthand notes dictated by Charles II, in *Charles II's Escape from Worcester: A Collection of Narratives Assembled by Samuel Pepys* (Berkeley: University of California Press, 1966), 51.

8. Allen Staley, *The Pre-Raphaelite Landscape* (Oxford: Clarendon Press, 1973), 85.

9. Karl Kroeber, *Romantic Landscape Vision: Constable and Wordsworth* (Madison: University of Wisconsin Press, 1975).

10. James L. Hill, "The Frame for the Mind: Landscape in 'Lines Composed a Few Miles above Tintern Abbey,' 'Dover Beach,' and 'Sunday Morning,' " *Centennial Review* 18 (1974), 34–35.

11. Kroeber, *Romantic Landscape Vision*, 31.

12. H. M. Margoliouth makes the suggestion in *The Poems and Letters of Andrew Marvell*, vol. 1: *Poems*, 2d ed. (Oxford: Clarendon Press, 1967), 224. Margoliouth originally published this idea with some other notes on Marvell in a journal article in 1922. He conjectures that the T.C. of the poem *did* in fact die young and that she was the second of three Cornewall children to be named after their mother Theophila. "Andrew Marvell: Some Biographical Points," *Modern Language Review* 17, (1922), 351–61. John T. Shawcross has pointed out to me what Margoliouth missed, namely that the phrase "darling of the gods" in line 10 is very convincing internal evidence that the poem is about a Theophila—literally "loved of the gods."

13. See A. Dwight Culler's discussion of this passage in *Imaginative Reason: The Poetry of Matthew Arnold* (New Haven: Yale University Press, 1966), 26–28.

14. John Barrell, *The Dark Side of the Landscape: The Rural Poor in English Painting, 1730–1840* (Cambridge: Cambridge University Press, 1980), 85.

15. Ibid., 15, 136.

16. Roy Strong, *Recreating the Past: British History and the Victorian Painter* (London: Thames and Hudson, 1978), 104, 119–21.

17. "The Three Colours of Pre-Raphaelitism," in *The Works of John Ruskin*, ed. E. T. Cook and Alexander Wedderburn (London: George Allen and Longmans Green, 1903–12), 34:150–51.

18. Michael Cohen, "The Rainbow in Millais' *The Blind Girl*," *Journal of Pre-Raphaelite Studies* 3 (1982), 16–27.

19. Staley, *The Pre-Raphaelite Landscape*, 127.

20. David Cordingly summarizes the literary background (though he omits Austen) in " 'The Stonebreaker': An Examination of the Landscape in a Painting by John Brett," *Burlington Magazine* 124 (1982), 142.

21. Marcia Pointon, "Geology and Landscape Painting in Nineteenth-Century England," *Images of the Earth: Essays in the History of the Environmental*

Sciences, ed. L. J. Jordanova and Roy S. Porter (Chalfont St. Giles: British Society for the History of Science, 1979), 97.

22. Cordingly, " 'The Stonebreaker,' " 145.

23. Ronald Paulson, "Turner's Graffiti: The Sun and Its Glosses," in *Images of Romanticism: Verbal and Visual Affinities*, ed. Karl Kroeber and William Walling (New Haven: Yale University Press, 1978), 167–88. Paulson concludes that the sun is an "ambiguous" symbol, which seems an understatement. He mentions Milton once in the article, but not Thomson. A revision of this article becomes part of his book *Literary Landscape*.

24. E. H. Gombrich, "Visual Metaphors of Value in Art," in *Meditations on a Hobby Horse and Other Essays on the Theory of Art* (New York: Phaidon, 1978), 12–29.

25. *'Longinus' on Sublimity*, trans., ed., and with an introduction and commentary by D. A. Russell (Oxford: Clarendon Press, 1965), 12.

26. Ten letters and four treatises in Greek, probably written in the Near East about A.D. 500, have been falsely attributed to the first-century convert to Christianity, Dionysius the Areopagite, who was himself later confused (by Abbot Suger among others) with the third-century Saint Denis, patron of France and of the Abbey Saint-Denis. This discussion of the Abbot and the Pseudo-Dionysius depends on Erwin Panofsky's essay in *Meaning in the Visual Arts* (Garden City, N.Y.: Doubleday, 1955), 108–45, and the Gombrich essay "Visual Metaphors."

27. See Murray Roston, *Prophet and Poet: The Bible and the Growth of Romanticism* (London: Faber and Faber, 1965), 117.

28. Marjorie Hope Nicolson, *Mountain Gloom and Mountain Glory: The Development of the Aesthetics of the Infinite* (Ithaca: Cornell University Press, 1959); *Spectator*, no. 414; John Dennis, *The Grounds of Literary Criticism in Poetry*, in *The Critical Works of John Dennis*, ed. Edward Niles Hooker (Baltimore: Johns Hopkins University Press, 1939–43), 1:347–54.

29. Thomson, *Spring*, lines 79–83, 394–95; *Summer*, lines 130–61.

30. Paulson, *Literary Landscape*, 49.

31. Kenneth Clark, *Looking at Pictures* (Boston: Beacon Press, 1960), 151.

32. Kenneth Clark, *Landscape into Art* (London: John Murray, 1949), 103.

33. Ann Livermore, "J. M. W. Turner's Unknown Versebook," *Connoisseur Year Book* (1957), 78–86; Jack Lindsay, *J. M. W. Turner: His Life and Work* (New York: New York Graphic Society, 1966; reprinted as *Turner: His Life and Work*, St. Albans: Panther, 1975), esp. chap. 5, "The World of Poetry," 72–87; Jerrold Ziff, "J. M. W. Turner on Poetry and Painting," *Studies in Romanticism* 3 (1964), 193–215. The information in the subsequent paragraphs concerning Thomson's influence is from entries

on individual paintings in Martin Butlin and Evelyn Joll, *The Paintings of J. M. W. Turner* (New Haven: Yale University Press, 1977).

34. The Canaletto influence is mentioned in John Rothenstein and Martin Butlin, *Turner* (New York: George Braziller, 1964), 40. Lindsay calls *Mortlake Terrace* "an act of homage to Ruisdael" (*Turner: His Life and Work*, 218).

35. Graham Reynolds, *Turner* (London: Thames and Hudson, 1969), 121.

36. Lawrence Gowing, *Turner: Imagination and Reality* (New York: Museum of Modern Art, 1966), 11, 19.

37. Thomson, *Summer*, lines 83–84, 86.

38. Quoted by John Walker, *The National Gallery of Art, Washington* (New York: Abrams, 1975), 414. Thoré, who recognized Turner's originality here, probably "holds the record," according to Kenneth Clark, "for having anticipated the judgments of posterity more often than any critic that has ever lived" (*The Romantic Rebellion: Romantic Versus Classic Art* [New York: Harper and Row, 1973], 302).

39. Butlin and Joll, *Paintings of J. M. W. Turner*, present both claims, 1:133.

40. John Gage, *Color in Turner: Poetry and Truth* (New York: Praeger, 1969), 143.

41. Andrew Wilton, *J.M.W. Turner: His Art and Life* (New York: Rizzoli, 1979), 221.

42. *Literary Gazette*, Feb. 4, 1837; *Spectator*, Feb. 11, 1837.

43. Paulson, "Turner's Graffiti," 182.

44. George P. Landow, "The Rainbow: A Problematic Image," in *Nature and the Victorian Imagination*, ed. U. C. Knoepflmacher and G. B. Tennyson (Berkeley: University of California Press, 1977), 341–69. Landow's article is revised, without substantial change to the ideas I challenge below, in *Images of Crisis: Literary Iconology, 1750 to the Present* (London: Routledge and Kegan Paul, 1982), 156–77.

45. Landow, "The Rainbow," 364, 362, 362–64.

46. Frances A. Yates, *Astraea: The Imperial Theme in the Sixteenth Century* (London: Routledge and Kegan Paul, 1975), 218. The picture is also discussed in René Graziani, "The Rainbow Portrait of Queen Elizabeth I and Its Religious Symbolism," *Journal of the Warburg and Courtauld Institutes*, 35 (1972), 247–59, but Graziani begs the question of scriptural reference in the Médicis and Elizabeth portraits: "One suspects Ruscelli of studiously avoiding the scriptural allusion when he came to explain Catharine de' Medici's rainbow *impresa*—he pressed, instead, the *fleur-de-lys*—iris—Iris chain of association [In G. Ruscelli, *Imprese illustri*, Venice, 1580, pp. 117–19]. What the Flood rainbow symbol could, however, express with decorum was a prince's humbler claim

to share in the hope or good will promised by it. This would seem to be its meaning in the Rainbow portrait of Elizabeth. The Queen grasps the rainbow as a token of protection and assurance, very much in the spirit of a later Protestant expression, 'taking hold of God's promises'" (252). Roy Strong also disagrees with the Graziani interpretation, "which misreads some of the attributes and totally ignores any historical context" (The Cult of Elizabeth: Elizabethan Portraiture and Pageantry [London: Thames and Hudson, 1977], 50, n. 64).

47. Yates, Astraea, 218; Strong, Cult of Elizabeth, pp. 50–53.

48. S. Foster Damon, A Blake Dictionary (Providence: Brown University Press, 1965), 340.

49. Wagenknecht, Blake's Night, 245, 275–76.

50. Landow, "The Rainbow," 343.

51. On Ward's imitation of Rubens's Chateau, see John Sunderland, Painting in Britain 1525 to 1975 (New York: New York University Press, 1976), 247. The Chateau and Rainbow locations are discussed in Frans Baudoin, Pietro Paulo Rubens, trans. Elsie Callander (New York: Abrams, 1977), 241.

52. Thomas Wright and R. H. Evans, Historical and Descriptive Account of the Caricatures of James Gillray, Comprising a Political and Humorous History of the Latter Part of the Reign of George the Third (London, 1851, reprint, New York: Benjamin Blom, 1968), 437–39.

53. John Harvey, Victorian Novelists and Their Illustrators (New York: New York University Press, 1971), 25.

54. Ruskin, Works, vol. 3: Modern Painters, 387.

55. Marjorie Hope Nicolson, Newton Demands the Muse: Newton's Opticks and the Eighteenth Century Poets (Princeton: Princeton University Press, 1946), 3.

56. "James Orrock noticed that Turner had not inverted the color sequence in the second reflected arc of the double rainbow" in his The Wreck Buoy (Butlin and Joll, Paintings of J. M. W. Turner, 1:246). According to Michael Sevier, Millais made the same mistake in The Blind Girl: "not knowing that a second rainbow is merely a reflection of the first, Millais did not originally reverse the order of the colors—a mistake which he later corrected" ("Notes to the Illustrations," in Sacheverell Sitwell, Narrative Pictures: A Survey of English Genre and Its Painters [London, 1937; reprint, London: Benjamin Blom, 1972], 95). Passages from English Landscape Scenery are reprinted in Basil Taylor's Constable: Paintings, Drawings and Watercolours (London: Phaidon, 1973), 220–23.

57. C. R. Leslie, Memoirs of the Life of John Constable, ed. Jonathan Mayne (London: Phaidon, 1951), 323.

58. Thomas Burnet, *The Sacred Theory of the Earth* (1684–90; reprint, ed. Basil Willey, Carbondale: Southern Illinois University Press, 1965), 16; John Ray, *The Wisdom of God in the Creation* (1691); William Wollaston, *The Religion of Nature Delineated* (London, 1722); William Derham, *Astro-Theology; or, A Demonstration of the Being and Attributes of God, from a Survey of the Heavens* (London: W. Innys, 1715), and *Physico-Theology; or, A Demonstration of the Being and Attributes of God from His Works of Creation* (London: W. Innys, 1713); William Paley, *Natural Theology; or, Evidences of the Existence and Attributes of the Deity* (London, 1802).

59. See Douglas Grant, *James Thomson: Poet of "The Seasons"* (London: Cresset Press, 1951), 53, 76, for citations of Thomson's contemporary critics. The comment on painting comes from the 1837 *National Academy of Design Catalogue* and is quoted in Sandra L. Langer, "The Aesthetics of Democracy," *Art Journal* 39 (1979/80), 132.

60. Butlin and Joll, *The Paintings of J. M. W. Turner,* 1:230.

61. See, for example, R. D. Gray, "J. M. W. Turner and Goethe's Colour Theory," in *German Studies Presented to Walter Horace Bruford* (London: George Harrap, 1962), 112–16; Lawrence Gowing, *Turner: Imagination and Reality* (New York: Museum of Modern Art, 1966), 51; Jack Lindsay, *J. M. W. Turner: His Life and Work* (New York: New York Graphic Society, 1966), 211; James A. W. Heffernan, "The English Romantic Perception of Color," in *Images of Romanticism: Verbal and Visual Affinities,* ed. Karl Kroeber and William Walling (New Haven: Yale University Press, 1978), esp. 141–43. A critic who does not wholly agree is John Gage, *Color in Turner: Poetry and Truth* (New York: Praeger, 1969), 185–87.

62. Landow, "The Rainbow," 363–64.

63. A more concise, thoughtful, and thought-provoking discussion of *The Blind Girl* can be found in Karl Kroeber's "Constable: Millais/Wordsworth: Tennyson," in *Articulate Images: The Sister Arts from Hogarth to Tennyson,* ed. Richard Wendorf (Minneapolis: University of Minnesota Press, 1983), 216–42, esp. 217–20. Although I think the picture is iconologically allusive where Kroeber thinks it symbolic, and I find it engaging where he is convinced that "the viewer is firmly positioned by the painting in the role of detached spectator" (219), we agree that the picture is important and worth looking at.

64. Landow, "The Rainbow," 343.

65. Paul D. Schweizer, the author of the very comprehensive article "John Constable, Rainbow Science, and English Color Theory," *Art Bulletin* 64 (1982), 424–45, has pointed out to me that there is a French edition of Ripa's *Iconography* that includes a rainbow as one detail of an emblem for "Sight." Another reaction to the Millais picture is that

of Allen Staley, who describes the way the viewer is made to "accept the honesty of the artist's vision and feel the joys inherent in the possibility of sight." For Staley, "the landscape is full, active, and close to the surface of the painting. It is not a subordinate backdrop for the figures, but an essential part of the subject. The spectacle of rainbows and landscape, which the blind girl cannot see, provides the meaning of the picture" (The Pre-Raphaelite Landscape, 54).

Chapter 4: Engagement and the Problems of Realism: The Pre-Raphaelite Experiment

1. William Morris, "Address on the Collection of the English Pre-Raphaelite School in the City of Birmingham Museum and Art Gallery on Friday, October 24, 1891." Most of Morris's address is reproduced in Victorian Poetry and Poetics, ed. Walter E. Houghton and G. Robert Stange (Boston: Houghton Mifflin, 1959), 600–605. The quotation is from 601.
2. William Holman Hunt, Pre-Raphaelitism and the Pre-Raphaelite Brotherhood (London: Macmillan, 1905), 1.87. Further page references are in the text except where ambiguity may result; all references are to vol. 1.
3. The Germ: Thoughts toward Nature in Poetry, Literature and Art, with an introduction by William Michael Rossetti (New York: AMS Press, 1965).
4. Rossetti called Ecce "my white picture," "the blessed white eye-sore," and "the blessed white daub" (Letters of Dante Gabriel Rossetti, ed. Oswald Doughty and J. R. Wahl [Oxford: Clarendon Press, 1965, 1967], 1:122, 133, 124). And on the whiteness he comments much later (April 25, 1874): "I find there is a little picture of mine—Annunciation, painted 1849–50 when I was 21—being sold at Christie's today. . . . In point of time it is the ancestor of all the white pictures which have since become so numerous—but here there was an ideal motive for the whiteness." And his opinion of it: "my impression on seeing it was that I couldn't do quite so well now." All of this correspondence is quoted at the entry for Ecce Ancilla Domini! in Virginia Surtees, The Paintings and Drawings of Dante Gabriel Rossetti (1828–1882): A Catalogue Raisonné (Oxford: Clarendon Press, 1971), 1:13–14. Rossetti refers, apparently, to paintings such as Whistler's various Symphonies in White; the "ideal motive" he speaks of—a reflection of the virgin's purity by the use of white—has general historical precedents, as E. H. Gombrich notes: "When in the fifteenth century, Leone Battista Alberti discussed the decoration suitable for places of worship, he considered the use of

gold only to reject it. Quoting the authority of Plato and of Cicero he advocated the use of plain white, as he was convinced that the divine powers loved purity best in life and art" ("Visual Metaphors of Value in Art," in *Meditations on a Hobby Horse and Other Essays on the Theory of Art* [Greenwich, Conn.: Phaidon, 1963], 16).

5. Timothy Hilton, *The Pre-Raphaelites* (New York: Praeger, 1974), 56. Hilton points out that William Mulready was using the wet white ground in the 1820s, and he also mentions as precedent the lightening of Turner's palette at the same period.

6. Surtees, *Paintings and Drawings of Rossetti*, 1:13.

7. Quoted by Sir Walter Armstrong in *Sir Joshua Reynolds* (London: Heinemann, 1900), 27.

8. Mary Ann Caws, *The Eye in the Text: Essays on Perception, Mannerist to Modern* (Princeton: Princeton University Press, 1981), 114n. Structuralist art critics have paid special attention to annunciation scenes and their power of working on the observer. In fact, a pioneer structuralist study deals with annunciations exclusively: Lucien Rudrauf, *L'Annonciation: Etude d'un thème plastique et de ses variations en peinture et en sculpture* (Paris: Grou-Radenez, 1943). Rudrauf does not include this particular Poussin annunciation (there are several) and only mentions the Rossetti to point out the unusual lack of wings on the angel (24). Other structuralist treatments of annunciation themes are Jean Paris, *L'espace et le regard* (Paris: Seuil, 1965), which considers five annunciations, not including the Rossetti or the Poussin discussed here, and Don Denny's *The Annunciation from the Right* (New York: Garland, 1977), which considers the implications of reversing the traditional angel-right and virgin-left arrangement of annunciations. Both Paris and Denny treat only pictorial examples.

9. Blake's comment on Reynolds will be found in "The Marginalia," in *The Poetry and Prose of William Blake*, ed. David V. Erdman (Garden City, N.Y.: Doubleday, 1970), 630. The other Blake quotations are from *The Marriage of Heaven and Hell*, plate 7, line 4, and plate 14, lines 17–19.

10. William Wordsworth, *Immortality Ode*, lines 202–203.

11. David J. DeLaura, "The Context of Browning's Painter Poems: Aesthetics, Polemics, Historics," *PMLA* 95 (1980), 367–88. Rio's *De la poésie chrétienne, dans son principe, dans sa matière et dans ses formes: Forme de l'art: Peinture* was published in France in 1836 and was not translated until 1854, when, according to DeLaura, "whatever vogue it had had was largely past" ("Context of Browning's Painter Poems," 367); DeLaura is quoting from the English translation by "Miss Wells," *The Poetry of Christian Art* (London: Bosworth, 1854).

12. John Ruskin, "The Three Colours of Pre-Raphaelitism," in *Works*, 34:155, 156, 163.
13. Ruskin, letter to the *Times*, May 13, 1851, in defense of the Pre-Raphaelites, in *Works*, 12:322.
14. Hunt, *Pre-Raphaelitism*, 73.
15. Ibid., 90–91.
16. Robyn Cooper, "The Relationship between the Pre-Raphaelite Brotherhood and Painters before Raphael in English Criticism of the Late 1840s and 1850s," *Victorian Studies* 24 (1981), 429.
17. *Ruskin: Rossetti: Preraphaelitism, Papers 1854 to 1862*, ed. William Michael Rossetti (New York, 1899), 103–105.
18. Hunt, *Pre-Raphaelitism*, 147.
19. Carol T. Christ, *The Finer Optic: The Aesthetic of Particularity in Victorian Poetry* (New Haven: Yale University Press, 1975), 19–20.
20. G. L. Hersey recognizes that Rossetti is in fact painting a picture of Jenny as the narrator's thoughts proceed: " 'Jenny' employs a form of ecphrasis. . . . the poetic or rhetorical description of real or imagined works of visual art, usually paintings or sculptures" ("Rossetti's 'Jenny': A Realist Altarpiece," *Yale Review* 69 (1979), 17.
21. The word *guinea* (in addition to its use as a derogatory term for an Italian, which the lines can accommodate) now refers merely to the amount of twenty-one shillings, but until 1900 it was the name of the gold coin (supposedly minted from gold from the Guinea Coast of Africa) of that amount. Gold coins and other golden or gilt objects figure importantly in the poem's imagery. Jenny cannot be considered as any generic (puns seem unavoidable) name for a prostitute. There is one precedent in Pope's "Sober Advice from Horace," mostly dealing with whores and whoremongers, which has two lines describing a Jenny who, like Rossetti's, has her bodice open to the waist: "bashful Jenny, even at Morning-Prayer, / Spreads her Fore-Buttocks to the Navel bare" (lines 33–34). Pope's source is the Horatian satire 1.ii, concerning adultery.
22. Anne Hollander points out that "Thick and abundant female hair safely conveyed a vivid sexual message in an atmosphere of extreme prudery" and that the long hair of the Magdalene "constituted a scriptural reference and was thus an identifying attribute" (*Seeing through Clothes* [New York: Viking, 1978], 73). Tradition confuses the Mary Magdalene mentioned in all four evangelists with the woman who washes Christ's feet with tears and dries them with her hair (Luke 7:36–38); hence the significance of her hair.

23. The reverse themes of fallen woman/annunciation in Rossetti are commented on by Linda Nochlin, "Lost and Found," 152; Martin Meisel, " 'Half Sick of Shadows': The Aesthetic Dialogue in Pre-Raphaelite Painting," *Nature and the Victorian Imagination*, ed. U. C. Knoepflmacher and G. B. Tennyson (Berkeley: University of California Press, 1977), 331–32; David Sonstroem, *Rossetti and the Fair Lady* (Middletown, Conn.: Wesleyan University Press, 1970), 3–4.

24. Graham Hough, *The Last Romantics* (London: Methuen, 1961), 69.

25. Ibid., 79.

26. Buchanan's review is reproduced in Houghton and Stange, *Victorian Poetry*, 839–49; the quotation is on p. 843.

27. Christ, *The Finer Optic*, 60–61.

28. George P. Landow, *William Holman Hunt and Typological Symbolism* (New Haven: Yale University Press, 1979), 7. See also his *Victorian Types, Victorian Shadows: Biblical Typology in Victorian Literature, Art and Thought* (London: Routledge and Kegan Paul, 1980).

29. Ruskin, "Three Colours of Pre-Raphaelitism," *Works*, 34:168. A more modern critic, Timothy Hilton, talks about Hunt's pictures as depicting sacred subjects "not with any spiritual grace, but with a strangely dispiriting religiosity" (*The Pre-Raphaelites*, 88). He also has another complaint about Hunt: "His pictures are not good-looking" (93).

30. Hunt, *Pre-Raphaelitism*, 73–75.

31. Although the standard source on Millais is John Guille Millais's *The Life and Letters of Sir John Everett Millais* (London: 1899), no mention of this episode will be found there. The story of the annulment of Ruskin's never-consummated marriage from Effie Gray's point of view was not told until *The Order of Release: The Story of John Ruskin, Effie Gray and John Everett Millais*, ed. Sir William James (London: John Murray, 1948). A more complete account, using letters unknown to James, is Mary Lutyens, *Millais and the Ruskins* (New York: Vanguard, 1967).

32. Hilton quotes William Allingham on the daffodil incident (*The Pre-Raphaelites*, 54).

33. See Sevier's "Notes on the Illustrations" in Sitwell, *Narrative Pictures*, 95.

34. At the end of the 1850s, according to Timothy Hilton, Millais's real talent began to be wasted, and he started to paint "little girls asleep in sermons, society ladies, popular historical subjects like *The Boyhood of Raleigh*, weak pastiches of Reynolds. England had lost, at the age of twenty-eight, the most talented painter, apart from Turner, that she

had ever produced" (*The Pre-Raphaelites*, 83).

35. Roy Strong has recently done much to reconstruct the reputation of Millais's history pieces with his book *Recreating the Past: British History and the Victorian Painter* (London: Thames and Hudson, 1978), in the foreword to which he admits that for him these pictures "still have that impact which produces a sense of wonder" (7).

36. Ruskin, *Works*, 3:140–48; 15:27n.

37. E. H. Gombrich, *Art and Illusion: A Study in the Psychology of Pictorial Representation*, rev. ed. (Princeton: Princeton University Press, Bollingen Series 35, 1969), 301.

38. Houghton and Stange, *Victorian Poetry*, 602.

39. At the time of the Brotherhood's inception, Hunt, Millais, and Rossetti brought in Thomas Woolner, a sculptor. Later were added James Collinson, a painter, Frederic George Stephens, a student of painting at the Royal Academy, and William Michael Rossetti, who did not paint or sculpt but became the editor of *The Germ*. Later associates included William Morris, Edward Burne-Jones, Val Prinsep, Christina Rossetti, Coventry Patmore, Algernon Charles Swinburne, Charles Allston Collins, Arthur Hughes, William Bell Scott, and Walter Howell Deverell. Although the ideas Yeats was absorbing in London in the 1890s were to him still vigorous Pre-Raphaelitism, Ruskin was already talking about the movement in the past tense in 1860 (*Modern Painters*, vol. 5, in *Works*, 7:233).

40. Rossetti, letter to Frederic G. Stephens, April 25, 1874, quoted in Surtees, *Paintings and Drawings of Rossetti*, 1:14.

41. James Abbott McNeill Whistler, *The Gentle Art of Making Enemies*, 2d ed. (London: William Heinemann, 1892), 138.

42. John Dixon Hunt writes that "Pre-Raphaelites . . . anticipated the work of the French symbolists," *The Pre-Raphaelite Imagination*, 1848–1900 (Lincoln: University of Nebraska Press, 1968), 12. Both Hunt (6) and Timothy Hilton (*The Pre-Raphaelites*, 207) point out the interchangeable use of the terms *Aesthetic* and *Pre-Raphaelite* in Walter Hamilton's 1882 book on the Aesthetic Movement. Hunt also discusses the frequent appearance together of Pre-Raphaelite and symbolist work in magazines of the 1880s and 1890s (9–10).

Chapter 5: The Earnestness of English Art

1. For example, in *Absorption and Theatricality: Painting and Beholder in the Age of Diderot* (Berkeley: University of California Press, 1980), Michael Fried

describes how the relationship between beholder and work changed in French painting during the 1750s from the beholder's feeling of being in the work to his being excluded from it. Fried defends the latter relationship and calls the former "theatrical."

2. Sir William Temple, "An Essay upon the Ancient and Modern Learning," in *Critical Essays of the Seventeenth Century*, ed. J. E. Spingarn (Oxford: Clarendon Press; reprint, Bloomington: Indiana University Press, 1957), 3:50–51. Temple's observations continue in "Of Poetry" (1690), in the same volume.

3. Ibid., 104–105.

4. See especially those papers on Addison's and Johnson's clubs in *The Spectator* and *The Rambler*; for Goldsmith see *The Citizen of the World*, Letter 4.

5. *The Works of the Late Edward Dayes*, ed. E. W. Brayley (London: Mrs. Dayes, 1805), 268.

6. *Lectures and Essays in Criticism*, vol. 3 of *The Complete Prose Works of Matthew Arnold*, ed. R. H. Super (Ann Arbor: University of Michigan Press, 1962), 351. Further page references to this work appear in the text except where ambiguity may result.

7. "Parallels in English Painting and Poetry" was originally delivered as a public lecture at the University of London. "English Art" first appeared in *Burlington Magazine*. Both are reprinted in Read's *In Defense of Shelley and Other Essays* (London: Heinemann, 1936).

8. Nikolaus Pevsner, *The Englishness of English Art* (London: Architectural Press, 1956; reprint, Harmondsworth: Penguin, 1964), p. 24.

9. *New Republic*, 25 April 1983, 23–26.

10. Ibid., 23, 24, 25.

11. Ibid., 26.

12. Ibid.

13. Kames, *Elements of Criticism*, 1:7.

14. Samuel Kliger, "Jane Austen's *Pride and Prejudice* in the Eighteenth-Century Mode," *University of Toronto Quarterly* 16 (1945–46), 359.

15. Sir Joshua Reynolds, *Discourses on Art*, ed. Robert R. Wark (New York: Macmillan, Collier Books, 1966), *Discourse 9*.

16. Lawrence Lipking, *The Ordering of the Arts in Eighteenth-Century England* (Princeton: Princeton University Press, 1970), 189.

17. Reported by Ruskin, who is quoting a letter of the Rev. Mr. Kingsley, "Notes on the Turner Collection of Oil Paintings at the National Gallery," *Works*, 13:162.

18. Hunt, *Pre-Raphaelitism*, 1:172, 90, 112.

19. Henry James, *The Painter's Eye: Notes and Essays on the Pictorial Arts* (Cam-

bridge: Harvard University Press, 1956), 115. The essay was originally published in the New York Tribune in 1876.
20. Samuel Johnson, The Rambler, no. 60.

Bibliography

Adams, Hazard. *William Blake: A Reading of the Shorter Poems*. Seattle: University of Washington Press, 1963.

Appleton, Jay. *The Experience of Landscape*. New York: Wiley, 1975.

Armstrong, Sir Walter. *Sir Joshua Reynolds: First President of the Royal Academy*. London: Heinemann, 1900.

Arnheim, Rudolf. "Space as an Image of Time." In Karl Kroeber and William Walling, eds., *Images of Romanticism: Verbal and Visual Affinities*. Pp. 1–12. New Haven: Yale University Press, 1978.

Arnold, Matthew. *The Complete Prose Works of Matthew Arnold*. 11 vols. Ed. R. H. Super. Ann Arbor: University of Michigan Press, 1960–77.

Baker, John Tull. *An Historical and Critical Examination of English Space and Time Theories from Henry More to Bishop Berkeley*. Bronxville, N.Y.: Sarah Lawrence College, 1930.

Barrell, John. *The Dark Side of the Landscape: The Rural Poor in English Painting, 1730–1840*. Cambridge: Cambridge University Press, 1980.

Bateson, F. W. "An Editorial Postscript." *Essays in Criticism* 11 (1961), 162–63.

Baudoin, Frans. *Pietro Paulo Rubens*. Trans. Elsie Callander. New York: Abrams, 1977.

Berger, John. *About Looking*. New York: Pantheon, 1980.

Berkeley, George. *The Works of George Berkeley*. 4 vols. Ed. Alexander Campbell Fraser. Oxford: Clarendon Press, 1901.

Blake, William. *The Poetry and Prose of William Blake*. Ed. David V. Erdman. Garden City, N.Y.: Doubleday, 1970.

Bloom, Harold. *Blake's Apocalypse: A Study in Poetic Argument*. New York: Doubleday, 1963.

Booth, Wayne C. *The Rhetoric of Fiction*. Chicago: University of Chicago Press, 1961.

Bradbrook, Muriel C. "Two Notes upon Webster." *Modern Language Review* 42 (1947), 287.

Burke, Joseph. *English Art, 1714–1800*. Oxford: Clarendon Press, 1976.

Burnet, Thomas. *The Sacred Theory of the Earth, 1684–90*. Ed. Basil Willey. Carbondale: Southern Illinois University Press, 1965.

Buswell, Guy Thomas. *How People Look at Pictures*. Chicago: University of Chicago Press, 1935.

Butlin, Martin, and Evelyn Joll. *The Paintings of J. M. W. Turner*. 2 vols. New Haven: Yale University Press, 1977.

Caws, Mary Ann. *The Eye in the Text: Essays on Perception, Mannerist to Modern*. Princeton: Princeton University Press, 1981.

Christ, Carol T. *The Finer Optic: The Aesthetic of Particularity in Victorian Poetry*. New Haven: Yale University Press, 1975.

Clark, Kenneth. *Landscape into Art*. London: John Murray, 1949. Reprint. Boston: Beacon Press, 1961.

———. *Looking at Pictures*. Boston: Beacon Press, 1960.

———. *The Romantic Rebellion: Romantic versus Classic Art*. New York: Harper and Row, 1973.

Cohen, Michael. "The Rainbow in Millais' *The Blind Girl*." *Journal of Pre-Raphaelite Studies* 3 (1982), 16–27.

Connolly, Thomas E. "Point of View in Interpreting 'The Fly.'" *English Language Notes* 22 (1984), 32–37.

Cooper, Anthony Ashley, Third Earl of Shaftesbury. *Characteristicks of Men, Manners, Opinions, Times*. 3 vols. London, 1714.

Cooper, Robyn. "The Relationship between the Pre-Raphaelite Brotherhood and Painters before Raphael in English Criticism of the Late 1840s and 1850s." *Victorian Studies* 24 (1981), 405–36.

Cordingly, David. " 'The Stonebreaker': An Examination of the Landscape in a Painting by John Brett." *Burlington Magazine* 125 (1982), 141–45.

Culler, A. Dwight. *Imaginative Reason: The Poetry of Matthew Arnold*. New Haven: Yale University Press, 1966.

Damon, S. Foster. *A Blake Dictionary*. Providence: Brown University Press, 1965.

———. *William Blake: His Philosophy and Symbols*. Boston: Houghton Mifflin, 1924.

Dayes, Edward. *The Works of the Late Edward Dayes*. Ed. E. W. Brayley. London: Mrs. Dayes, 1805.

DeLaura, David. "The Context of Browning's Painter Poems: Aesthetics, Polemics, Historics." *PLMA* 95 (1980), 367–88.

Dennis, John. *The Critical Works of John Dennis*. 2 vols. Ed. Edward Niles Hooker. Baltimore: Johns Hopkins University Press, 1939–43.

Denny, Don. *The Annunciation from the Right*. New York: Garland, 1977.

Derham, William. *Astro-Theology: Or a Demonstration of the Being and Attributes of*

God, From a Survey of the Heavens. London: W. Innys, 1715.

————. Physico-Theology: Or, A Demonstration of the Being and Attributes of God, from his Works of Creation. London: W. Innys, 1713.

de Sola Pinto, Vivian. "William Hogarth." From Dryden to Johnson. The Pelican Guide to English Literature 4. Ed. Boris Ford. Baltimore: Penguin, 1957.

Dobson, Austin. William Hogarth. Rev. ed. New York: McClure; London: Heinemann, 1907.

Donaldson, Ian. "The Satirists' London." Essays in Criticism 25 (1975), 101–22.

Doran, Madeleine. Endeavors of Art: A Study of Form in Elizabethan Drama. Madison: University of Wisconsin Press, 1964.

Dryden, John. "A Parallel of Poetry and Painting" (1695). Essays of John Dryden. 2 vols. Vol. 2, pp. 115–53. Ed. W. P. Ker. Oxford: Clarendon Press, 1926.

Edelstein, T. J. "Augustus Egg's Triptych: A Narrative of Victorian Adultery." Burlington Magazine 125 (1983), 202–10.

Erdman, David. The Illuminated Blake: All of William Blake's Illuminated Works with a Plate-by-Plate Commentary. Garden City, N.Y.: Doubleday, Anchor Books, 1974.

Fish, Stanley, E. Is There a Text in This Class?: The Authority of Interpretive Communities. Cambridge: Harvard University Press, 1980.

————. Self-Consuming Artifacts: The Experience of Seventeenth-Century Literature. Berkeley: University of California Press, 1972.

Freeman, Rosemary. English Emblem Books. London: Chatto and Windus, 1948.

Fried, Michael. Absorption and Theatricality: Painting and Beholder in the Age of Diderot. Berkeley: University of California Press, 1980.

Friedman, Sarah L., and Marguerite B. Stevenson. "Perception of Movement in Pictures." In Margaret A. Hagen, ed., Alberti's Window: The Projective Model of Pictorial Information, vol. 1 of The Perception of Pictures. New York: Academic Press, 1980.

Frye, Northrop. Anatomy of Criticism. Princeton: Princeton University Press, 1957. Reprint. New York: Atheneum, 1966.

Frye, Roland Mushat. Milton's Imagery and the Visual Arts: Iconographic Traditions in the Epic Poems. Princeton: Princeton University Press, 1978.

Gage, John. Color in Turner: Poetry and Truth. New York: Praeger, 1969.

Gibson, Walker. "Authors, Speakers, Readers, and Mock Readers." College English 11 (1950), 265–69.

Gleckner, Robert F. The Piper and the Bard: A Study of William Blake. Detroit: Wayne State University Press, 1959.

Gombrich, E. H. *Art and Illusion: A Study in the Psychology of Pictorial Representation.* Rev. ed. Bollingen Series 35. Princeton: Princeton University Press, 1969.

———. "The Mask and the Face: The Perception of Physiognomic Likeness in Life and in Art." In Maurice Mandelbaum, ed., *Art, Perception, and Reality.* Pp. 1–46. Baltimore: Johns Hopkins University Press, 1972.

———. *Meditations on a Hobby Horse and Other Essays on the Theory of Art.* Greenwich, Conn.: Phaidon, 1963.

———. "Moment and Movement in Art." *Journal of the Warburg and Courtauld Institutes* 27 (1964), 293–306.

Gowing, Lawrence. *Turner: Imagination and Reality.* New York: Museum of Modern Art, 1966.

Grant, Douglas. *James Thomson: Poet of "The Seasons."* London: Cresset Press, 1951.

Grant, John E. "Interpreting Blake's 'The Fly.'" *Bulletin of the New York Public Library* 67 (1963), 593–615.

———. "Misreadings of the 'The Fly.'" *Essays in Criticism* 11 (1961), 481–86.

Gray, R. D. "J. M. W. Turner and Goethe's Colour Theory." In *German Studies Presented to Walter Horace Bruford.* London: George Harrap, 1962.

Graziani, René. "The Rainbow Portrait of Queen Elizabeth I and Its Religious Symbolism." *Journal of the Warburg and Courtauld Institutes* 35 (1972), 247–59.

Hagstrum, Jean H. "'The Fly.'" In Alvin H. Rosenfeld, ed., *William Blake: Essays for S. Foster Damon.* Pp. 368–82. Providence: Brown University Press, 1969.

Harris, James. *Three Treatises, The First Concerning Art. The Second Concerning Music, Painting and Poetry. The Third Concerning Happiness.* London: H. Woodfall, 1744.

Harvey, John R. *Victorian Novelists and Their Illustrators.* New York: New York University Press, 1971.

Heffernan, James A. W. "The English Romantic Perception of Color." In Karl Kroeber and William Walling, eds., *Images of Romanticism: Verbal and Visual Affinities.* Pp. 133–48. New Haven: Yale University Press, 1978.

Hersey, G. L. "Rossetti's 'Jenny': A Realist Altarpiece." *Yale Review* 69 (1979), 17–32.

Hibbard, G. R. "The Country House Poem of the Seventeenth Century." *Journal of the Warburg and Courtauld Institute* 109 (1956), 159–74.

Hill, James L. "The Frame for the Mind: Landscape in 'Lines Composed a Few Miles Above Tintern Abbey,' 'Dover Beach,' and 'Sunday

Morning.' " *Centennial Review* 18 (1974), 29–48.

Hilton, Timothy. *The Pre-Raphaelites.* New York: Praeger, 1974.

Hirsch, E. D., Jr. *Innocence and Experience: An Introduction to Blake.* New Haven: Yale University Press, 1964.

Hogarth, William. *The Analysis of Beauty, with the Rejected Passages from the Manuscript Drafts and Autobiographical Notes.* Ed. Joseph Burke. New York: Oxford University Press, 1955.

Hollander, Anne. *Seeing through Clothes.* New York: Viking, 1978.

Home, Henry, Lord Kames. *Elements of Criticism.* 3 vols. Edinburgh: Millar, Kincaid and Bell, 1762.

Hough, Graham. *The Last Romantics.* London: Duckworth, 1947. Reprint. London: Methuen, 1961.

Houghton, Walter E., and G. Robert Stange, eds. *Victorian Poetry and Poetics.* Boston: Houghton Mifflin, 1959.

Hughes, Robert. *The Shock of the New.* New York: Knopf, 1980.

Hunt, John Dixon. *The Pre-Raphaelite Imagination, 1848–1900.* Lincoln: University of Nebraska Press, 1968.

Hunt, William Holman. *Pre-Raphaelitism and the Pre-Raphaelite Brotherhood.* 2 vols. New York: Macmillan, 1905.

Ingarden, Roman. *The Cognition of the Literary Work of Art.* Trans. Ruth Ann Crowley and Kenneth Olson. Evanston: Northwestern University Press, 1973.

Iser, Wolfgang. *The Act of Reading: A Theory of Aesthetic Response.* Baltimore: Johns Hopkins University Press, 1978.

———. *The Implied Reader: Patterns in Communication in Prose Fiction from Bunyan to Beckett.* Baltimore: Johns Hopkins University Press, 1974.

———. "Indeterminacy and the Reader's Response in Prose Fiction." In J. Hillis Miller, ed., *Aspects of Narrative: Selected Papers from the English Institute.* New York: Columbia University Press, 1971.

James, Henry. *The Painter's Eye: Notes and Essays on the Pictorial Arts.* Cambridge: Harvard University Press, 1956.

James, Sir William, ed. *The Order of Release: The Story of John Ruskin, Effie Gray and John Everett Millais.* London: John Murray, 1948.

Kirschbaum, Leo. "Blake's 'The Fly.' " *Essays in Criticism* 11 (1961), 154–62.

Kliger, Samuel. "Jane Austen's *Pride and Prejudice* in the Eighteenth-Century Mode." *University of Toronto Quarterly* 16 (1945–46), 357–70.

Knoepflmacher, U. C., and G. B. Tennyson, eds. *Nature and the Victorian Imagination.* Berkeley: University of California Press, 1977.

Korshin, Paul J. *Typologies in England 1650–1820.* Princeton: Princeton University Press, 1982.

Kroeber, Karl. "Constable: Millais/Wordsworth: Tennyson." In Richard Wendorf, ed., *Articulate Images: The Sister Arts from Hogarth to Tennyson*. Pp. 216–42. Minneapolis: University of Minnesota Press, 1983.

———. *Romantic Landscape Vision: Constable and Wordsworth*. Madison: University of Wisconsin Press, 1975.

Kroeber, Karl, and William Walling, eds. *Images of Romanticism: Verbal and Visual Affinities*. New Haven: Yale University Press, 1978.

Landow, George P. *Images of Crisis: Literary Iconology, 1750 to the Present*. London: Routledge and Kegan Paul, 1982.

———. "The Rainbow: A Problematic Image." In U. C. Knoepflmacher and G. B. Tennyson, eds., *Nature and the Victorian Imagination*. Pp. 341–69. Berkeley: University of California Press, 1977.

———. *Victorian Types, Victorian Shadows: Biblical Typology in Victorian Literature, Art, and Thought*. London: Routledge and Kegan Paul, 1980.

———. *William Holman Hunt and Typological Symbolism*. New Haven: Yale University Press, 1979.

Langer, Sandra L. "The Aesthetics of Democracy." *Art Journal* 39 (1979–80), 132–35.

Langer, Suzanne K. *Feeling and Form: A Theory of Art*. New York: Scribner's, 1953.

Leslie, C. R. *Memoirs of the Life of John Constable*. Ed. Jonathan Mayne. London: Phaidon, 1951.

Lessing, Gotthold Ephraim. *Laocoön: An Essay upon the Limits of Painting and Poetry*. Trans. Edward Allen McCormick. Indianapolis: Bobbs-Merrill, 1962.

Lindsay, Jack. *J. M. W. Turner: His Life and Work*. New York: New York Graphic Society, 1966. Reprinted as *Turner: His Life and Work*. St. Albans: Panther, 1975.

Lipking, Lawrence. *The Ordering of the Arts in Eighteenth-Century England*. Princeton: Princeton University Press, 1970.

Livermore, Ann. "J. M. W. Turner's Unknown Versebook." *Connoisseur Year Book* (1957), 78–86.

Locke, John. *Works*. 3 vols. London, 1714.

Longinus, Dionysius. *'Longinus' on Sublimity*. Ed. and trans. D. A. Russell. Oxford: Clarendon Press, 1965.

Lutyens, Mary. *Millais and the Ruskins*. New York: Vanguard, 1967.

Mack, Maynard. "The Muse of Satire." *Yale Review* 41 (1951), 80–92.

Manlove, C. N. "Engineered Innocence: Blake's 'The Little Black Boy' and 'The Fly.' " *Essays in Criticism* 27 (1977), 112–21.

Margoliouth, H. M. "Andrew Marvell: Some Biographical Points." *Modern Language Review* 17 (1922), 351–61.

Marvell, Andrew. *The Poems and Letters of Andrew Marvell.* Ed. H. M. Margoliouth. Oxford: Clarendon Press, 1967.

Matthews, William, ed. *Charles II's Escape from Worcester: A Collection of Narratives Assembled by Samuel Pepys.* Berkeley: University of California Press, 1966.

Meisel, Martin. " 'Half Sick of Shadows': The Aesthetic Dialogue in Pre-Raphaelite Painting." In U. C. Knoepflmacher and G. B Tennyson, eds., *Nature and the Victorian Imagination.* Pp. 309–40. Berkeley: University of California Press, 1977.

Millais, John Guille. *The Life and Letters of Sir John Everett Millais.* London, 1899.

Miner, Earl, ed. *Literary Uses of Typology from the Late Middle Ages to the Present.* Princeton: Princeton University Press, 1977.

Mitchell, W. J. T. "Spatial Form in Literature: Toward a General Theory." *Critical Inquiry* 6 (1980), 539–67.

Monk, Samuel Holt. *The Sublime: A Study of Critical Theories in XVIII-Century England.* New York: Modern Language Association, 1935. Reprint. Ann Arbor: University of Michigan Press, 1960.

Moore, Robert Etheridge. *Hogarth's Literary Relationships.* Minneapolis: University of Minnesota Press, 1948.

Nicolson, Marjorie Hope. *Mountain Gloom and Mountain Glory: The Development of the Aesthetics of the Infinite.* Ithaca: Cornell University Press, 1959.

———. *Newton Demands the Muse: Newton's Opticks and the Eighteenth-Century Poets.* Princeton: Princeton University Press, 1946.

Nochlin, Linda. "Lost and Found: Once More the Fallen Woman." *Art Bulletin* 58 (1978), 139–53.

O Hehir, Brendan. *Expans'd Hieroglyphicks: A Critical Study of Sir John Denham's Coopers Hill.* Berkeley: University of California Press, 1969.

Ortega y Gassett, José. *The Dehumanization of Art and Other Essays on Art, Culture, and Literature.* Princeton: Princeton University Press, 1948.

Ostriker, Alicia. "Metrics: Pattern and Variation." In Morton D. Paley, ed., *Twentieth Century Interpretations of Songs of Innocence and of Experience.* Pp. 10–29. Englewood Cliffs, N.J.: Prentice-Hall, 1969.

Paley, William. *Natural Theology; or, Evidences of the Existence and Attributes of the Deity.* London, 1802.

Panofsky, Erwin. *Meaning in the Visual Arts: Papers in and on Art History.* Garden City, N.Y.: Doubleday, 1955.

Paris, Jean. *L'espace et le regard.* Paris: Seuil, 1965.

Pastore, Nicholas. *A Selective History of Theories of Visual Perception: 1650–1950.* New York: Oxford University Press, 1971.

Patrides, C. A., ed. *Aspects of Time.* Manchester: Manchester University Press, 1976.

Paulson, Ronald. *Emblem and Expression: Meaning in English Art of the Eighteenth-*

Century. Cambridge: Harvard University Press, 1975.

———. "The Englishness of English Art." *New Republic*, 25 April 1983, pp. 23–26.

———. "*The Harlot's Progress* and the Tradition of History Painting." *Eighteenth-Century Studies* 1 (1967), 69–92.

———. *Hogarth: His Life, Art, and Times*. New Haven: Yale University Press, 1971.

———. *Hogarth's Graphic Works*. 2 vols. Rev. Ed. New Haven: Yale University Press, 1970.

———. *Literary Landscape: Turner and Constable*. New Haven: Yale University Press, 1982.

———. "Turner's Graffiti: The Sun and Its Glosses." In Karl Kroeber and William Walling, eds., *Images of Romanticism: Verbal and Visual Affinities*. Pp. 167–88. New Haven: Yale University Press, 1978.

Pevsner, Nikolaus. *The Englishness of English Art*. London: Architectural Press, 1956. Reprint. Harmondsworth: Penguin, 1964.

Pointon, Marcia R. "Geology and Landscape Painting in Nineteenth-Century England." In L. J. Jordanova and Roy S. Porter, eds. *Images of the Earth: Essays in the History of the Environmental Sciences*. Pp. 84–116. Chalfont St. Giles: British Society for the History of Science, 1979.

Praz, Mario. *Mnemosyne: A Parallel between Literature and the Visual Arts*. Bollingen Series 35. Princeton: Princeton University Press, 1970.

Quennell, Peter. *Hogarth's Progress*. New York: Viking, 1956.

Read, Herbert. "English Art." In *In Defence of Shelley and Other Essays*. Pp. 251–82. London: Heinemann, 1936.

———. "Parallels in English Painting and Poetry." In *In Defence of Shelley and Other Essays*. Pp. 225–48. London: Heinemann, 1936.

Reichert, John. *Making Sense of Literature*. Chicago: University of Chicago Press, 1977.

Reynolds, Graham. *Constable: The Natural Painter*. New York: McGraw-Hill, 1965.

———. *Turner*. London: Thames and Hudson, 1969.

Reynolds, Sir Joshua. *Discourses on Art*. Ed. Robert R. Wark. New York: Macmillan, Collier Books, 1966.

Rossetti, Dante Gabriel. *Letters of Dante Gabriel Rossetti*. Ed. Oswald Doughty and J. R. Wahl, 4 vols. Oxford: Clarendon Press, 1965–67.

Rossetti, William Michael, ed. *The Germ: Thoughts toward Nature in Poetry, Literature, and Art*. New York: AMS Press, 1965.

———. *Ruskin: Rossetti: Preraphaelitism, Papers 1854 to 1862*. New York, 1899.

Roston, Murray. *Prophet and Poet: The Bible and the Growth of Romanticism*. London: Faber and Faber, 1965.

Rothenstein, John, and Martin Butlin. *Turner*. New York: George Braziller, 1964.

Rothstein, Eric. " 'Ideal Presence' and the 'Non Finito' in Eighteenth-Century Aesthetics." *Eighteenth-Century Studies* 9 (1976), 307–32.

Rouquet, Jean Andre. *Lettres de Monsieur ** à un de ses amis à Paris, pour lui expliquer les estampes de Hogarth*. London, 1746.

Rudrauf, Lucien. *L'Annonciation: Etude d'un thème plastique et de ses variations en peinture et en sculpture*. Paris: Grou-Radenez, 1943.

Ruskin, John. *The Works of John Ruskin*. 39 vols. Ed. E. T. Cook and Alexander Wedderburn. London: 1903–12.

Schorer, Mark. *William Blake: The Politics of Vision*. New York: Holt, 1946.

Schweizer, Paul D. "John Constable, Rainbow Science, and English Color Theory." *Art Bulletin* 64 (1982), 424–45.

Sitwell, Sacheverell. *Narrative Pictures: A Survey of English Genre and Its Painters*. London, 1937. Reprint. London: Benjamin Blom, 1972.

Sonstroem, David. *Rossetti and the Fair Lady*. Middletown, Conn.: Wesleyan University Press, 1970.

Souriau, Etienne. *La correspondance des arts. Eléments d'esthétique comparée*. Paris: Flammarion, 1969.

———. "Time in the Plastic Arts." *Journal of Aesthetics and Art Criticism* 7 (1949), 249–307. Reprinted in Suzanne K. Langer, ed., *Reflections on Art*. Pp. 122–41. Baltimore: Johns Hopkins University Press, 1958.

Stack, George J. *Berkeley's Analysis of Perception*. The Hague: Mouton, 1970.

Staley, Allen. *The Pre-Raphaelite Landscape*. Oxford: Clarendon Press, 1973.

Steiner, George. *Language and Silence: Essays on Language, Literature, and the Inhuman*. New York: Atheneum, 1977.

Stevens, Wallace. "The Relations between Poetry and Painting." In *The Necessary Essays on Reality and the Imagination*. Pp. 159–76. New York: Knopf, 1951.

Stevenson, Warren. "Artful Irony in Blake's 'The Fly.' " *Texas Studies in Literature and Language* 10 (1968), 77–82.

Strong, Roy. *The Cult of Elizabeth: Elizabethan Portraiture and Pageantry*. London: Thames and Hudson, 1977.

———. *Recreating the Past: British History and the Victorian Painter*. London: Thames and Hudson, 1978.

Sunderland, John. *Painting in Britain 1525 to 1975*. New York: New York University Press, 1976.

Surtees, Virginia. *The Paintings and Drawings of Dante Gabriel Rossetti (1828–1882): A Catalogue Raisonné*. 2 vols. Oxford: Clarendon Press, 1979.

Taylor, Basil. *Constable: Paintings, Drawings, and Watercolours*. London: Phaidon, 1973.

Temple, Sir William. "An Essay upon the Ancient and Modern Learning." *Critical Essays of the Seventeenth Century.* 3 vols. Vol. 3, pp. 32–72. Ed. J. E. Spingarn. Oxford: Clarendon Press. Reprint. Bloomington: Indiana University Press, 1957.

Tillotson, Geoffrey. *On the Poetry of Pope.* Oxford: Clarendon Press, 1938.

Tolley, Michael J., and Jean Hagstrum. "Debate." *Blake Studies* 2 (1970), 77–88.

Trusler, John. *Hogarth Moralized.* Ed. John Major. London, 1831. Originally published in 1768.

Turner, James. *The Politics of Landscape: Rural Scenery and Society in English Poetry 1630–1660.* Cambridge: Harvard University Press, 1979.

Uphaus, Robert W. *The Impossible Observer: Reason and the Reader in 18th-Century Prose.* Lexington: University Press of Kentucky, 1979.

Wagenknecht, David. *Blake's Night: William Blake and the Idea of Pastoral.* Cambridge: Harvard University Press, Belknap Press, 1973.

Walker, John. *The National Gallery of Art, Washington.* New York: Abrams, 1975.

Wardle, Judith. " 'For Hatching ripe': Blake and the Educational Uses of Emblem and Illustrated Literature." *Bulletin of Research in the Humanities* 81 (1978), 324–48.

Wark, Robert R. "Hogarth's Narrative Method in Practice and Theory." *England in the Restoration and Early Eighteenth Century: Essays on Culture and Society.* Pp. 161–72. Ed. H. T. Swedenberg, Jr. Berkeley: University of California Press, 1973.

Warren, Richard M., and Rosalyn P. Warren. *Helmholtz on Perception: Its Physiology and Development.* New York: Wiley, 1968.

Wasserman, Earl R. *The Subtler Language: Critical Readings of Neoclassic and Romantic Poems.* Baltimore: Johns Hopkins University Press, 1959.

Waterhouse, Ellis. *Reynolds.* London: Phaidon, 1973.

Whistler, James Abbott Mcneill. *The Gentle Art of Making Enemies.* 2d ed. London: Heinemann, 1892.

Whitney Geoffrey. *A Choice of Emblemes.* Leiden: Plautin, 1586.

Wilton, Andrew. *J. M. W. Turner: His Art and Life.* New York: Rizzoli, 1979.

———. *Turner and the Sublime.* London: British Museum, 1980.

Wolff, Erwin. "Der intendierte Leser: Überlegungen und Beispiele zur Einführung eines literaturwissenschaftlichen Begriffs." *Poetica* 4 (1971), 141–66.

Wollaston, William. *The Religion of Nature Delineated.* London, 1722.

Wright, Thomas, and R. H. Evans. *Historical and Descriptive Account of the Caricatures of James Gillray, Comprising a Political and Humorous History of the Latter Part of the Reign of George the Third.* London: 1851. Reprint. New York: Benjamin Blom, 1968.

Yarbus, A. L. *Eye Movements and Vision*. New York: Plenum Press, 1967.
Yates, Frances A. *Astraea: The Imperial Theme in the Sixteenth Century*. London: Routledge and Kegan Paul, 1975.
Ziff, Jerrold. "J. M. W. Turner on Poetry and Painting." *Studies in Romanticism* 3 (1964), 193–215.

Index

Boldface numbers indicate illustrations.

Aestheticism, 5, 185
Annunciation, The (Poussin), 146–49, **147**
Arnheim, Rudolf, 25, 45–46
Arnold, Matthew, 95, 102, 178–79;
—**Works:** "On the Study of Celtic Literature," 178–79; "Stanzas from the Grande Chartreuse," 95, 102
Awakening Conscience, The (Hunt), **28**, 29, 170–71

Barrell, John, 106
Beatrice Addressing Dante from the Car (Blake), **129**
Berger, John, 1–2
Berkeley, George, 6–8, 11
Blake, William, 5, 12, 49, 65–76, 95, 102, 107, 110, 128–29, 151, 157, 165;
—**Works:** Beatrice Addressing Dante from the Car, **129**; "The Chimney Sweeper," 107, 165; "The Four and Twenty Elders," 129; "The Fly," 66–76, **67**; "The Ecchoing Green," 72; "The Garden of Love," 99, 102, 107; "Holy Thursday," 107; "The Little Black Boy," 72; "London," 107, 110; "Nurse's Song," 95, 102; "Satan Smiting Job with Sore Boils," 129; "Spring," 72
Blind Girl, The (Millais), 107–111, **108**, 125, 138–42, 152, 171, 172
Brett, John, 6, 19, 111;
—**Works:** The Stonebreaker, 19, **20**, 111
Browning, Robert, 5, 149–52, 164, 187;
—**Works:** "Fra Lippo Lippi," 149–52, 187; "My Last Duchess," 5

Brueghel, Jan, and Peter Paul Rubens, 109–110;
—**Works:** Paradise, **109**, 110
Buchanan, Robert, 165, 167
Burton, William Shakespeare;
—**Works:** A Wounded Cavalier, 87–89, **89**
Butlin, Martin, 122, 138

Caws, Mary Ann, 149
Children: ordinary portrait conventions, 95; in gardens, 94–106; excluded from gardens, 106–112
Christ, Carol, 169
Clark, Kenneth, 117
Claude, Lorrain, 117, 121, 123
Coleridge, Samuel Taylor, 91
Constable, John, 19, 93–94, 106, 135–36, 184;
—**Works:** The Cornfield (Landscape: Noon. The Cornfield), 19, **21**, 93–94; Dedham Vale, 106–107; Salisbury Cathedral from the Meadows, **135**, 136; Wivenhoe Park, Essex, 81, **82**
Cooper, Robyn, 153–54
Cordingly, David, 111
Cornfield, The (Constable), 19, **21**, 93–94
Cornforth, Fanny, 167
Country-house poems, 78–81
Courbet, Gustave, 111
Crabbe, George, 106

Damon, S. Foster, 66, 128
Dante Alighieri, 155, 174
Davies, Sir John, 127–28
DeLaura, David, 151–52
Denham, Sir John, 84–86

Dennis, John, 116
Donaldson, Ian, 57
Dryden, John, 38, 51, 63–64, 86–87;
—**Works:** *Absalom and Achitophel*, 51, 63; *Epistle to Dr. Charleton*, 86–87; *Mac Flecknoe*, 51, 63–64; "A Parallel Betwixt Painting and Poetry," 38

Ecce Ancilla Domini! (Rossetti), **26**, 146–49, 153, 155, 166, 170, 171, 175
Edelstein, T. J., 22
Egg, Augustus, 6, 20–25;
—**Works:** *Past and Present, Number 1*, 20–23, **22**; *Past and Present, Number 2*, 23–24, **23**; *Past and Present, Number 3*, 24–25, **24**
Eildon Hills with the Tweed (Ward), **131**
Eliot, T. S., 16
Elizabeth I, the "Rainbow Portrait" (unknown painter), 125–28, **126**
Empiricism, 6–8, 177, 180
Engagement: defined, 1–2; treated by Lord Kames, 2–4; period during which it is an artistic aim, 4–5; and empiricism, 6–8; and time, 16–43; and space, 43–48; and comparison or metaphor, 49–76; and nature, 77–142; and Pre-Raphaelites, 143–76; and Englishness, 177–86; as criterion of value in art, 186–87

Figures, in landscapes, 77–112; children in gardens, 94–106; children excluded from gardens, 106–112; figure/landscape relationships: *proprietary*, 78–82; *formal harmony*, 84–85; *emblematic*, 85–91; *philosophical*, 91–94
Fish, Stanley, 11, 13
"The Fly" (Blake), **67**
Fried, Michael, 31
Frye, Northrop, 47

Gage, John, 122
Gainsborough, Thomas, 12, 31, 34, 35, 79–82, 95, 103–104, 106;
—**Works:** *Blue Boy* (*Jonathan Buttall*), 104; *Master John Heathcote*, 95, **96**, 103–104; *Mr. and Mrs. Andrews*, 79–81, **79**; *Mrs. Siddons*, 35, **37**; *The Morn-

ing Walk*, 82; *Two Shepherd Boys with Dogs Fighting*, 31, **32**
Gillray, James, 131–34;
—**Works:** *Titianus Redivivus;—or—The Seven Wise Men Consulting the New Venetian Oracle*, 131–34, **132**
Gimcrack with a Groom on Newmarket Heath (Stubbs), 17–19, **18**
Girlhood of Mary Virgin, The (Rossetti), **27**
Gombrich, E. H., 31, 45, 112, 172
Grant, John E., 68, 71, 72, 73
Gray, Thomas, 183
Gypsy Sisters of Seville (Phillip), 31, **33**

Hagstrum, Jean, 70, 73, 75
Harvey, John, 133
Helmholtz, Hermann von, 6
Hill, James L., 92–93
Hireling Shepherd, The (Hunt), 167–70, **169**
Hirsch, E. D., Jr., 73, 75
Hogarth, William, 5, 12, 19, 30–31, 49–65, 170;
—**Works:** *The Election*, 19, 50, 51; *The Graham Children*, 95; *Marriage a la Mode*, 19, 30, 38, 40, 50, 51: "The Contract," **30**, 38, 40; *The Rake's Progress*, 12, 19–20, 50–65: "The Heir," **29**, 52–54, "The Levee," **54**, 55–56, "The Orgy," **56, 57**, "The Arrest," 57, **58**, 59, "The Marriage," **59**, 60–61, "The Gaming House," **60**, 61, "The Fleet Prison," 61, **62**, "The Madhouse," 61–65, **63**
Home, Henry, Lord Kames, 2–4, 8–10, 15, 182
Hopkins, Gerard Manley, 95, 99, 102, 157
Hughes, Arthur, 89–91;
—**Works:** *The Long Engagement*, 89–91, **90**
Hunt, William Holman, 6, 29, 143–46, 167–71, 184;
—**Works:** *The Awakening Conscience*, **28**, 29, 170–71; *The Finding of the Saviour in the Temple*, 29, 170; *The Hireling Shepherd*, 167–70, **169**; *The Lady of Shalott*, 170; *The Light of the World*, 170

Ideal presence (Kames), as an aspect of engagement, 3
Impressionism, 175, 177
Iser, Wolfgang, 11, 12, 13

James, Henry, 184–85
Johnson, Samuel, 10, 64, 178, 186
Joll, Evelyn, 122, 138
Jonson, Ben, 78–81

Kames, Lord. See Home, Henry, Lord Kames
Keates, John, 134, 174
Kirschbaum, Leo, 73, 74, 75
Kliger, Samuel, 182
Kroeber, Karl, 91, 93–94

Lady Caroline Howard (Reynolds), 95, **98**, 105
Lady Elizabeth Delmé and Her Children (Reynolds), 81–82, **83**, 184
Landow, George, 29, 124–25, 139–40
Landscapes, relationships with figures, 77–112: proprietary, 78–82; formal harmony, 84–85; emblematic, 85–91; philosophical, 91–94; children in landscapes: children in gardens, 94–106; children excluded from gardens, 106–112
Landscape with a Rainbow (Rubens), **130**, 131
Langer, Suzanne, 43
Lawrence, Sir Thomas, 12, 95, 104–105;
—**Works:** Miss Murray, 95, **97**, 104–105
Leighton, Frederic, Lord, 12, 35, 38, 95, 105–106;
—**Works:** May Sartoris, 35, 38, **39**, 95, 105–106
Lessing, Gotthold Ephraim, 6, 8, 15, 183;
—**Works:** Laocoön, 8
Light and Colour (Goethe's Theory)—the Morning after the Deluge—Moses Writing the Book of Genesis (Turner), 137–38, **139**
Lipking, Lawrence, 183
Locke, John, 6–7, 11, 42–43
Long Engagement, The (Hughes), 89–91, **90**

Mack, Maynard, 12
Marriage à la Mode (Hogarth), 19, 30, 50, 51: "The Contract," **30**
Marvell, Andrew, 78–81, 95, 99–102;
—**Works:** Upon Appleton House, 78–81; "The Picture of Little T.C. in a Prospect of Flowers," 95, 99–102
Master John Heathcote (Gainsborough), 95, **96**, 103–104
May Sartoris (Leighton), 35, 38, **39**, 95, 105–106
Meredith, George, 22–23;
—**Works:** Modern Love, 22–23
Michelangelo Buonarroti, 17;
—**Works:** Fall and Expulsion (Sistine Chapel), 17
Millais, Sir John Everett, 6, 29, 87, 107–111, 138–42, 143–45, 152, 171–73;
—**Works:** The Blind Girl, 107–111, **108**, 125, 138–42, 152, 171, 172; The Boyhood of Raleigh, 172; Christ in the House of His Parents, 29, 171; Isabella, 170, 172; Mariana, 170, 172; Ophelia, 170, 171, 172; The Order of Release 1746, 171; The Princes in the Tower, 172; The Proscribed Royalist 1651, 87, **88**, 171; The Rescue, 172; The Return of the Dove to the Ark, 171; The Violet's Message, 172
Miller, Annie, 167
Milton, John, 4, 110–11, 112–20, 140–42, 166;
—**Works:** Paradise Lost, 110–11, 113–15, 140–42, 166; Samson Agonistes, 113–14
Miss Murray (Lawrence), 95, **97**, 104–105
Miss Willoughby (Romney), 40, **41**
Mr. and Mrs. Andrews (Gainsborough), 79–81, **79**
Mrs. Siddons (Gainsborough), 35, **37**
Mrs. Siddons as the Tragic Muse (Reynolds), 35, **36**
Mitchell, W. J. T., 46–47
Molyneux's problem, 7
Moore, Robert, 52
Morris, Jane, 167
Morris, William, 143, 172–73
Mortlake Terrace (Turner), 117, **118**, 120–22

Mulready, William, 19;
—**Works:** *The Seven Ages,* **18**, 19

Newton, Isaac, 116, 121, 125, 134, 138
Nicolson, Marjorie Hope, 116, 134
Nochlin, Linda, 20–21

Opie, John, 95
Ostriker, Alicia, 73

Paradise (Brueghel and Rubens), **109**
Past and Present, Number 1 (Egg), **22**
Past and Present, Number 2 (Egg), **23**
Past and Present, Number 3 (Egg), **24**
Paulson, Ronald, 5, 52, 65, 87, 112, 117, 181
Pevsner, Nikolaus, 180
Phillip, John, 31;
—**Works:** *Gypsy Sisters of Seville,* 31, **33**
Pointon, Marcia, 111
Pope, Alexander, 16–17, 51, 53, 57, 62, 64, 84–85;
—**Works:** "Couplet on Newton," 63; *Dunciad,* 62, 133; *Epilogue to the Satires,* 57; *Epistle to Burlington,* 51, 53; *Epistle to Dr. Arbuthnot,* 57; *An Essay on Criticism,* 51; *First Satire of the Second Book of Horace Imitated,* 57; *The Rape of the Lock,* 16–17, 51; *Windsor Forest,* 84–85
Poussin, Nicolas, 38, 121, 145–49;
—**Works:** *The Annunciation,* **147**
Praz, Mario, 70
Pre-Raphaelites, 13, 143–76
Proscribed Royalist 1651, The (Millais), 87, **88**, 171
Proserpine (Rossetti), **168**
Puritanism, 6, 179, 180, 181

Quennell, Peter, 50

Raeburn, Sir Henry, 95
Rainbow, the, 124–42; in Genesis, 124–25; as political symbol, 125–28; as personal symbol in Blake, 129; as homage to Rubens, 130–31; as

satire and reference to Titian, 131–34; as scientific or sublime sign, 134–38; as emblem of sight, 138–42
Rake's Progress, The (Hogarth), 19–20, 30: "The Heir," **29**, 30; "The Levee," **54**; "The Orgy," **56**; "The Arrest," **58**; "The Marriage," **59**; "The Gaming House," **60**; "The Fleet Prison," **62**; "The Madhouse," **63**
Raphael, 145, 161
Read, Herbert, 179–80
Reader-response criticism, 11–13
Realism: as Pre-Raphaelite program, 143–46; as opposed to seventeenth-century conventions, 143–49; in mid-nineteenth-century debate, 149–52; for Rossetti, 153–67; for Hunt, 167–71; for Millais, 171–73; its problems, 173–76
Regulus (Turner), 117, **119**, 122–23
Reichert, John, 2
Reynolds, Sir Joshua, 5, 12, 34, 35, 38, 81–82, 95, 105, 145, 148, 151, 153, 182–83, 184;
—**Works:** *David Garrick between Tragedy and Comedy,* 35; *Discourses on Art,* 38, 145, 151, 182; *Lady Caroline Howard,* 95, **98**, 105; *Lady Elizabeth Delmé and Her Children,* 81–82, **83**, 184; *Lord Heathfield,* 184; *Self-Portrait,* 184; *Mrs. Siddons as the Tragic Muse,* 35, **36**
Richards, I. A., 1
Rio, Alexis François, 151–54
Rochester, Earl of. *See* Wilmot, John, Earl of Rochester
Romney, George, 40–41, 82–84;
—**Works:** *Miss Willoughby,* 40, **41**, 82–84
Rossetti, Dante Gabriel, 5, 12, 25–27, 143–44, 146–49, 153–67, 175, 184;
—**Works:** *Astarte Syriaca,* 167; "The Blessed Damozel," 164–66, 175; *The Day Dream,* 167; *La Donna della Finestra,* 167; *Ecce Ancilla Domini!,* 25, **26**, 146–49, 153, 155, 166, 170, 175; *The Girlhood of Mary Virgin,* 25, **27**, 155; *The House of Life,* 155–56; "Jenny," 5, 158–65, 175; "Mary's Girlhood: For a Picture," 148; *La*

Pia de'Tolomei, 167; *Poems*, 165; *Proserpine*, 167, **168**; *Venus Verticordia*, 167; *Veronica Veronese*, 167; "The Woodspurge," 157, 164, 175
Rothstein, Eric, 4, 11
Royal Academy, 50, 120, 121, 131, 145, 182
Rubens, Peter Paul, 109–110, 130–31;
—**Works:** *Chateau de Steen*, 130; *Landscape with a Rainbow*, **130**, 131; *Paradise* (with Jan Brueghel), **109**, 110
Ruskin, John, 107–109, 134, 140, 145, 152–53, 154, 170, 171, 184, 185;
—**Works:** *Letters*, 154; *Modern Painters*, 152–53; "The Three Colours of Pre-Raphaelitism," 107–109, 152

Salisbury Cathedral from the Meadows (Constable), **135**, 136
Schorer, Mark, 75–76
Seven Ages, The (Mulready), **18**
Shakespeare, William, 4, 69, 112, 161, 174
Shelley, Percy Bysshe, 91, 134
Siddal, Elizabeth, 167
Staley, Allen, 91, 111
Stevens, Wallace, 166
Stonebreaker, The (Brett), **20**, 111
Strong, Roy, 107, 127
Stubbs, George, 5, 17–19;
—**Works:** *Gimcrack with a Groom on Newmarket Heath*, 17–19, **18**
Sublime, the, 91, 113–18, 125, 136–37
Sun, the, in Milton, Thomson, and Turner, 112–23
Symbolist poetry, 175

Temple, Sir William, 178
Tennyson, Alfred, Lord, 156–57, 171, 172, 174, 183
Thomson, James, 112–21, 134–35
Thoré, Théophile, 121
Tillotson, Geoffrey, 64
Titianus Redivivus;—or—The Seven Wise Men Consulting the New Venetian Oracle (Gillray), 131–34, **132**
Turner, James, 77, 78

Turner, Joseph Mallord William, 2, 112–13, 117–23, 135–38, 171, 184;
—**Works:** *The Burning of the Houses of Parliament*, 2; *Buttermere Lake with a Rainbow*, 119, 136; *Childe Harold's Pilgrimage*, 121; *Cottage Destroyed by an Avalanche*, 120; *Dido Building Carthage: The Rise of the Carthaginian Empire*, 117; *The Fountain of Indolence*, 120; *Frosty Morning*, 119; *The Golden Bough*, 121; *Light and Colour (Goethe's Theory)— the Morning after the Deluge—Moses Writing the Book of Genesis*, 137–38, **139**; *Mortlake Terrace*, 117, **118**, 120–22; *Regulus*, 117, **119**, 122–23; *Slavers Throwing Overboard the Dead and Dying*, 120; *The Snowstorm*, 2, 184; *The Sun Rising through Vapour*, 117; *Thomson's Aeolian Harp*, 120; *Ulysses Deriding Polyphemus*, 117; *The Wreck Buoy*, 136–37, **138**
Two Shepherd Boys with Dogs Fighting (Gainsborough), 31, **32**

Uphaus, Robert, 64

Wagenknecht, David, 71, 73, 128
Wallis, Henry, 111
Ward, James, 130–31;
—**Works:** *Eildon Hills with the Tweed*, 130, **131**; *Fighting Bulls with a View of St. Donat's Castle*, 130
Wark, Robert, 40
West, Benjamin, 34
Whistler, James Abbott McNeill, 174, 175, 185;
—**Works:** *Arrangement in Grey and Black*, 175; *Symphony in White*, 175; "Ten O'Clock Lecture," 175, 185
Wilde, Oscar, 175, 185;
—**Works:** "The Harlot's House," 175; "Le Jardin," 175; *The Picture of Dorian Gray*, 185
Wilding, Alexa, 167
Wilkie, David, 6
Wilmot, John, Earl of Rochester, 60
Wilton, Andrew, 122

Wivenhoe Park, Essex (Constable), 81, **82**
Wordsworth, William, 44–45, 91–94, 151, 152, 183, 184;
—**Works:** "Strange Fits of Passion Have I Known," 44–45; *Tintern Abbey (Lines Composed a Few Miles above Tintern Abbey on Revisiting the Banks of the Wye During a Tour. July 13, 1798),* 91–94
Wounded Cavalier, A (Burton), 87–89, **89**
Wreck Buoy, The (Turner), **138**
Wright of Derby, Joseph, 6, 35

Yates, Frances, 127

About the Author

Michael Cohen received his master's and doctorate degrees from the University of Arizona. He is Professor of English, Murray State University.